Border Aesthetics

Time and the World: Interdisciplinary Studies in Cultural Transformations

Series editor: Helge Jordheim, University of Oslo, Norway

Published in association with the interdisciplinary research program Cultural Transformations in the Age of Globalization (KULTRANS) at the University of Oslo.

Time is moving faster; the world is getting smaller. Behind these popular slogans are actual cultural processes, on global and local scales, that require investigation. *Time and the World* draws on research in a wide range of fields, such as cultural history, anthropology, sociology, literary studies, sociolinguistics, and law, and sets out to discuss different cultures as sites of transformation in a global context. The series offers interdisciplinary analyses of cultural aspects of globalization in various historical and geographical contexts, across time and space.

Editorial board: Andrew Barry, University of Oxford; Richard Baumann, Indiana University; Costas Douzinas, Birkbeck, University of London; Thomas Hylland Eriksen, University of Oslo; Lynn Hunt, University of California Los Angeles; Fazal Rizvi, University of Melbourne; Hartmut Rosa, Jena University; Inger Johanne Sand, University of Oslo; Stefan Willer, Center for Literary and Cultural Research Berlin; Clifford Siskin, New York University

Volume 1
From Antiquities to Heritage: Transformations of Cultural Memory
Anne Eriksen

Volume 2
Writing Democracy: The Norwegian Constitution 1814-2014
Edited by Karen Gammelgaard and Eirik Holmøyvik

Volume 3
Border Aesthetics: Concepts and Intersections
Edited by Johan Schimanski and Stephen F. Wolfe

Border Aesthetics

Concepts and Intersections

>• •◄

Edited by
Johan Schimanski and Stephen F. Wolfe

berghahn

NEW YORK • OXFORD
www.berghahnbooks.com

Published in 2017 by

Berghahn Books

www.berghahnbooks.com

© 2017, 2019 Johan Schimanski and Stephen F. Wolfe
First paperback edition published in 2019

Library of Congress Cataloging-in-Publication Data

Names: Schimanski, Johan, editor. | Wolfe, Stephen, editor.
Title: Border aesthetics : concepts and intersections / edited by Johan
 Schimanski and Stephen F. Wolfe.
Description: New York, NY : Berghahn Books, 2017. | Series: Time and the
 world : interdisciplinary studies in cultural transformations ;
 Volume 3 | Includes bibliographical references and index.
Identifiers: LCCN 2016053591 (print) | LCCN 2016058522 (ebook) | ISBN
 9781785334641 (hbk) | 9781789200539 (pbk) | ISBN 9781785334658 (e)
Subjects: LCSH: Cross-cultural studies. | Borderlands--Philosophy. |
 Boundaries--Philosophy. | Human geography. | Political anthropology.
Classification: LCC GN345.7 .B67 2017 (print) | LCC GN345.7 (ebook) | DDC
 320.1/2--dc23
LC record available at https://lccn.loc.gov/2016053591

British Library Cataloguing in Publication Data

A catalogue record for this book is available from the British Library

ISBN 978-1-78533-464-1 (hardback)
ISBN 978-1-78920-053-9 (paperback)
ISBN 978-1-78533-465-8 (ebook)

▸● ●◂

Contents

▶● ●◀

Figures

Acknowledgements

We would like to thank all those writers, reviewers, editors, and the indexer who have been involved in the process of creating this book. We also would like to thank those institutions that provided support for the editors and writers of these essays.

The book is a result of the Border Aesthetics (2010–2013) research project financed by the Research Council of Norway (project number 194581), as part of the KULVER Programme, and by the Department of Language and Culture, Faculty of Humanities, Social Science and Education, UiT The Arctic University of Norway.

The book also contributes to the work package 10, 'Border Crossing and Cultural Production', of the EUBORDERSCAPES research project (Bordering, Political Landscapes and Social Arenas: Potentials and Challenges of Evolving Border Concepts in a Post-Cold War World, 2012–2016), which was funded by the European Commission under the 7th Framework Programme (FP7-SSH-2011-1, Area 4.2.1 'The evolving concept of borders', grant number 290775).

Johan Schimanski and Stephen F. Wolfe

▶● ●◀

Introduction

Mireille Rosello and Stephen F. Wolfe

Ecology, Imaginary, Invisibility, Palimpsests, Sovereignty, Waiting: what do all these concepts have in common? We present them to our readers as the conceptual tools that have helped us approach borders from a perhaps counterintuitive angle: that of aesthetics.

Our book is a contribution to border studies, a vast and thriving field that makes sense of the widely different, sometimes incompatible and constantly changing definitions of the border. Our six concepts intend to highlight the constantly evolving state of this research area which reaches into many disciplines. We know that no single discourse of mastery will exhaust our understanding of borders: they belong to the topographer, to the geographer, to the lawyer, to the philosopher, or to the mathematician, and it is clear that we do not intend to cover all these fields of expertise. Our specific point of entry is based in the disciplines currently recognized as the humanities and social sciences (philosophy, film studies, literature studies, narratology, history and geography). Yet our challenge was to find an interdisciplinary approach that would both acknowledge the existence and validity of those discourses and interrogate what those disciplinary borders do to the different types of borders that we have chosen to analyse. In short, we treat borders as methodologies (Boer 2006) and objects of study.

At the same time, the term 'object of study' must be nuanced because we wish to remember that the border cannot be reduced to academic and professional fields. The concepts that we deploy in this book have helped us structure the chapters in a way that recognizes that borders exist both within and outside of discourse, but also have shaped the subjectivity of those subjects who encounter borders in their everyday life. When we reflect on borders, we write as subjects who were formatted very early on by our experience of borders. The contingencies of birth will have determined to some extent at least whether a subject internalizes national borders as serious, dangerous or non-existent obstacles. If you were born within the EU with an EU passport after the Schengen agreements, you may have to learn to imagine how

an East Berliner after the Second World War or a refugee trying to enter Fortress Europe conceptualizes borders (Balibar 2004). But it may also be different to theorize borders depending on how you perceive your body, or more specifically the relationship between your bodies and categories of gender, able-bodiedness, health and racialization (Higonnet 1994). Psychoanalytical approaches, which define the construction of the subject in terms of the recognition or refusal of borders, have taught us to be sensitive to the way in which bodies react to, are shaped by and create borders.[1]

That approach is in synch with the spatial turn which, within the field of cultural studies, aims to connect topographical spaces with the medial spaces of culture especially through the use of discourse analysis.[2] Local, urban, intimate and subjective spaces are now just as important as geopolitical national boundaries. Consequently, the border-crossing narrative (as manifest in travel writing, exploration narratives, captivity narratives, autobiographical writing, migration literature, etc.) can thus be apprehended as performative renegotiations of nations and their narration, as well as the border itself.

A focus on the performativity of borders goes hand in hand with a questioning of which comes first: the border or its performative engendering. According to Georg Simmel's 1997 [1903] dictum, '[t]he boundary is not a spatial fact with sociological consequences, but a sociological fact that forms itself spatially' (Simmel 1997 [1903]: 142). In his view the border is a product of symbolic differences, even if it is also a spatial dimension. A form of classification or a way of making and marking distinctions, borders not only separate however, they also imply interactions. The separation axiomatically generates a connection between the separated entities. In Judith Butler's terms, 'the boundary is a function of the relation, a brokering of difference, a negotiation in which I am bound to you in my separateness' (Butler 2009: 44). And Marylin Strathern argues that borders are able to generate zones of interchange and trade across differences by providing a means to translate and transact (Strathern 2004: 46–47). In arguing that borders integrally involve relations as well as separations, Butler and Strathern also imply that the identity of each part depends upon a relationship, either of separation or of separation and a potential exchange, with the different parts. We suggest that borders can have a life of their own, producing border effects after their original installation or statement; they can reinforce the symbolic difference that created them, or even cause changes in these symbolic differences; they can continue to have effects after the symbolic differences that caused them have disappeared or lessened. Border formation can include an element of unpredictability and uncanny effects coming from the border itself.

What does Studying Border Aesthetics Mean?

At this point, we would like to explain why we have chosen to focus on 'border aesthetics', why we think it is urgent and important. We also wish to clarify what we mean by 'border aesthetics'. As we suggested above, bordering processes influence everyone's way of being in the world. Knowing up to which point one may travel safely without a passport or a visa is not something anyone can afford to ignore. Neither is it possible to blunder across conceptual (legal, propriety) borders without getting into serious trouble.[3]

Border aesthetics, however? Will you follow us there? Aren't we staking our flag at the hypothetical intersection between borders and aesthetics that readers might find less immediately relevant? To be fair, we are precisely less interested in 'staking a flag' than in inviting our audience to notice and question the metaphor we just (almost) smuggled into our text. We wish to alert you to the ease with which cultural subjects may be tempted to 'understand' a thought without questioning the values (here associated with conquering) that make a point legible through a spatial metaphor. And with the word 'point' (like the word limit, or field) we have already begun to participate in a logic of bordering that is historically, geographically and socially aestheticiz-able (Saunders 2010). As we shall see below, one of our contributions to the discussion of borders is the interrogation and recognition of the imaginative actions of generative and receptive representation that are taking place within a particular discursive and generic formation: an essay, a narrative, a film, a map, or a painting (Mukherji 2011: xvii–xxvii, Görling 2007).

For us, border aesthetics is a familiar territory, almost a home. The book you have in your hand began as the final part of a large project in Border Aesthetics sponsored by the Research Council of Norway, 'Assigning Cultural Values' KULVER research programme from 2010 to 2013. The project was centred on a core of eight researchers at UiT The Arctic University of Norway (previously the University of Tromsø) and a network of seven external part-ners (Kirkenes and Bergen, Norway; Amsterdam and Nijmegen, Netherlands; Düsseldorf, Germany; Joensuu, Finland; and Bergamo, Italy), which included literary scholars, media scholars, a political geographer, a folklorist, an urban planner and a social anthropologist. Twelve of these scholars participated in this book project. The collaborative structure and goals of the book proj-ect were developed over three weekend workshops in Rome (2011), Tromsø (2012) and Oslo (2013) and through web and internet conversations.[4]

From there many of the authors have published essays using a border aesthetics framework in books and journals on questions arising from the border, geo-cultural and geo-political case studies of border zones and border crossings in contemporary Europe; in public policy debates on immigration,

migration and the refugee crisis; and in cultural studies journals.[5] The impact of our work has been noted in a 2015 issue of the journal *Geopolitics* edited by Elena dell'Agnese and Anne-Laure Amilhat Szary, who argue that the study of border aesthetics for the border studies researcher is 'another way of expressing the relational dimension of socio-spatial interfaces and of questioning their political component' as well as opening 'the ground for questioning the positionality of the investigator' (12–13). All the recent studies referenced throughout this introduction have had an impact on a number of different academic communities who focus on actual social processes at specific borders, or for border theory, where borders are studied in a largely metaphorical and conceptual manner (Brambilla 2015: 3).

For us, border aesthetics has a specific definition and a purpose: before we even set out to define what we mean by border aesthetics, we wish to emphasize that aesthetics, as we understand it, is not an abstract and de-politicized academic field. We care about border aesthetics because it has everything to do with the proliferating and dangerous borders of our globalized world. Border aesthetics is about people who die trying to cross a border.

Chiara Brambilla has written about the hundreds of migrants who drowned in their attempt to reach Lampedusa and were then granted posthumous Italian nationality (Pop 2013). She studies the LampedusaInFestival and the border and migration nexus centred on the island and insists that the creation of alternative border imaginaries has crucial political implications for the Euro/Mediterranean border space within the aesthetic activities on the island during the festival (Brambilla 2015: 111–122; see the chapter on Invisibility in this volume). On the evening of 3 October 2013, when 368 people and one unborn child drowned, the migrant/refugee crisis and the border/boundary crisis became intertwined and for the past few years have been at the centre of worldwide attention. The event was immediately and has been continually anesthetized. Francis Stonor Saunders recently called such borders 'the creation of a death zone, portals to the underworld': despite being half a mile from Lampedusa in Italian territorial waters, the boat was crossing the common European border, 'only to encounter its own vanishing point, the point at which its human cargo simply dropped off the map. *Ne plus ultra*, nothing lies beyond' (Saunders 2016: 7). Border aesthetics helps us confront such volatile and potentially dangerous configurations of border as Lampedusa, and provides us with an orientation in the already interdisciplinary field of border studies.

As used in this book, the term aesthetics refers to a set of theories that scholars invoke primarily to interpret works but also to identify what will count as 'works of art'. In terms of disciplinary recognition, they form the branch of philosophy that addresses notions such as the beautiful and the ugly, the grotesque and the sublime. Our claim is that aesthetics is essential whenever we

need to recognize and appreciate the criteria that define borders (inside and outside, threshold spaces and in-between zones, classification and control, legitimate denizen, resistant border-dweller or undocumented migrant).

We understand aesthetics as the language that articulates the subject's sensory perception of a given world, including what counts as art or politics, true or false, beautiful or ugly. It participates in the apprehension of a border through sensory perceptions. This definition of aesthetics connects to the word's etymological root, a Greek verb meaning 'to perceive, feel, sense'. Borders must have a sensible component in order to function as borders (these arguments are developed in the chapters on Imaginary and Invisibility). One most evident aesthetic aspect of the border is its statistically high level of visibility: we view fences, markers, gates or contours in a landscape as what constitutes a boundary. A border that is not sensed by someone or something is not a border (Larsen 2007). The sensing of borders goes well beyond the visual or even the five basic senses when they organize symbolic differences and separations between neighbourhood or communities, but also the limits between 'safe' and 'dangerous' areas of a city, or 'the difference' between Finland and Russia. Borders become meaningful through sensory perception and can only be legible, understandable via forms of aesthetic sensitivity that we learn as geo-political subjects. Here we propose to rely on theories of 'sensuous cognition' or *cognitio sensitiva* as Alexander Baumgarten called it in the book that gave its name to the discipline (Baumgarten 1983 [1750]). Jacques Rancière makes a similar point about the 'distribution of the visible' in politics: 'Politics revolves around what is seen and what can be said about it, around who has the ability and the talent to speak, around the properties of spaces and the possibilities of time' (Rancière 2004: 13).

The other crucial aspect of aesthetics has to do with how one distinguishes between objects that may or may not fall under the category of aesthetic representations: we observed our responses to how painting, film, music, literature represent borders as spaces of constant production.[6] These borders are lived in through images and symbols whose aesthetics cannot be taken for granted or ignored. For they are also generated by the social and cultural performances of border subjects whose lives are traversed by boundaries. At times, the border is reduced to a memory whose survival is guaranteed by individual and collective memories (a memoryscape). When borders are 'traces' they present themselves as attempts to hold on to historical figures and figurations within a social-political landscape, or a symbolic landscape presented in previous representations, such as a poem, story, essay, artwork, or an ideological formation. As the chapter on Palimpsests shows, each border carries within it the archaeology of previous borders, enabling an analysis of their figurative representations to function as a community of practices or a style.

When we talk about 'border aesthetics' then, we do not restrict our analysis to what would be aesthetic or aestheticizable about a border. We do not wish to aestheticize already existing borders by turning them into fiction or art. Nor do we pretend that all borders can be reduced to stories, or fictions, or complex narratives. A border represented within a work of art, however, is just are real as a check point even if the reality it belongs to invites different sites of encounters and other practices: watching a documentary about a refugee/beekeeper (*Der Imker*) or a film about detention centres (*Illégal*, *La Forteresse*) is not the same as surviving, day after day, in the Jungle of Calais. We hope to have avoided the obvious trap of giving the impression that it is possible to collapse the two forms of border work while still questioning the practices that turn some realities into fictions and some fictions into prescriptions. In other words, while acknowledging a difference (a border) between the work of art that represents the border and the border 'itself' we also wish to question the assumptions that produce and police that type of border because we suspect that the 'itself' of the border is a product of the aesthetic laws that format the realm of the social and the political. We do not avoid such objects of study that are already recognized as works of art, but neither do we treat them as more obvious sites of inquiry, nor do we wish to limit our study to such already acknowledged representations. Our theoretical starting point is precisely that there is no such a thing as a non-aesthetic figuration of the border. We have resisted opposing border art (the installation of a door in the middle of a field on the US-Mexican border – Richard Lou's 1988 'Border Door') and political or media discourses that talk about a border as if we all agreed that it is a porous membrane, an impenetrable wall, a natural obstacle or a contact zone. Both border art and the apparently non-self-reflexive metaphorical representation of borders constitute examples of what we call here border aesthetics.

The social and institutional practices that manage (inter)national and regional borders involve or rely on cultural productions. It is crucial to study the complex workings of border aesthetics because once the relationship between borders and aesthetics solidifies, we can interrogate how certain types of borders or border practices remain visible, or legitimate, or acceptable.

We do not ask whether or not representations of the border are aesthetic but in which ways they all are. And the fact that aesthetics and borders are always in each other's pocket does not liberate us from choosing a lens, a reading grid and a focus: border aesthetics is our theoretical starting point, not the topic of a book. What we specifically want to focus on here is the way in which border aesthetics reflects and creates friction and change when borders and aesthetics rub against each other and change each other accordingly. The signifying practices of the border are not created passively or all at once but take place over time and are often over-written and reinterpreted by creator and audience alike (Brambilla 2015: 114).

Borderscapes and Border Aesthetics

The chapters in this book address these questions and speak to the imaginative power of the border as a productive space for asking how art represents, explores and negotiates border experience. Regardless of which point of engagement we have with borders, we have to reckon with hegemonic or minoritized representations. Our interest in the border as dynamic zone and process helps us privilege concepts such as borderscape, borderland, border culture, *la frontera*, or b/ordering words that suggest that we care more about what one does with or around the border than about what the border is.

We are aware that the kind of cultural work that demarcation lines used to perform still exists. Just as we pointed out earlier, when national boundaries are the dominant object of study, border zones still proliferate unacknowledged. We also recognize that the border as linear obstacle and impenetrable division is far from having disappeared from the domains of the real or of the imaginary. Think for example of the way in which artists have denounced what goes on along the US-Mexico border or between Palestine and Israel by 'hacking' the walls that symbolize the partition.[7] Nor does it mean that when lines become 'zones', the situation on the border necessarily becomes more utopian, liberal or liberating.

On a less concrete, but nonetheless crucial plane however, the connection between borders and various regimes of power is made through the constant transport of the border through representations (maps, images, etc.) throughout state territories, and by the principals of legal sovereignty itself. We are indebted to scholars who are mapping what they have called the borderscape (Rajaram and Grundy-Warr 2007; Strüver 2005; Brambilla 2010). This neologism, inspired by Arjun Appadurai's theory of 'scapes' (1990), denotes a net of signs and versions of the border stretching out from its concrete site and insinuating itself into a multiplicity of fields and locations, involving in effect everything taking part in the bordering process. A borderscape is the result of processes of differentiation that are continuously challenged by human interaction, as David Newman argues (2006). These processes of bordering produce spatial effects that do not begin or end at demarcation lines drawn on maps. All the actors involved in that process contribute to its aestheticization by accepting or resisting pre-existing narratives, visions or myths and creating others. To recognize oneself as a border-crosser, one must already envisage the border as something that can be crossed (rather than ignored, or simply inhabited as a zone). To be a legible border control agent, one needs to believe in and impose the idea of illegal and legal crossings. The 'agent' may be hired by a state (and position him or herself vis-à-vis the official directives) or imagines him or herself as a committed patriot who substitutes him or herself

to a failing authority (as is the case on the United States border to Mexico, for example [Doty 2007]).

Consequently, the word 'borderscape' is one of the concepts that enabled a productive understanding of the dislocated and dispersed nature of borders, their regimes, and the assemblages of practices which now constitute the 'complexity and vitality of, and at, the border' (Rajaram and Grundy-Warr 2007: x). Borderscapes are a 'zone of varied and differentiated encounters' that are often 'invested with a certain aesthetic and moral value' (xxx–xxxiii). The term allows us to analyse a set of represented practices in a particular way, especially political and aesthetic practices. The potential is to see community 'as disconnected from the rigid territorial spatialities of the nation state ... [while] forming new, irregular, and fluid spatialities and communities as it operates' (xi–xii).

As Anke Strüver reminds us, a borderscape is a way of representing/ perceiving the area around the border:

> A borderscape ... brings together the two dimensions of representations ... it relies on narratives, images and imaginations as imagined realities of the border which are constitutive of its meanings and effects, including the practices with relation to the border ... The borderscape – shaped though representations of all kinds – implies borderscaping as practices through which the imagined border is established and experienced as real. (Strüver 2005: 170)

The following chapters start from that perspective and link it to two very specific aspects of aesthetic experience at a border. First they analyse the performative nature of the border through an analysis of practices of constituent communities within a border zone or on a border. Then they work at 'deforming' the border in art works, video installations, staging festivals at the border, and literature of the border. In their study of the role of aesthetics in the negotiation and functioning of borders and borderscapes, Johan Schimanski and Stephen F. Wolfe (2013) assert the significance of the sensible in general, and artworks in particular, for processes of bordering. Drawing upon the thought of Victor Shklovsky (1965 [1916]), they argue that the work of art has the inherent potential to insert 'difference into our ideologically fixed versions of reality, partly by delimiting art from the everyday, partly by deforming experience' (241). According to them, '[t]his defamiliarisation gives it [art] its critical potential' (241) and enables a political role of cultural expressions also in relation to contemporary regimes and practices of bordering.

Both these kinds of aesthetic representations attempt to de-familiarize through exaggeration, parody, overstated ambiguities of purpose and intention. They confirm a modernist and formalist aesthetics of difference. This defamiliarization has a critical potential. Moving or performing the border

off site or moving border posts into an installation not only aestheticizes the border, it also reminds us that the border was already an aesthetic construct. The appealing colours of the border posts, the overstated uniforms of the 'border guards' at airports, the monumentality, and the ten-foot high border fences or walls are not purely utilitarian: they are designed (Schimanski and Wolfe 2013).

Two writers in this collection, Holger Pötzsch (2015) and Johan Schimanski (2015), have examined elsewhere aesthetic representations in the Barents region with this ambiguity in mind. As they have persuasively demonstrated, the Barents region emerges as a complex borderscape where identities, connections and divisions are constantly negotiated in and through not only economic and political performances, but equally by means of cultural expressions. The material regimes of borders and the practices of in/exclusion they invite are enmeshed in a cultural domain and vernacular day-to-day performances that inherently reinforce, or challenge and subvert, border mechanisms and procedures at the border. The Northern borderscape, as such, becomes conceivable as 'a network held together by strategies of rhetorical, symbolic and discursive signification' that enables exclusionary division as well as inclusive cooperation – 'the borderscape can be an ambivalent space of both power and resistance' (Schimanski 2015: 41–43).

This collection would like to invite readers to interrupt their daily activities, to 'redistribute the visible', and to make something visible. That something is not extraordinary; rather it was always there, as an on-going process: it is the border itself. That entails an awareness that the border concept is itself being constantly negotiated in many fields – including the aesthetic, theoretical, political and ethical – and that this negotiation involves a constant interplay amongst these fields. Such negotiations, we suggest, also reveal what changes affect the border concept. The new ways of conceptualizing borders are never innocent. When borders are extended as borderscapes reaching far from the outer borders of nations, when borders are redefined as spaces, dynamic spaces of bordering, this leads to a broad shift in this already interdisciplinary field, from political and social geography towards anthropological and cultural sciences, and simultaneously from the macro relations of 'hard' geopolitics and economy to the micro narratives of borderland communities and border-crossers.

These changes affect the determination of who can speak and who is visible in borderland populations. Borderland populations counter perceived marginalization and trauma with newly formed narratives, and in doing so, they must relate to established narratives of state and nation that are enacted in metropolitan centres, that is, often at a distance from the borderland. Refugees and migrant minorities also resist dominant narratives while living inside metropolitan centres, often very aware of the contingent nature of

the boundaries placed around them or their communities. But representatives of dominant metropolitan cultures who find themselves in the periphery can also create representations of the borderland or of minority populations from within the majority discourse. Sometimes the border faces – or folds – outwards instead of inwards, such as when prospective immigrants are placed in a waiting zone outside the border (see the chapter on Waiting).

In these cases, we usually meet with some sense of ambivalence or paradox in the aesthetic representation of the border. Foundational discourses of the nation are challenged by minority discourses, which risk becoming foundational in turn. Metropolitan cultures attempt to represent and give voice to that which is different within them, but often end up not doing this adequately, as they are ultimately unable to mediate that which is other to them. Borrowing from Gilles Deleuze and Félix Guattari, Henk van Houtum writes that the border catches us between a 'schizoid' and a 'paranoid desire' for borders (Houtum 2010). Each chapter must thus speak to the generative and receptive power of the border as a creative engine and productive space in art and literature; or as a space of ideological formation and maintenance where social thinking and aesthetic imagination are negotiated.

Michael Bakhtin's work on 'chronotropes' has taught us that genre is another strong operator when it comes to analysing the aesthetics of the border as a spatial phenomenon. The theorist has clearly linked literary genres to a sense of space and time (Bakhtin 1981). Our question would be: what specific genres fit border zones, urban border spaces, national border crossings, or other spatial configurations in the new borderscapes of the nation, or transnational border processing places? Each of the chapters works with specific genres: half are literary while the others are a mixture of interdisciplinary medial expressions that have attempted to represent a border in both theory and or praxis. As border scholars will tell you, in northern European popular culture many border tourists going from Norway into Russia re-enact the road movie, moving through a landscape often perceived as barren, and often exposed to law enforcement agents dressed as border guards (see the chapter on Palimpsests).

Contemporary literary and visual artists create alternative histories and alternative maps as forms of intervention with which to defamiliarize the borderscape in which they find themselves and which forced migrants and refugees have to negotiate. Participatory video is a genre being used by migrant filmmakers to visualize Euro-African borderscapes. Border *corridos* and concept albums are musical and narrative genres that can be appropriated and used to remember an erased Mexican neighbourhood or to remind listeners of alternative ways of living together. All these aesthetic genres adapt to a lesser or greater extent to the constraints of the borderscape, and sometimes offer a liminal way of seeing. Not unlike classic discussions of the hierarchy

of the arts, border aesthetics poses the question of which genre works best or which genre or mode is privileged in a given national or transnational context.

All these chapters in some way posit that borders become liminal zones that not only separate but also connect divided entities and identities. As Pötzch has written, it is a 'potentially disruptive alternative state of being on the border, in-between divided entities, or as the ability to cross borders and access both sides on equal terms'. Being disruptive, 'liminality interrogates division' (2012: 72). Liminality carries the subversive potential to posit a relationship and a separation simultaneously or, as Homi K. Bhabha writes, 'liminality opens up the possibility of articulating different, even incommensurable cultural practices and priorities'. It is a 'third space' enabling a cultural translation, denying essentialism. Liminality displaces 'the histories that constitute it, and sets up new structures of authority, new political initiatives' (Bhabha 1990a: 210–211; this is further developed in the chapter on Sovereignty). Liminal space should also be considered as a location of contact, the negotiation of cultural values and of relational identity as we argued above.[8]

A relational identity is not reducible to borders. Nor is it relegated to a temporal limited transition outside daily life as in narratives of liminality or rites of passage. Rather, it is an aspect of the conscious and contradictory never-ending experience of contacts among cultures, at both the external and internal borders of a state. Today's complex apparatus of bordering and ordering regimes are obsessed with a verifiable and then verified identity and wish to ignore the fact that identity is produced in the chaotic network of relations and not simply by filiation.

Border Aesthetics within Contemporary Border Studies

In the first decade of the new millennium, a series of books and collections of essays appeared, all focusing on cultural expressions of border-crossing practices in literature, film, museum exhibitions and art installations on significant border sites throughout the world. Academic critics and practicing artists found questions of identity, belonging, community, nation and narration, and diasporic community best posed at national and transnational borders, or at borderlines, or in locational spaces of conflicted sexualities, ethnicities and genders, and communities. Narratives from the margins also moved to what used to be imagined as the 'centre' of literary and cultural studies (Ponzanesi and Merolla 2005; Ponzanesi and Waller 2012). Migrant or diasporic voices are now set in historic 'homelands', gritty or futuristic 'cultural borderscapes' or in an interstitial space beyond centre/periphery dichotomies (Mercer 2008). These border-crossing narratives depict individuals and communities

negotiating with placelessness, language, ethnicity and sexualities in hybridized discourses of resistance and ambivalence. We recognize that it is clearly urgent to address territorial and symbolic borders, as cultural forms of production that political and social science discourse may not consider as their primary case studies.

Several anthologies of analyses have brought together border crossings and literature, film and art (Schimanski and Wolfe 2007; Viljoen 2013). Several monographs have focused on literature and borders in Europe and North America (Robinson 2007; Sadowski-Smith 2008), and on questions of borders and postcolonial identities (Boer 2006). The need for work on cultural production and aesthetics in relation to borders has been strongly emphasized in articles appearing in special issues and in two recent major Readers on Border Studies (Walter 2011; Wilson and Donnan 2012).

Today, border studies scholars are fascinated by the continual process of bordering that creates categories of difference or separation (Rumford 2008, 2014; Houtum 2002; Houtum, Olivier and Zierhofer 2005; Newman 2006; Pötzsch 2010; Popescu 2012). Bordering is ordering, othering and negotiating difference:

> The process through which borders are demarcated and managed are central to the notion of border as process and border as institution. … Demarcation is not simply the drawing of a line on a map or the construction of a fence in the physical landscape. It is the process through which borders are constructed and the categories of difference or separation created. (Newman 2007: 35)

For us, one of the obvious consequences of this process is that narrative and figural representations are a central element in border formation. Terms such as allocation, antecedence, subsequence, superimposition, reconfiguration, removal, disappearance, construction, opening and closing create different narratives of what we would call border formation. Moreover, these processes have a dynamic involving both institutional, top-down management of borders and bottom-up negotiations of borders and in border zones. Border formation is not only a top-down process in the hands of power elites: currently a more dynamic view of bordering allows for the possibility of bottom-up agency. As Bhabha suggests in his description of national identification processes, the border is a product of a tension between the pedagogic and the performative (1990b: 145). By extension, it comes about as a product of the grand narratives (border formation) but also of performative minor narratives about day-to-day border crossing.

At the same time, another group of writers from political, cultural and geo-political geography and other social sciences have focused on developing a new vocabulary to interrogate and remap national borders and the national

and international institutions that supported legal forms of bordering and ordering. We have heeded the repeated calls to pay more attention to the study of cultural productions through the analysis of art works, architecture, festivals, installations, exhibitions, literature and film. Here we are indebted to Robert J. Kaiser and Anne-Laure Amihat-Szary who have studied the performativity of art works and their relationship to bordering practices, both in historical and contemporary situations (Kaiser and Nikiforova 2006, 2008; Amilhat Szary 2012, 2014).

None of these books, however, focus on the aesthetic issues raised by the uses of permeable national and international cultural languages and aesthetic forms. In this book, we set out to bridge two very important fields of research on borders that do not necessarily dialogue with each other: research connected to cultural studies and postcolonialism, whose focus is on identity, law and sovereignty (Kuortti and Nyman 2007), and, within the last five years, theoretical works on aesthetics grounded in social and political issues (Rancière 2004, 2010). Our book addresses questions of aesthetics and borders in a more systematic and theoretical way.

We are also suggesting that border aesthetics will help us recognize new borders and new narratives which will emerge simultaneously. Thus we follow Claudia Sadowski-Smith who has suggested how important it is to take account of specific aesthetic devices in border fiction. She insists on the unexplored connection between borders and genres such as magic realism; she highlights the need to research specific border figures such as the trickster; and she invites us to observe the way in which novels acquire composite characteristics. We also argue in a number of the chapters that border fictions change dominant conceptualizations of who inhabits and can speak for the border. We agree that such fictions cannot and should not be easily equated with a specific ethnic or national tradition and origin, and we do not assume that border fictions are necessarily aligned with a given politics or ideological commitment. We also acknowledge the need for comparative studies that take account of 'distinct histories of settlement, colonization, contact, and subordination in different nations' with a trans-hemisphere and international focus (Sadowski-Smith 2008: 10–11).

We are also indebted to Shameem Black's important book *Fiction Across Borders: Imagining the Lives of Others in Late-Twentieth Novels* (2009). In her introduction Black outlines an 'ethics' of border-crossing fictions that has a very strong emphasis on the border as the space in which contemporary writers interrogate otherness and ethical dilemmas in their own national histories.

The chapters in this collection do not focus exclusively on one form of cultural expression. Each chapter is set on the shifting ground of in-between zones and threshold spaces of the twentieth and twenty-first centuries, especially those upon which a political or social conflict is being played out. The

argument of each chapter does not follow the inevitability of inside/outside oppositions but most are shaped as a parabolic structure with a mirroring effect inclined to allegory and parable in some cases, while finding imaginative means to represent borders through 'constructed projections, pictures, phantasms that are wholly aesthetic in nature' (Welsch 1997: 21). We argue, following Welsh, that aesthetic representations are now produced through a refusal to confine the border to a knowable location or form, thus 'estranging or de-familiarizing' the border space and scape, either as a place and scape of 'transformation and difference'; or of translation and encounter (Black); or, to borrow Bhabha's formulation, 'a third space where the negotiations of incommensurable differences create a tension peculiar to border-line existences' (1994: 218).

Book Structure

The chapters in this book form a collaborative interdisciplinary monograph. Each of the six pairs of authors has provided one keyword that they find crucial to the ongoing debate on the role of the arts in persistent contemporary border situations. The keywords are tools designed to explore both a border concept and an aesthetic problem. Once the key concept is elaborated, the authors focus on an analysis of one or two examples to explore the aesthetic characteristics of the examined bordering process/concept. This leads to a discussion of the specific relationship between the concept and practices that address the relationship between borders and aesthetics. The chapters are also to be read as echoing one another and re-configuring the continuing discussion of borders and aesthetics in flux throughout the book. Thus the chapters intersect with each other through the use of a common set of strategies, and the insistent examination of the aesthetic dimensions of borders which will reveal their complexity and differentiation.

Throughout we use two analytical strategies: the first is to pay close attention to the planes onto which the concept of borders can be projected in cultural texts: topographical, symbolic, temporal, epistemological and textual. Topographically, the border divides and unites spaces (between nation states for example). Symbolically, the border distinguishes between values (right and wrong, good and bad). On the temporal plane the border separates time zones (the past and the present, old and new). On the epistemological plane it splits the known and the unknown. Finally, textually, the border organizes the different parts of the text and distinguishes between what is in or out of the textual unit.

The second strategy is to pay attention to the aestheticization of each type of border: how is the border represented within different generic signifying

practices for example? And here, by representation we mean the process by which the social meaning of spaces is negotiated among individuals and groups through literary creations, visual and verbal images, and tropes (metaphors or rhetorical gestures) in other media. The chapters challenge the representation of territorial and symbolic borders, asking how they acquire significance and which values they are assigned. For example, in recent artistic exhibitions centring on migration, diasporas, and the relation between traces and processes in bordering/ordering practices, artists and writers have created places within the borderscape in which representations and multiple perspectives emerge that would otherwise remain invisible (cf. Mercer 2008; Carey-Thomas 2012; or see the work of Mona Hatoum, the Black Audio Film Collective [1982–1998], or Rosalind Mashashibi). These spaces themselves are often defined by their transience, mobility and contingency, functioning as 'passages' through discrepancies in gender, ethnicity and national identities.

Our central objective is to investigate how aesthetic activity participates in the processes by which people relate to the real and conceptual border regions in which they live, work and through which they move. We wish to develop and interrogate the notion of a new globalized aesthetics of place that emerges from and responds to the co-existence of migrants, minorities and trans-national identities within borderscapes and zones – places where borders are being encountered and crossed, formulated and negotiated in their material and figurative manifestations, but also spaces in which the lived experiences of people cause a proliferation of aesthetic responses: cognitive, critical, linguistic and representational to the border.

There follow six chapter summaries which provide a preview of the signifying practices and key generative and receptive representations of borders in the book.

1. Ecology

This first chapter addresses the strong hold which conceptions of nature and the natural have on how both borders and aesthetics are configured. Conceptions of borders and aesthetics formed on natural models imagine the boundary as an obstacle to be respected and treat border-crossers, whose crossings alter and form the unstable terrains they cross, as the irrelevant exception or the disturbing or disruptive dissident. To highlight the flawed ideological circularity that constructs nature and borders as co-dependent, the chapter takes the example of Johann Winckelmann and Friedrich Schlegel's metaphorical descriptions of Roman and Hellenistic art to show how some aesthetic forms are blamed for having transgressed natural habitats. It then points out that even borders literally set in stone (such as a range of mountains) can, just as easily, be erased as borders by a historical myth. The naturalization of borders

legitimizes divisions between inside and outside, us and them, instead of allowing borders to function as contact zones, making border-crossers into unsuccessful transplantations. Roman conceptions (especially in the *Aeneid*) of nature as strong outer border creating unity, erasing internal boundaries and allowing for the multiplicity of empire, are precisely subject to the criticism that nature provides a new absolute boundary to the state and its empire.

The question is, what can challenge and transform traditional, nature-based conceptions of territorial and aesthetic borders into more democratic institutions? Interestingly, one of the 'natural' sciences, ecology, provides an alternative to nature, by providing a vocabulary which is much more geared to the dynamics of migration and a more self-reflective and critical conception of borders. Bruno Latour's concept of a 'political ecology' transcends the divisions between culture and nature. It ditches the risk-free natural units of conventional models, replacing them with 'tangled objects' caught in networks of concern, requiring a recognition of incompleteness. A careful evaluation of the potential issues involved in a Latour-based border aesthetics, especially as it might apply to the ongoing European experiment with its internal multiplicity and 'reappearing' borders, reveals the possibility of ecology just becoming another ultimate frontier in which natural territorial borders are done away with, to be replaced by natural temporal borders. Border-crossers become belated subalterns in a neo-imperial global system. The chapter concludes that in order to account for ways in which border-crossers and their art transform the terrain, we must instead entangle the various border ecologies discussed, in a process that produces different types of community.

2. Imaginary

The next chapter formulates a critical reflection on aesthetic and changing social imaginaries seen as the implicit frameworks in which borders have been figured. In what ways can cultural tropes deviate from accepted imaginaries and move toward new imaginaries? Taking an example from the first chapter, how might we transform nature into ecologies? Borders are here seen as emerging through processes of prefiguration within the three dimensions constituted by institution, tradition and the imaginary. To examine this is to understand how borders both confirm and interrogate their own structuring.

Aesthetics becomes a question of border encounters between imaginaries – our own and those of others, old and new. In addition to carrying representations of borderings, aesthetics carries an ethical dimension which enables reflections on and evaluation of those representations. Central to this ethics of aesthetics is the interplay between the social imaginaries which provide the glue to our everyday existence and social communities, as elaborated

by thinkers such as Benedict Anderson, Charles Taylor and Cornelius Castoriadis, and the more radical, incomprehensible and monstrous imaginaries which Jacques Derrida envisages as being presented by the future. Derrida's monsters are here a figure of the incomplete, as proposed in the chapter on Sovereignty.

This chapter focuses on Robert Frost's famous border poem 'Mending Wall', with its idiomatic phrase that carries its force – 'Good fences make good neighbors'. The poem provides the basis for a discussion of the etymological and social connection between tradition and treason. Tradition is not only a form of cohesion, but also a transmission highlighting the treacherous difference between sender and receiver. Dag Solstad's central novel of the Norwegian post-war imaginary, *Comrade Pedersen*, questions the possibility of a radical imaginary and an ideology which might have come into being – 1970s revolutionary communism – against the background of a social imaginary defined by a separate, prosperous, marginal and peaceful nation. Moving to a society more typically characterized by a clash of imaginaries, Paul Muldoon's avant-garde play on words in the poem 'Quoof' is seen as introducing a linguistic monster, a new terminology which could be the basis of a new social imaginary in Northern Ireland and a new border aesthetic.

3. In/visibility

Whereas in Chapter 2, 5 and 6 art becomes a way of negotiating and changing social imaginaries, as well as examining how aesthetics as sensory cognition contributes to the formation and negotiation of borderscapes and the politics of borders, this chapter focuses on the visual and the audial as dominant senses that help define the 'distribution of the sensible', which Rancière sees as connecting the aesthetic to the political. Following Hannah Arendt and Rancière, the aesthetic is seen as framing which lives, which subjectivities are to be seen and heard, which are relevant and which irrelevant, which are visible and which are invisible, or even 'invisibilized'. Illegal migrants and other border-crossers referred to in our first chapter on ecology are typically, as Marieke Borren states, publicly invisible and naturally visible, i.e. made pervasively visible in terms of their natural traits while having no role as public actors. Two pressing examples are examined, one hegemonic and the other counter-hegemonic, of how regimes centred around borders can bolster or help to transform the very terrain in which border-crossers move: the dehumanizing strategies of drone warfare and the redistributory effects of migrant self-representation in participatory video. As in Chapters 1 and 2, solutions are offered that indicate how politics may be thought of as an open and incomplete process, rather than being reduced to 'politics as police' (Rancière), namely through an epistemology of seeing.

4. Palimpsests

This chapter interrogates the regimes of visibility discussed in Chapter 3 in border landscapes, examining how concepts of palimpsest and symbolic layering may inform aesthetic borderscapes – especially after the specific, geopolitical transformation of communities represented by regime change. Here transformation is approached retrospectively, rather than being opened as a future possibility as in the previous chapters. Post-Soviet and post-Cold War borderscapes provide an obvious geo-political example involving regime change and pressing questions of social contrast and development. Despite radical social and economic change, the contemporary cultural landscape of Russia and Eastern Europe contains more or less modified Soviet infrastructure and monuments of the Soviet past that by their aesthetics convey various overt or neglected political meanings. Blended together with new symbols, they produce an ambivalent picture where elements compete, interrupt and contradict each other. The palimpsest on which the emerging world is inscribed reveals the new processes locked within the previous territorial divisions and inherited authoritarian political structures. Although the emerging socio-economic systems bear only partial similarity to their predecessor, they relate by denial or adoption to its cultural symbols. This chapter explores the meaning of post-Soviet spaces in contemporary Russia as part of a cultural and physical palimpsest and compares them with post-Soviet and obsolete Cold War structures in northeastern Norway and the Lithuanian city of Klaipeda. Palimpsests reveal the on-going conflicts between attempts to eradicate, deny or reuse spatial structures and their ideological meanings under new economic dynamics that manifest themselves in radically changed borderlands, as expressed aesthetically through contested city spaces and architectural symbolism.

5. Sovereignty

This chapter focuses on the relationship between the sovereign and the border. Today in public discourse, sovereignty has become associated both with a nation's right to self-determination and with the violent defence and transgression of borders. It is, however, haunted by the figure of the sovereign, which involves everything associated with it – be it subjects, full/bare lives, camps, etc. – in an economy of binaries and hierarchies. The sovereign is in turn haunted: while he or she claims to be independent of all Others and rules unconditionally, the sovereign is in fact dependent on his or her subjects and is as caught up in the economy of the sovereign as they are. How are we to escape this economy and transform our conceptions of citizenship so as to avoid these border binaries and economies, so as to accommodate border-crossers and other subjectivities?

This chapter on sovereignty, as well as the final chapter of the book, construct their arguments in dialogue with literary texts, among them two parables by Franz Kafka; in this chapter it is 'The Cares of a Family Man' (1919). The main character or motif in this parable is Odradek, which/who relates to the sovereign family man in an indeterminate, unconditional and 'insovereign' way. Odradek is of indeterminate abode, cannot be positioned inside or outside the borders of the house, and inhabits a third space which is not a container and which has no borders to the Other. Odradek's 'un-condition' is that of the border-crosser, the transitional object, the migrant, the traumatized refugees of the First World War. Odradek's physical and aesthetic appearance is that of being both unfinished and lacking in nothing. This chapter argues that Odradek thus offers us one way of attaining the incomplete being-in-process demanded earlier in the book. Odradek is easily interpreted, as a particularly literary or aesthetic way of writing, and is a way of thinking the aesthetic as unconditional – as well as a source of unconditionality – in its relationship to sovereign power and borders.

6. Waiting

This chapter focuses on the practice of waiting at a border. National or transnational states or national institutions of the state such as the Law create borders that require waiting or can even be defined as an act of waiting. The authors provocatively move away from the commonplace assumption that borders are about crossing, reaching the other side, passing and transgressing and counter-intuitively emphasize the other side of the coin. They define the border as what causes a standstill, or a delay: a difference in time and space. We have seen that when border studies scholars point out that the border is not merely a line, object or place that can be fixed in time, they usually wish to point out that activities proliferate on the border, in the supposedly liminal place that they precisely refuse to see as an in-between. This chapter, however, takes a different approach: it argues that the border constitutes a whole symbolic order that creates a state of abeyance, a waiting. Here border aesthetics is an act of narration which has the power to determine who belongs, who can pass through its frontiers, and who will be left waiting within and outside the legal and security structures of the borderscape or the institutions of the state.

This leads us to a state of waiting at the border that is analysed in two works of literature. We return to Franz Kafka's parables, in this case 'Waiting for the Law' (1914–1915, published 1915), which serves here as a companion to John Maxwell Coetzee's novel *Waiting for the Barbarians* (1980). Both texts represent waiting as typical of the b/ordering and othering processes of the border. Waiting is both a symbolic and psychological process of subjectification and internalization as well an act of exclusion through various

aesthetic formulations. In the texts discussed each protagonist is carried to the threshold of his or her own story, as they wait on the edge of a language that will constitute them as subjects within the law, the state, and the story. To be inscribed in the law is to make someone appear 'before' the law, i.e. within a borderscape and within its discourses. In each text these two performances are represented aesthetically through imagery of sight and the act of allegorical interpretation depending upon an outside/inside spatial analogy. Each text moves from these limited analogies, to new presentations of multiple aesthetic perspectives on witnessing and waiting at an ideological or medial border.

Each of these chapters then proposes to make sense of the various and sometimes incompatible or antagonistic ways in which divergent groups aestheticize the border or perceive and represent it from an aesthetic point of view. If borders are set up through theories of the border, then borders will not remain the same kind of entity over time, because the concept of a border itself is subject to change as are the concepts that created it. When people, objects, values and activities inhabit and pass through border zones, they also contest and change uses and inadequacies of current formulations of borders and aesthetics. When a group of asylum seekers sew their lips together at the Christmas Island detention camp in Australia[9] or when a fictional Russian asylum seeker burns her fingertips on her iron to avoid being identified by the Belgium immigration police,[10] then the violence of a representation that falls under the category of the aesthetic is also a powerful and political argument about how to re-imagine visibility and invisibility, sovereignty and bare life, and about what a different economy or ecology or border could be.

Mireille Rosello teaches at the University of Amsterdam (in the department of Literary and Cultural Analysis and the Amsterdam School for Cultural Analysis). She focuses on globalized mobility and queer thinking. Her latest works are a special issue of the journal *Culture, Theory and Critique* (on 'disorientation', co-edited with Niall Martin, 2016) and an anthology on queer Europe, *What's Queer about Europe? Productive Encounters and Re-Enchanting Paradigms* (co-edited with Sudeep Dasgupta, Fordham University Press, 2014). She is currently working on rudimentary encounters.

Stephen F. Wolfe (PhD) is Associate Professor of English Literature and Culture at the UIT, The Arctic University of Norway. He has co-coordinated research projects on border aesthetics, and within the EU FP7 project EUBORERSCAPES. He has co-edited the volume *Border Poetics Delimited* (2007) and edited 'Border Work/Border Aesthetics', *Nordlit* (2014,

Volume 31). Recent publications include: 'A Happy English Colonial Family in 1950s London?: Immigration, Containment and Transgression in The Lonely Londoners' (*Theory, Culture and Critique*, 2016), and 'The Borders of the Sea: Spaces of Representation' (in *Navigating Cultural Spaces: Maritime Places*, Rodopi, 2014).

NOTES

1. See Julia Kristeva's theories of abjection (1982) and Lacan's famous analysis of the mirror stage (Lacan 2006). See also Moruzzi (1993).
2. See http://spatial.scholarslab.org/spatial-turn/
3. The border between a joke and an injurious comment, for example, is a volatile and delicate border. Sometimes the State controls that border, writing up blasphemy laws or hate speech laws. Sometimes acts of violence mark the contested border between humour and injurious comments. We are thinking here of the worldwide controversies and acts of violence that accompanied the publication of caricatures of the Prophet Mohammed first in Denmark and then in Europe and the world wide web.
4. See http://uit.no/hsl/borderaesthetics
5. https://en.uit.no/prosjekter/prosjektsub?p_document_id=344772&sub_id=359668
6. We are also indebted to the work of Immanuel Kant on beauty and the value of art. In *The Critique of Judgment* (1790), one of the pivotal texts of modern aesthetics, Kant gave art the role of bridging the sensible world and the ideal world of ethics, God and the self. Not only did he claim that all arts shared a common aesthetic nature, he also placed aesthetics in a crucial position as a mediator between the world we experience and the ideal world to which we aspire. Since then, though, both the arts' capability to communicate with one another, and their ability to relate meaningfully to the political and social spheres that surround them, have become subject to debate. Our book addresses these questions within the specific contexts of borders by looking at various geographical locations as well as at the historical and political contexts that have contributed to creating them as utopian or dystopian border zones.
7. See Banksy's 'hacking' of the wall between Palestine and Israel in August 2005. See also Richard Lou's *Border Door* (1988), an installation that consists of a door and a frame placed on the border, in the area of Tijuana (Latorre 2012).
8. Liminality is a complex phenomenon which cannot be confined to a straightforward definition as a rite of passage, a journey or a transitory moment. The study of liminal states, the discourses of limits, and the transgression of limits at thresholds can be potentially liberating, especially when used in border analysis as meaning is generated in the interfaces between established cultural/aesthetic structures and political/gendered/ethnic systems.
9. See BBC report, 9 November 2010, 'Protesters sew lips shut at Australia asylum camp', http://www.bbc.co.uk/news/world-asia-pacific-11795786. See also Farrier 2011.
10. See Olivier Masset-Dupasse's film *Illégal*.

BIBLIOGRAPHY

Amilhat Szary, A.-L. 2012. 'The Geopolitical Meaning of a Contemporary Visual Arts Upsurge on the Canada-US Border', *International Journal* 64(7): 953–964.

_____. 2014. 'Latin American Borders on the Lookout: Recreating Borders through Art in the Mercosul', in Reece J. and Corey J. (eds), *Placing the Border in Everyday Life*. Farnham: Ashgate, pp. 346–378.

Appadurai, A. 1990. 'Disjuncture and Difference in the Global Cultural Economy', *Theory, Culture & Society* 7(2–3): 295–310.

Bakhtin, M.M. 1981. 'Forms of Time and of the Chronotope in the Novel: Notes toward a Historical Poetics', trans. C. Emerson and M. Holquist, in M. Holquist (ed.), *The Dialogic Imagination: Four Essays*. Austin: University of Texas Press, pp. 259–422.

Balibar, É. 2004. *We, the People of Europe: Reflections on Transnational Citizenship*. Princeton: Princeton University Press.

BBC. 'Protesters sew lips shut at Australia asylum camp', 9 November 2010. Retrieved on 9 March 2016 from http://www.bbc.co.uk/news/world-asia-pacific-11795786.

Baumgarten, A.G. 1983 [1750]. *Theoretische Ästhetik*. trans. H.R. Schweizer. Hamburg: Meiner.

Bhabha, H.K. 1990a. 'The Third Space: Interview with Homi Bhabha', in J. Rutherford (ed.), *Identity: Community, Culture, Difference*. London: Lawrence & Wishart, pp. 207–221.

_____. 1990b. 'DissemiNation: Time, Narrative, and the Margins of the Modern Nation', in H.K. Bhabha (ed.), *Nation and Narration*. London: Routledge, pp. 323–322.

_____. 1994. *The Location of Culture*. London: Routledge.

Black, S. 2009. *Fiction Across Borders: Imagining the Lives of Others in Late-Twentieth Novels*. New York: Columbia University Press.

Boer, I. 2006. *Uncertain Territories: Boundaries in Cultural Analysis*. Amsterdam: Rodopi.

Brambilla, C. 2010. '"Pluriversal" Citizenship and Borderscapes', in M. Sorbello and A. Weitzel (eds), *Transient Spaces: The Tourist Syndrome*. Berlin: Argobooks, pp. 61–65.

_____. 2015. 'Navigating the Euro/African and Migration Nexus through the Borderscape Lens: Insights from the LampedusaInFestival', in C. Brambilla, J. Laine, J.W. Scott and G. Bocchi (eds), *Borderscaping: Imaginations and Practices of Border Making*. Aldershot: Ashgate, pp. 111–122.

Butler, J. 2009. *Frames of War: When is Life Grievable?* London: Verso.

Carey-Thomas, L. (ed.). 2012. *Migrations: Journeys into British Art*. London: Tate Publishing.

Chouinard, V., E. Hall and R. Wilton. 2010. *Towards Enabling Geographies: 'Disabled' Bodies and Minds in Society and Space*. Farnham: Ashgate.

Dell'Agnese, E., and A.-L. Amilhat Szary. 2015. 'Borderscapes: From Border Landscapes to Border Aesthetics', *Geopolitics* 20(1): 4–13.

Doty, R.L. 2007. 'States of Exception on the Mexico–U.S. Border: Security, "Decisions", and Civilian Border Patrols', *International Political Sociology* 1(2): 113–137.

Farrier, D. 2011. *Postcolonial Asylum: Seeking Sanctuary Before the Law*. Liverpool: Liverpool University Press.

Görling, R. 2007. 'Topology of Borders in Turkish-German Cinema', in J. Schimanski and S. Wolfe (eds), *Border Poetics De-limited*. Hannover: Wehrhahn, pp. 149–162.

Higonnet, M. (ed.). 1994. *Borderwork: Feminist Engagements with Comparative Literature*. Ithaca: Cornell University Press.

Houtum, H. v. 2002. 'Borders of Comfort: Spatial Economic Bordering Processes in the European Union', *Regional and Federal Studies* 12(4): 38–58.

_____. 2010. 'Waiting Before the Law: Kafka on the Border', *Social & Legal Studies* 19(3): 285–297.

_____, K. Olivier and W. Zierhofer (eds). 2005. *B/ordering Space*. Aldershot: Ashgate.

Kaiser, R., and E. Nikiforova. 2006. 'Borderland Spaces of Identification and Dis/location: Multiscalar Narratives and Enactments of Seto Identity and Place in the Estonian-Russian Borderlands', *Ethnic and Racial Studies* 29(5): 928–958.

_____. 2008. 'The Performativity of Scale: The Social Construction of Scale Effects in Narva, Estonia', *Environment and Planning D: Society and Space* 26(3): 537–562.

Kristeva, J. 1982. *Powers of Horror: An Essay on Abjection*, trans. L. Roudiez. New York: Columbia University Press.

Kuortti, J., and J. Nyman (eds). 2007. *Reconstructing Hybridity: Post-colonial Studies in Transition*. New York & Amsterdam: Rodopi.

Lacan, J. 1977. 'The Mirror-Stage as Formative of the I as Revealed in Psychoanalytic Experience', trans. A. Sheridan in *Écrits: A Selection*, New York: W.W. Norton & Co., pp. 74–88.

Larsen, S.E. 2007. 'Boundaries: Ontology, Methods, Analysis', in J. Schimanski and S. Wolfe (eds), *Border Poetics De-limited*. Hannover: Wehrhahn, pp. 97–113.

Latorre, G. 2012. 'Border Consciousness and Artivist Aesthetics: Richard Lou's Performance and Multimedia Artwork', *American Studies Journal* 57. Retrieved on 9 May 2016 from http://www.asjournal.org/archive/57/216.html.

Mercer, K. (ed.). 2008. *Exiles, Diasporas & Strangers*. Boston: MIT Press.

Moruzzi, N.C. 1993. 'National Abjects: Julia Kristeva on the Process of Political Self-Identification', in Kelly Oliver (ed.), *Ethics, Politics, and Difference in Julia Kristeva's Writing*. London: Routledge, pp. 135–149.

Mukherji, S. (ed.). 2011. *Thinking on Thresholds, The Poetics of Transitive Spaces*. London: Anthem Press.

Newman, D. 2006. 'Borders and Bordering: Towards an Interdisciplinary Dialogue', *European Journal of Social Theory* 9(2): 171–186.

_____. 2007. 'The Lines that Continue to Separate Us: Borders in Our "Borderless" World', in J. Schimanski and S. Wolfe (eds), *Border Poetics De-Limited*. Hannover: Wehrhahn, pp. 27–57.

Ponzanesi, S., and D. Merolla. 2005. *Migrant Cartographies: New Cultural and Literary Spaces in Post-Colonial Europe*. New York: Lexington Books.

Ponzanesi, S., and M. Waller (eds). 2012. *Postcolonial Cinema Studies*. New York: Routledge.

Pop, V. 2013. 'Italy grants citizenship to Lampedusa dead', *EUObserver* (7 October 2013) Retrieved on 19 September 2016 from https://euobserver.com/justice/121681

Popescu, G. 2012. *Bordering and Ordering the Twenty-first Century: Understanding Borders*. London: Rowman and Littlefield.

Pötzsch, H. 2010. 'Challenging the Border as Barrier: Liminality in Terrence Malick's *The Thin Red Line*', *Journal of Borderlands Studies* 25(1): 67–80.

———. 2012. 'Aspects of Liminality in Knut Erik Jensen's "Stella Polaris"', *Folklore* 52: 118–123.

———. 2015. 'Seeing and Thinking Borders', in C. Brambilla, J. Laine, J.W. Scott and G. Bocchi (eds), *Borderscaping: Imaginations and Practices of Border Making*. Aldershot: Ashgate, pp. 217–227.

Rajaram, P.W., and C. Grundy-Warr. 2007. 'Introduction', in P.W. Rajaram and C. Grundy-Warr (eds), *Borderscapes: Hidden Geographies and Politics at Territory's Edge*. Minneapolis: University of Minnesota Press, pp. ix–xl.

Rancière, J. 2004. *The Politics of Aesthetics: The Distribution of the Sensible*, trans. G. Rockhill. London: Continuum.

———. 2010. *On Politics and Aesthetics*, ed. and trans. S. Corcoran. London: Continuum.

Robinson, R. 2007. *Narratives of the European Border: A History of Nowhere*. London: Palgrave Macmillan.

Rumford, C. 2008. *Citizens and Borderwork in Contemporary Europe*. London: Routledge.

———. 2014. *Cosmopolitan Spaces: Europe, Globalization, Theory*. London: Routledge.

Sadowski-Smith, C. 2008. *Border Fictions: Globalization, Empire, and Writing at the Boundaries of the United States*. Charlottesville: University Press of Virginia.

Saunders, F.S. 2016. 'Borders', *London Review of Books* 38(5): 7–15.

Saunders, T. 2010. 'Roman Borders and Contemporary Cultural Criticism', *Journal of Borderlands Studies* 21(1): 51–58.

Schimanski, J. 2015. 'Border Aesthetics and Cultural Distancing in the Norwegian-Russian Borderscape', *Geopolitics* 20(1): 35–55.

———, and S. Wolfe (eds). 2007. *Border Poetics De-Limited*. Hannover: Wehrhahn.

———, and S. F. Wolfe. 2013. 'The Aesthetics of Borders', in K. Aukrust (ed.), *Assigning Cultural Values*. Peter Lang: Frankfurt am Main, pp. 235–250.

Shklovsky, V. (1965 [1916]). 'Art as Technique', in L.T. Lemon and M.J. Reis (eds. and trans.), *Russian Formalist Criticism: Four Essays*. Lincoln, NE: University of Nebraska Press, pp. 3–24.

Simmel, G. 1997 [1903]. 'The Sociology of Space', trans. M. Ritter and D. Frisby, in D. Frisby and M. Featherstone (eds), Simmel *on Culture: Selected Writings*. London: Sage, pp. 137–170.

Strathern, M. 2004. *Commons and Borderlands: Working Papers on Interdisciplinarity, Accountability and the Flow of Knowledge*. Wantage: Sean Kingston.

Strüver, A. 2005. *Stories of the 'Boring Border': The Dutch-German Borderscape in People's Minds*. Münster: Lit Verlag.

Viljoen, H. (ed.). 2013. *Crossing Borders, Dissolving Boundaries*. Amsterdam: Rodopi.

Wastl-Walter, D. (ed.). 2011. *The Ashgate Research Companion to Border Studies*. Burlington, VT: Ashgate.

Welsch, W. 1997. *Undoing Aesthetics*, trans. A. Inkpin. London: Sage Publications.

Wilson, T.M., and H. Donnan (eds). 2012. *A Companion to Border Studies*. Oxford: Blackwell.

�� 1 ⱷⱵ

Ecology

Mireille Rosello and Timothy Saunders

Is there such a thing as a natural border? Yes and no. We may answer yes if we presuppose that both we and our readers share a common set of conceptions and assumptions about what nature is, what a border is, and about what we do with, around and to nature and borders. Seen from the point of view of human beings who wish to cross a pass in winter, a mountain is a natural border; it is not if we study a population of mountain goats.

As authors of this chapter, we therefore prefer to start with a 'no' answer. Or rather, we would like to suggest that there is no such thing as a natural border without an aesthetic regime that organizes our representation of the relationship between nature and borders. Nature and borders are always imagined and therefore represented, aestheticized. The relationship between them may be named (perhaps in our examples we would have to choose between the discourse of human geography and biology). How we define nature will influence what we do with borders and vice versa. Depending on which period, area, language or culture we focus on, our conceptualization of borders and nature (and therefore of what a natural border is) will change.

We have chosen ecology as one of the terms that enables us to think through the relationship between imagined borders and imagined nature. When we speak of an ecology of borders, therefore, and enquire into the difference it might make to both the theorization and the lived experience of the arenas we shall explore, we refer to the aesthetic mediation and manifestation of this relationship between borders and nature through the figure of ecology. A relatively new and transdisciplinary discourse, ecology insists on relationality.[1] This insistence enables us to observe not only the interaction between borders and nature, but also the broader mutations to which this particular interaction both responds and gives space (does nature help certain subjects police or transgress borders, do certain borders help us exploit or protect nature?). It will therefore help us, too, rethink the aesthetic and political practices that occur in the presence of such definitions (for example, if we no longer believe that nature is to be dominated and controlled, what happens

to our representation of borders?). Using ecology as our key word is a way of asking: what kind of aesthetic regime obtains when our imaginary about borders and nature is re-organized under this relational banner?

Aesthetic Paradigms of Borders

In recent times, ecology has been held to offer a new and more productive set of paradigms for how to organize and reflect upon cultural and political activity (e.g. Burel and Baudry 2003; Buell 2005; Latour 2004; Morton 2007; Egerton 2012). In this chapter, we shall focus specifically on the consequences that could follow were we to allow ecological models to determine the configuration of the aesthetic and border regimes within which those activities would then have to operate. Above all, we shall assess the capacity of ecological formations of borders and aesthetics to accommodate and award positive value to a scenario which seems increasingly thinkable. When border-crossing actors (people, goods and ideas) travel, they traverse an inherently shifting and unstable terrain that their journey alters and thereby helps to form. This scenario is frequently either overlooked or outlawed by systems of regulation and evaluation based on more traditional – and frequently static – conceptions of nature. The primary question we shall be asking of any proposed ecological configuration of borders and aesthetics, then, is this: can they, by contrast, make visible, accommodate and recognize value in the various participants in this scenario?

In pursuit of this goal, our deployment of the two key terms of this book will also remain mobile. The borders we shall consider will be conceptual and temporal, as well as spatial. Our understanding of aesthetics, meanwhile, will encompass the three senses of that word we are employing throughout this volume: the process by which something is made available to our senses (the root meaning of the Greek word *aesthesis*); the process by which such phenomena are incorporated within systems of knowledge (in order to codify which Alexander Gottlieb Baumgarten founded the discipline of aesthetics in the eighteenth century); and the process by which these phenomena are awarded value (this last concern brings us into the arena of aesthetic judgement, which traditionally includes, but by no means needs to be confined to, beauty and artistry as key criteria).

In keeping with the primary aims of this book, moreover, we shall seek to elucidate not only how the relationship between borders and aesthetics shifts whenever the conceptions of nature or ecology to which they are grafted change, but also how what emerges itself manifests a 'border aesthetics'. Every restructuring of the relationship between nature, borders and aesthetics, that is, renders borders visible and thus available for use in forms that are not

just distinctive, but that can be – and often have been – both expressed and assessed by means of figures and analogues associated with the arts. It is our contention that the aesthetic formations these borders assume, as well as the figural forms and analogues they attract, play a constitutive role in determining how these borders operate and how they are negotiated.

In order to establish the parameters of our discussion, we begin by providing an overview of some of the challenges and limitations that have arisen from the tendency to relate thinking about borders and aesthetics to earlier conceptions of nature. We then review the claims advocates of ecology have made about the capacity of this paradigm to offer an alternative to nature. Finally, we offer a critical assessment of these claims, explore some of the continuing impediments inherent in the ecological models put forward thus far and propose ways in which they might be evolved further.

Nature's Borders and the Borders of Nature

Throughout history, borders of all kinds – national, social, conceptual, cultural and aesthetic – have been established, institutionalized and sedimented in daily practice through reference to nature. Whenever this happens – whenever a discourse of home (an eco-logy) connects 'borders' and 'nature' – there is the potential for a form of solipsistic circular logic to develop. Let us assume, for instance, that a given order of discourse or a sovereign power takes it upon itself to police a border (be it social, national, artistic or anything else). In order to legitimate that border as 'natural' – and thus to instantiate nature as a border – it will have to impose the idea that a body of water, say, or a mountain range constitutes an obstacle for 'everyone' (for you, for us and for others that we cannot yet imagine). This it must do regardless of whether the topographical formation in question has served historically as a constantly variable contact zone: a place of exchange and fruitful encounters where the flow of people, goods and ideas may actually have been (and continue to be) more intense than in the imagined centre of the territory. This particular equation of nature and borders, in other words, configures the topological site as a natural limit, which consequently seems 'naturally' to slow down, interrupt or stop the flow of circulation of humans, goods and ideas. This natural border thus comes to serve as a line of demarcation that encodes 'inside' as I, us, mine and ours, and 'outside' as they or what is theirs (their people, their culture, their exotic products).

If a given order of discourse or a sovereign power has a vested interest in policing that kind of border, moreover, it will at some point appear logical to invoke its 'naturalness'. The arbitrariness of power (the ability to draw and enforce a line of demarcation) is then made invisible by a discourse that treats

the obstacle as having always been there, prior to human intervention or ideology. The natural border (which may no longer constitute an obstacle once the technology of transportation changes, or which, indeed, may never or only at certain seasons have constituted such an obstacle) is (still) invoked as a reason not to transgress a border that has, at some moment in time, emerged as an ideological line of demarcation. Such a border may have depended on a very limited conception of nature as an obstacle in order for it to claim to be 'natural' in the first place. Yet, once achieved, this very naturalness constantly reproduces itself as an obstacle, so that the obstacle becomes the definition of the border and the reason why it should not be crossed. The crowning achievement of this naturalizing logic, meanwhile, comes when it succeeds in rendering this mental switch invisible, whereupon it becomes natural that a border should be policed because it is natural.

Examples of the implementation of this kind of thinking in practice are manifold. We witness it, for instance, in a number of writings about aesthetics from the eighteenth and nineteenth centuries. Some of these writings not only helped to establish aesthetics as a discipline, but they have also continued to be hugely influential within that discipline ever since. One prominent example is Johann Joachim Winckelmann's *Geschichte der Kunst des Alterthums* (History of the Art of Antiquity) from 1764. In this work, Winckelmann divided up the art of antiquity into clearly demarcated units, in which territory, time and artistic style were closely correlated. Those cultures which appeared to Winckelmann to observe the requisite boundaries of geography, period, taste and propriety – such as classical Greece – were deemed to have displayed an appropriate degree of integrity and thus came out of this process particularly well. Those which transgressed these boundaries, by contrast, did not.

Two of the periods and styles of art which fared particularly badly in Winckelmann's reckoning were the Roman and the Hellenistic. In a manner that set the pattern for evaluations of those two cultures over the following two centuries at least, Winckelmann condemned both for having sought to transplant artistic practices from different times and places (primarily classical Greece) into what he regarded as alien environments. 'Greek art', Winckelmann claimed in relation to Hellenistic culture, 'would not take root in Egypt, in a climate foreign to it, and it lost amid the splendour of the courts of the Seleucids and the Ptolemies much of its grandeur and its true conception' (Winckelmann 2006: 319). The result of such topographical and temporal transgressions, Winckelmann believed, were works of art that were not just imitative, but lifeless and ugly: works, that is, that also transgressed the boundaries of taste, artistry and even ethics.

The problem as Winckelmann saw it, as for many who came after him, was that neither Hellenistic nor Roman art observed what he regarded as 'natural'

borders of time, place or taste. What we might call the 'border aesthetics' they thus exemplified and brought into play were accordingly also very much out of kilter. This becomes clearer if we observe that Winckelmann himself associated each of the four periods into which he divided Greek art with a distinctive artistic style: the straight and the hard; the grand and the angular; the beautiful and the flowing; and the style of the imitators (Winckelmann 2006: 244). It is notable that three of these four periods correlate with and are defined by the shape of the lines that describe a work of art's outer form. The exception is the fourth period – the one in which Hellenistic art is to be found. This consists instead of a crossing of boundaries and a mixing of artistic forms from different times and different places. The modern analogy Winckelmann himself suggested for Hellenistic art was the Baroque, a form of artistic expression that has often been characterized (and criticized) for its flowing exuberant lines and for its supposed 'decadence' and 'excess'. This was by no means intended to be an enabling comparison on Winckelmann's part: in his view, Baroque art was the manifestation of a 'noxious epidemic' which very evidently 'forsook nature' (Winckelmann 2006: 319).

There are numerous examples of this kind of thinking and practice in the geopolitical sphere as well. In such instances, vested ideological interests identify topographical features such as mountains, rivers and seas as limits rather than zones of contact and thus constitute them as natural borders of national and other forms of identity. One well-known example of this is the representation of England as, in Shakespeare's often-cited words, 'this sceptred isle … This fortress built by nature for herself' (*Richard II* 2.1.43f.).[2] Another, which we shall trace in more detail here, concerns the Pyrenees. From a geographical or geological perspective, these might be described as a range of mountains that separates the Iberian Peninsula from the rest of Northern Europe. From both a geopolitical and historical perspective, however, the Pyrenees can also be – and have often been – perceived as the 'natural' border between two nation states: France and Spain. In this latter dispensation, nature is mobilized to justify a north–south narrative of separation.[3]

The two examples we have just cited may seem to come from another era – and from one whose thoughts and practices we might try to persuade ourselves we have long superseded. Yet the ideological impulses they display live on in a variety of forms and continue to shape a number of present-day imaginaries. Even within academic discourse – and despite the work of border studies scholars who have highlighted the value and potentiality of replacing a discourse of reified borders with a more subtle configuration of borderscapes, borderzones and interwoven border regimes – the metaphoric power of the 'nature as border/border as nature' motif still retains much of its ideological appeal. In a paper published as recently as 2006, for instance, three authors made the following claim:

> If a country looks like a perfect square with borders drawn with straight lines, the chances are these borders were drawn artificially. On the contrary, borders which are coastlines or squiggly lines (perhaps meant to capture geographic features and/or ethnicities) are less likely to be artificial. Squiggly geographic lines (like mountains) are likely to separate ethnic groups, for obvious reasons of communication and migration. (Alesina et al. 2006: 4–5)

The circular definition and mutual justification of 'natural' phenomena and border practices which all three of our examples display is not exactly the same in each case. Nonetheless, every such manifestation institutes an organization of space and a set of regimes that have potentially dire consequences for the people, objects and ideas which want, or are forced, to move across the terrains thereby demarcated. As the title of an article by Juliet Fall indicates, in which she takes the authors of the 2006 article just cited to task for trying to superimpose their definition (presented here as mere description) of 'natural' borders and for their corresponding attempt to deploy it in the service of an ideological defence of ethnic homogeneity, such thinking represents an 'enduring geographical myth' (Fall 2010). This is a myth that evidently needs to be dismantled if we are to achieve a configuration of aesthetic and border regimes that is capable of awarding visibility, accommodation and a positive value to border-crossers. In the next part of this chapter, we shall explore the limitations of seeking to carry out such a dismantling within a context in which the discourse of nature continues to inform conceptualizations of both borders and aesthetics.

The Unity of Nature and the Nature of Unity

There are several ways in which one might challenge the discourses identified in the previous section. To take the example of the Pyrenees first, we might do so by paying attention to changes in how this mountain range has been deployed in constructions of both conceptual and territorial space over time. In recent European history, when the Schengen treaty transformed former national borders into a difference that does not make a difference, the irrelevance of old checkpoints suddenly put into relief the obsolescence of pre-existing visions of 'natural' borders. Even before then, it was possible to view the Pyrenees as one territory whose more meaningful orientational axis is East-West rather than North-South (we can do this, for example, by focusing on the Basques whose identity cuts across national boundaries). Only for as long as it is important to construct and police the border between Spain and France can we think of it as 'natural' to use the Pyrenees as a 'natural border' (i.e. a line of demarcation, an obstacle that makes movements more difficult, slower or even impossible at times).

Altering the narrative in order to make it reflect changing political realities of separation or reunion sometimes also undermines the discourse of a 'natural border' by generating curiously paradoxical discursive events. One might consider, for instance, the intriguing remark 'Il n'y a plus de Pyrénées' ('the Pyrenees are no more'). This is a famous, often quoted, yet often distorted and vaguely remembered French expression that evokes (often undesirable) movement across the Spain-France border and summarizes it. This historic quotation exemplifies the necessary circularity of the logic that treats nature as the guardian of the idea of obstacles, as we shall now outline.

In November 1700, when the King of Spain died without an heir, his will designated Louis XIV's grandson as the successor to his throne. Fearing that the young Duke of Anjou's reign would destabilize a fragile European equilibrium, Louis XIV first hesitated to accept the crown on his behalf. When he finally did, the formula 'Il n'y a plus de Pyrénées' started circulating, (mis-) attributed to various political actors including the king himself (by Voltaire) and the Spanish Ambassador Castel dos Rios.[4] Yet the expression is, in its simplicity, both incomprehensible and meaningless. In no way, of course, had the Pyrenees disappeared or sunk into the ground as other versions of the metaphor suggest.[5] Yet, as long as the dominant ethos agrees to treat the Pyrenees as what separates France from Spain, they must constitute a formidable natural obstacle.

When Louis XIV accepts the will, when Schengen changes the meaning of borders, something is altered but language struggles with the circularity that has so far been used to cover the arbitrariness of the conflation between nature and politics. It is apparently more plausible to accept that the Pyrenees have sunk into the ground than to realize that they never were a natural obstacle. It is easier to keep alive the memory of a coincidence between nature and politics than admit that the two discourses have to be disentangled.

Most of the time, the metaphors we use to accommodate the tortuous logic of our natural border discourses do not present as spectacular a vision as that of the Pyrenees sinking into the ground. Nonetheless, even unremarkable metaphors and set phrases betray the delicate entanglement between an implicit definition of nature and its (our) changing politics of borders.

Let us return in this context to our example of the evaluation of Hellenistic and Roman art. There too a language of nature and, in particular, the conceptualization of nature as a border has been employed to characterize them both as discrete but transcultural phenomena whose transgressions of temporal and territorial borders are inextricably intertwined with their transgression of a variety of intellectual, artistic and ethical borders. Friedrich Schlegel, for instance, who began his career as a critic with the express intention of becoming the Winckelmann of Greek poetry (Behler 1993: 36; Schlegel 2001: 12), commented in his *Geschichte der alten und neueren Literatur* (Lectures on the

History of Literature, Ancient and Modern) of 1812 on the seemingly mobile and transcultural art of ancient Rome in the following terms:

> [Rome's] writers both neglected the ancient and national traditions of their own country, and bestowed much unprofitable labour on the imitation of foreign modes of writing, which, as soon as they are transplanted from their native soil, for the most part assume the appearance of unproductiveness, coldness, and death, or, at best, protract a lingering and inefficient life, like the sickly exotics of a green-house. (Schlegel 1841: 75)

Clearly, a whole set of natural myths is here mobilized to justify an aesthetic judgement. To this way of thinking, when cultures cross borders, they become plants (and can be talked about as if they were plants). And plants, it is assumed, cannot thrive if they are transported away from their native soil. This assumption is obviously undermined, however, by an abundance of cases such as that of the Caribbean, where the supposedly 'indigenous' palm trees that grace postcards for tourists and have become the symbol of tropical paradise, were in practice imported by Europeans. It is also countermanded by the evolution of plant life and the development of agricultural practices in the Mediterranean (Braudel 1972) and the United States.[6] Notably, a number of these successful transplantations were initiated and developed – like, it should be said, those that characterize both Hellenistic and Roman cultures – within colonial contexts, and we shall turn to such imperialistic and globalized conceptions of nature, borders and aesthetics shortly. Nonetheless, the kind of aesthetic thinking and evaluation enacted here by the likes of Winckelmann and Schlegel does not allow the ability for plants to develop and grow in green houses or supposedly alien environments to undermine rather than affirm their aesthetic judgements. Instead, the obviously disturbing alternative is rationalized and removed through a value judgement which, once again, criss-crosses between nature and culture. Aren't plants in the green house sick because they are exotic rather than exotic because they are sick? And what exactly would be a culture's 'inefficient life' in this case? Nature is invoked in order to discredit those who have obviously been able to ignore this supposedly insurmountable obstacle.

As we have just indicated, nature is not always used to propose that the Other's culture should stay over there, where it comes from, beyond the obstacle, where it belongs. It could instead (presumably) be respected for its (natural) health. In our second model, nature functions as the border (albeit, as we shall see, a deceptive one) of an all-encompassing, multiple and hybrid culture.

By looking in a different way from Schlegel at how the Roman Empire and Roman art manipulated the intersection between borders and nature, it becomes possible to identify other vestiges of thought that are perhaps even

more powerful today than the appeal to authentic national territories. The way in which Europe currently constructs the globe and the planet, and the ways in which the Roman Empire imagined nature, are very different; yet a set of interwoven notions of how to map 'inside' and 'outside' onto 'civilized' and 'barbarian', 'cultural' and 'natural' continues to govern our imaginary (see the chapter on Waiting).

In the following example, nature is mobilized to dissolve rather than reinforce local boundaries. But it also serves simultaneously to erect a stronger external boundary. In his *Aeneid,* the Roman poet Virgil (70–19 BCE) documents both the Roman Empire's and his own epic poem's ambition to dismantle all internal borders. All political, social, conceptual, cultural and aesthetic boundaries become coterminous with a natural border: the ocean, which the Romans believed encircled the earth.[7] Today, we would agree that this characterization of the ocean can be treated as a discursive and imaginary construction – that is, as something that would not even fall under the category of nature. This representation is palimpsestic because it is not a 'memory' as such but something that is made to reappear by burrowing down through the archaeology of knowledge (see the chapter on Palimpsests).

In this representation, the borders of Roman artistic expression and power were to be aligned with those of the planet. Nature, as invented by this particular culture, is called upon to advance and underpin the requisite distribution of borders in two complementary ways. On the one hand, nature is the all-encircling ocean, the ultimate border of civilization. That border is unique (in as far as it is the only one this ideology recognizes) and also unifying: within the border, everything is alike. This unique status and unifying function participates in rendering borders in at least two senses: first, difference is erased because every place, event, story, history, object, idea and person is interconnected within the Empire; second, the equation it upholds between the limits of the Roman sphere and the limits of the physical world naturalizes that sphere. The provisionality (historical contingency) of its constitutive borders disappears, so that the shape of the Empire is nature, sheltered from questioning and critique. While it may be potentially liberating to break down borders between cultures by redrawing the border and unifying a larger territory, the tactic still relies on the taking for granted of a supposedly natural border: nature is simply elsewhere, larger and even more all-encompassing.

In other words, the natural limit of the cultural world seems at first to allow for mobility and multiplicity. Yet it remains grounded in, and therefore restricted by, an overriding unity which theorizes by constructing nature and culture as a mutually exclusive binary pair, and by naturalizing that very opposition. The *Aeneid* may well draw upon a multiplicity of cultural traditions and art forms (including, as it happens, the Hellenistic) to tell a story of migrancy (primarily of the Trojans, but there are others as well), yet it is

nonetheless a story with one destination, grounded in a unified understanding of the nature of the planet, of human history, of individual humans and of aesthetic value.

If we look closely at the specific representation of the ocean here, the description renders visible the Roman Empire's inability (or, arguably, the text's perception of the Roman Empire's inability) to accommodate and sustain a genuine multiplicity of ideas, practices, claims and cultures. Unlike the Empire of Michael Hardt and Antonio Negri (2000), the warp and weft (and thus 'text', from Latin *textus*, a form of the verb *texto* 'to weave') of the Roman Empire are so woven as to bind together all the disparate elements of the poem and its representations of Empire. Those peoples, histories, objects and ideas that do not conform with this vision of the world – and that, as often as not, actively resist it – invariably find themselves quite visibly 'all at sea', in a primordial, borderless and therefore chaotic oceanic environment in which their only prospects are to wander around aimlessly and, ultimately, drown.[8]

Both later naturalizations of cultures and Virgil's vision of a unique culture bordered by nature are capable of being put at the service of discrimination and denigration. In the case of the ocean-bounded unique culture, border-crossers – regardless of whether they are human beings, ideas, works of art, goods or whatever – become visible only as purveyors of and participants in a world of chaos. This, in turn, justifies the imposition of a unifying order over them through a process either of subsumption and assimilation or of submersion and destruction. The *Aeneid*'s appeal to a unified conception of nature places heavy restrictions on the kind of multiplicity to which its perception of the Roman Empire was able to play host.

On the other hand, individual national cultures that are distinguished from one another through supposedly natural borders allow for the recognition of a more variegated and incommensurable set of natural environments, but they render border-crossers visible primarily as transgressive, degenerate and unnatural. In both cases, that is, the nature/border paradigm brings into existence an aesthetic regime in which border-crossers are dismissed, denigrated and/or excluded in all three senses of the term 'aesthetics' used throughout this volume.

Ecology and Nature

What we appear to need, then, is a change in paradigm. What system of thought could accommodate borders which are capable of sustaining and validating a genuine multiplicity and mobility of cultural, political and other activities? And how is it possible to maintain a self-reflexive and critical

attention to the borders of the paradigms themselves? In other words, we have now moved our focus from the practice of treating the relationship between nature and borders, and ultimately nature as a border, to the borders of nature. The first issue that arises in this context is whether concepts of nature should be abandoned entirely as reference points for the formation of borders and the regimes they institute.

It could, after all, be argued that the limitations and flaws in both social and aesthetic systems of evaluation lie precisely in the recourse they make to nature as an agent of 'naturalization' (legitimization, rendering invisible) of the system of thought itself. As our previous examples have indicated, whenever one model of territory is dominant, the categories that are deployed to naturalize the shape of political, conceptual, aesthetic and other domains prevent other types of ensembles from claiming or enacting their identity. Any claim to naturalize a set of regimes is bound to prove both restrictive and exclusive, since states, regions, intellectual disciplines and cultures – along with the aesthetic forms with which they are associated – are all the more powerful symbolically the more their contours have appeared to be natural and unquestionable. Perhaps it is therefore precisely an abandoning of this rhetoric of nature that is needed in order to highlight the provisionality of all such configurations instead. As far as borders in particular are concerned, it could be argued that, in keeping with a general tendency to seek to move away from using the category of nature when describing people, cultures and societies,[9] we need to detach borders from ideas about nature in order to bring into being a more liberated, and liberating, environment. This approach has been discussed by a number of scholars working in the field of border studies (e.g. Brambilla 2008; Houtum 2000; Houtum 2005; Newman and Paasi 1998). What is more surprising and productively challenging is that a number of voices interested in 'ecology' have also come to a similar conclusion (e.g. Latour 2004; Morton 2007). Popularized as the science of the environment (rather than as its etymological concern with 'logos' [reason/word/account] and 'oikos' [home]), ecology brings to mind images of endangered tigers and rain forests, of recycling and mother earth. At least in the Global North, it is hard to imagine how it is possible to separate ecology from (the protection of) nature. At the same time, ecological thinking also presents itself as a contemporary discourse that seeks to interrupt former myths about nature. In other words, ecology creates new representations of nature that may well destabilize the symbolic power of metaphors used in previous attempts to match borders and nature. If 'nature' changes in scientific, popular and political circles, then ways of naturalizing, correct or not, theoretically tenable or not, will also evolve.

A leading advocate of ecological thinking, and of the idea that ecology should be understood as an alternative to nature, is Bruno Latour. We use

the arguments he presents in his book *Politics of Nature* (2004) as our main point of departure for our consideration of the capacity of an ecological configuration of borders to render visible, play host to and recognize value in the individual elements of our principal scenario – wherein by the very act of travelling, border-crossing actors (people, goods and ideas) traverse inherently shifting and unstable terrains that their journeys alter and thereby help to form.

In the process of arguing for a practice of what he calls 'political ecology', Latour claims that 'nature is the chief obstacle that has always hampered the development of public discourse' and stipulates that 'political ecology does not speak about nature and has never sought to do so' (Latour 2004: 9, 21). What lies at the heart of Latour's objections to the deployment of nature in the understanding and organization of social and political spheres is its tendency to be used precisely to limit those spheres. 'From the time the term "politics" was invented', he writes, 'every type of politics has been *defined* by its relation to nature, whose every feature, property and function depends on the polemical will to *limit*, reform, establish, short-circuit or enlighten public life' (Latour 2004: 1, emphases ours).

What Latour understands by (and seeks to find fault in) the category of nature is the objective world of hard and rigidly delimited facts. The concept of nature, he argues, identifies a world of risk-free objects, which are characterized by '*clear boundaries*, a well-defined essence, well-recognized properties' and which can therefore be used to control and regulate the more chaotic world of human interactions and exchange (Latour 2004: 22–23, emphases ours).[10] In Latour's view it is, by contrast, precisely this alternative world of 'risky attachments' and 'tangled objects' that political thinking – and we would add aesthetic thinking – should recognize and engage with instead (Latour 2004: 22). For this, he claims, an ecological approach is better equipped than one grounded in nature, since it replaces discussions about matters of fact with discussions about matters of concern. Unlike matters of fact, he asserts, matters of concern 'have no clear boundaries, no well-defined essences, no sharp separation between their own hard kernel and their environment. It is because of this feature that they take on the aspect of tangled beings, forming rhizomes and networks' (Latour 2004: 23–24).

Latour's suggestion, however, begs the question: given that nature and territory have played such persistent roles in the formation of the social, intellectual, cultural and other terrains which border-crossing actors have traditionally had to cross and experience, could so radical a change in paradigm remove the very features of our intellectual landscape that have thus far defined these actors and rendered them visible in the first place? We fear that to eradicate them entirely could lead us to abandon any genuine attempt to describe, engage with or in any way address that experience.[11]

Perhaps it would be more productive to see in which ways the questions raised from an ecological perspective can help to clarify the implicit or explicit agendas that pertain if we follow Latour's critique of the consequences of a naturalized nature/border discourse. Which issues do we need to keep in mind when we turn our attention to the intersection between ecology and borders, not least when we wish to elucidate their aesthetic consequences? What are our own (overlapping and entangled) 'matters of concern'?

Some of the questions we shall address as we proceed through the rest of this chapter are the following:

- Would an ecology of borders help to redefine the constantly evolving relationship between the dominant paradigms that construct territories and their corresponding borders, and that render counter-systems inaudible and invisible?
- Would an ecology of borders make it more obvious that the definition of what is bordered must change at least as much as the traditionally bordered territories if borders are to be more democratic?
- Would an ecology of borders help to create new discrepant topographies where different types of borders take into account simultaneous and incompatible definitions of territories?
- Would an ecology of borders be able to describe, accommodate and sustain formerly excluded groups of people and aesthetic productions such as migrants and hybrid, transcultural works of art?

Ecology and Borders

An ecologically-inflected conception of borders suggests promising ways of better describing, accommodating and sustaining those groups of people and forms of art that have been denigrated or excluded by the organization of space and by sets of regimes which have thus far been instituted by the practice of establishing borders through reference to nature. Ecology's association with systems of evolution, adaptation and change indicates a capacity to sustain a genuine multiplicity without grounding it in the conception of a fixed and static nature of the kind identified and critiqued by Latour (amongst others). Indeed, were not some prominent advocates of ecological approaches to both social and aesthetic questions, such as Latour himself and Timothy Morton, keen to do away with the categories of nature and culture entirely, we might be tempted to commend ecology as a system that describes, accommodates and sustains a genuine multiplicity of natures and cultures rather than one which once again grounds a spurious multiculturalism in a corresponding belief in mononaturalism.[12]

The vocabulary of ecological discourse constructs, on the face of it at least, a more welcoming environment for border-crossers. Latour's claim that a multitude of 'tangled' objects could come more prominently into view would, if verified, have as much impact upon aesthetic, cultural and conceptual concerns as upon political ones. Indeed, one of the claims an ecological approach would make is that none of these concerns can ultimately be separated off from one another. The language of ecology has persistently made recourse to a language of migrancy. Ecological discourse speaks in terms of 'communities', 'populations', 'metapopulations', 'migration', 'immigration', 'emigration', 'life history', 'development', 'adaptation', 'inheritance', 'behaviours' and – importantly for sustaining a genuine sense of multiplicity – 'webs', 'niches' and 'diversity'. Indeed, the very claim that ecology is better equipped to 'accommodate' or 'harbour' formerly excluded peoples and works of art activates the etymological roots of ecology in a notion of 'home'. Due to ecology's recognition, or generation, of a landscape of networks rather than one of mutually exclusive and clearly demarcated countries or regions, the notion of home can be mobilized to do away with barriers between a person's or object's new place of residence on the one hand and their place of origin on the other. Home now structures itself instead in the form of a network of relations, rather than as a rigidly policed landscape of exclusions.

The ability of ecological approaches to organize and regulate social, conceptual and cultural domains in such a way that they thereby become better able to describe, accommodate and sustain formerly excluded elements depends, however, on their own production and regulation of a border aesthetics. Latour for one characterizes this as an environment of 'tangled beings', 'rhizomes' and 'networks', although there are other possibilities. At the very least, ecology constructs the borders and aesthetic regimes it is then required to negotiate in all the senses of aesthetics explored in this volume: the elements and environments it renders visible and invisible; the systems of knowledge to which it plays host; and the rules and regulations which determine the attribution of aesthetic value. One of the boldest claims made in the name of ecology has been its alleged capacity to make manifest an entirely new terrain for social, political, conceptual and cultural activity. In Latour's view, an ecological perspective 'must provide an environment for itself that is completely different from the environment of a culture surrounded by a nature' (Latour 2004: 184). Currently, the domain of risk-free, clearly bounded objects and concepts is very much centre stage, while that of what he calls 'risky attachments' and 'tangled objects' is kept out of sight or, at best, at the periphery. The goal is to make manifest this alternative environment 'by becoming sensitive to the whole that has not yet been collected and that harbours all those which it has excluded and which can appeal to be recognized again as present' (Latour 2004: 184). Latour's notion of a political ecology 'proposes to

move the role of unifier of the respective ranks of all beings out of the dual arena of nature and politics and into *the single arena of the collective*' (Latour 2004: 29–30, emphases ours). As such, it hopes to supplement – and therefore change – the already visible domain of risk-free, clearly bounded objects and concepts with a 'different universe, composed of entities less easy to delimit', which had previously been kept hidden (Latour 2004: 22–23).

In terms of the examples of Hellenistic and Roman art we introduced earlier, such a dispensation would appear to accord with and further promote two tendencies of recent scholarship, both of which have led to them being awarded a much greater value than those they received in the estimations of Winckelmann and Schlegel we looked at earlier. The first tendency has been to see them not as cut off by 'natural' borders of time, place and taste from the aesthetic productions of fifth-century Athens, but as part of an ongoing and mutually enriching network of exchanges.[13] The second tendency, which chimes especially with Latour's call for an environment which is 'sensitive to the whole that has not yet been collected', has been an increased emphasis on reception in the perception and evaluation of works of art. This too represents a way of viewing art that is mobile both in the sense that it is ongoing and thus never finally complete and in the sense that it involves a leaping over of the kinds of borders of time, place and so on erected by any system of evaluation that adheres to the 'nature as obstacle' motif.

In recognizing, sustaining and, arguably, helping to generate this new environment, ecology brings more fully into view what the previous rhetoric of nature had worked to conceal: the mechanisms by which all such domains come into existence. Of the 'matters of concern' that in his ecological dispensation are to replace the 'matters of fact' generated by earlier conceptions of nature, Latour writes: '[T]heir producers are no longer invisible, out of sight; they appear in broad daylight, embarrassed, controversial, complicated, implicated, with all their instruments, laboratories, workshops, and factories' (Latour 2004: 23–24).

But how are borders instantiated in the construction of this new terrain? To what degree might they in practice participate in the creation of aesthetic regimes that render visible and evaluate in more accommodating ways the border-crossers that have been excluded by previous dispensations?

Borders of Ecology

Our first challenge is to map such a (desired) 'ignorance of totality' on the specific agenda of this chapter (our own 'matter of concern'), which is to make sure that borders are simultaneously both redrawn and reconceptualized along ecological rather than natural lines.

The practice of establishing borders of all kinds through reference to nature persists today and influences border policy and aesthetic thinking. The examples we explored earlier in this chapter, despite being by no means entirely commensurable, are paradigmatic of thinking about borders, and of the implementation of border regimes, that are still operative in various forms.

Europe is caught between models that would rather impose their own definition of borders than attempt to function in a network of tangled and perhaps irreconcilable visions of what a territory is. Contemporary Europe is striving to move away from its own nineteenth-century legacy. Rather than emphasizing the borders between nation states, it constructs itself as a larger unit within which goods (mostly) but also people and ideas can travel freely. Europe insists on its cultural diversity, on its multifaceted cultural heritage, and on its multilingual richness. It is clear that the dominant myth does not seek to place an 'ocean' around its enlarged borders. Instead, the re-enforced obstacles that are intended to demarcate the territory identified by the Schengen treaty are seen as a human-made barrier. Europe is now often figured as a 'fortress'. For those who wish to keep the non-Europeans out, it would be possible, after all, to insist that Europe is a geographical entity. But today, the natural borders of Europe can hardly be invoked as an obvious myth, or as a narrative sanctioned by contemporary sciences. No equivalent of the encircling ocean is readily available and it is more likely for those who want to reinforce the borders around the EU to invoke the economy (non-Europeans would deprive Europeans of scarce resources) or culture (for example the legacy of Christianity or the Enlightenment). On the other hand, those who deplore how the dismantling of national borders has created international figures of relegation that die or barely survive as they try to penetrate its newly-strengthened outer circle, talk about the scandal of 'fortress' Europe: they make us imagine the walls of a medieval castle, not an ocean. And if the figure of the refugee dying on a raft or on the shores of Southern Europe has become emblematic, it is of course because the Mediterranean is the political border of Europe. But the sea is not a natural obstacle that justifies the contours of political Europe. Given the right circumstances, a plane can ignore it. Europeans have erected a wall that manifests itself as a re-appearing border, in airports and detention centres, when migrants are 'randomly' controlled or deported, or when they try to cross the Mediterranean.

Would an ecology of borders help in this case? Would it help Europe to avoid the Charybdis of imperialism on the one hand (a state of affairs into which any form of global thinking has a tendency to slide) and the Scylla of nationalism on the other?[14] Or does this supposedly unnatural invocation of old natural borders (Charybdis and Scylla have lost their 'natural' relevance but kept their meaningfulness in this context) already reveal our inability to

think beyond binary and competing sets of paradigms? What are the questions that we still need to consider if we wish an ecology of borders to avoid 'integrat[ing] the entire set of its localized and particular actions into an overall hierarchical program'. Latour claims that political ecology 'is incapable' of it and that 'it has never sought to do so' (Latour 2004: 22). While giving 'it' the benefit of the doubt, we would like, in this last part, to redefine 'it' as the mutually enriching movement between 'ecologies of borders' and the 'borders of ecology' and to explore what we see as unresolved questions. Three interwoven issues arise:

- To what extent would an ecology of borders risk presenting itself as yet another ultimate frontier?
- If spatial natural borders are indeed de-naturalized by an ecological thinking of borders, is there not a danger of replacing natural space with natural time?
- And finally to what extent does an ecology of borders construct globalized agentless subjects?

As far as the first question is concerned, should we gamble that an ecology of borders will redraw the local or global connections between culture and nature such as we have seen in our earlier examples? Or are we right to doubt the ability of contemporary ecological (political) thought to generate, in Latour's words, 'an environment for itself that is completely different from the environment of a culture surrounded by a nature'? For all Latour's insistence that political ecology describes and sustains a world of risky attachments, tangled objects and radical uncertainty, his promotion of a 'single arena of the collective' in place of a pursuit of a world of multiple natures and cultures keeps alive the suspicion that ecology, like empire and like globalizing aesthetic projects such as Virgil's *Aeneid*, ultimately adheres to one single and unifying organizing principle. The perception and positive evaluation of, say, Hellenistic art is unlikely to be greatly advanced if it is rescued from the clutches of a restrictive relationship between borders and aesthetics grounded in the 'nature as obstacle' motif of the kind practised by Winckelmann – and thus from inhabiting and displaying a supposedly Baroque and 'unnatural' border aesthetics – if (as has happened) it is then only to be set free in the service of the 'single arena' of the Roman (or any other political and or cultural) Empire.

We fear that any attempt to ecologize borders may well end up producing a single, all-encompassing ecology of borders that will not have theorized the complex struggles that emerge when power relationships are radically problematized. Characterizations of ecology include, after all, Ernst Haeckel's original definition of it as involving 'those complex interrelations referred to by Darwin as the conditions for the struggle for existence' – a set of interrelations

more popularly known as 'the survival of the fittest' (cited by Bate 1991: 36–39 and Kroeber 1994: 22–23). By the same token, we should not accept too readily the ameliorating connotations of the English word 'home', which translates one of ecology's etymological roots. For while the Greek word *oikos* may sound harmless to modern ears, we should remember that it also provides the etymology for 'economy', a word and a concept that has, indeed, often had an influence on ecological discourse and action.[15] What really brings out ecology's less appealing and more imperialistic connotations, moreover, is its Roman orientation. After all, the Latin word for home, *domus*, also serves to underpin the verb 'to dominate'. For all its advocacy of multiplicity and plurality, that is, ecology's apparent trajectory towards the eradication of all internal boundaries other than its own self-defining frontier has the capacity to commit it to an ultimately unifying and universalizing conception of organized and inhabited space. Thus, like the *Aeneid*, it too has the potential to equate its boundaries with those of the planet and to submerge those elements that do not conform.

Figuring out Ecological Border Aesthetics

Latour, to be fair, has anticipated such objections when he claims that political ecology 'possesses other transcendences':

> an exteriority constructed according to a well-formed procedure that produced provisional excluded entities and postulants. It is thus quite capable of showing a difference between past and future, but it obtains that difference *by way of the gap between two successive iterations* and no longer by way of the old distinction between facts and values: 'Yesterday', it might say, 'we took into account only a few propositions; tomorrow, we shall take others into account, and, if all goes well, even more; yesterday, we gave too much importance to entities whose weight will decrease tomorrow; in the past, we could compose a common world with only a few elements; in the future we shall be able to absorb the shock of a larger number of beings that were incommensurable before now; yesterday, we could not form a *cosmos*, and we found ourselves surrounded by *aliens* that no one had formed – the former reservoir – and that no one could integrate – the former dumping ground; tomorrow we shall form a slightly less misshapen *cosmos*'. (Latour 2004: 191, author's emphases)

Does this process of 'cosmos-izing' retain, however, enough radical uncertainty to prevent it from instituting a new form of imperialism? Latour would probably deny that this practice constitutes a form a 'globalizing' and that it can (should?) be distinguished from a model based on an idea of nature which, he believes, 'makes it possible to recapitulate the hierarchy of beings in a single ordered series'. He clearly emphasizes iterations rather than discontinuities. Nonetheless, this infinitely expanding, ecologically-inflected

approach can easily be misread or misappropriated and nurture the seeds of a potential imperialism. What is more, the logic of this expansion accords with other imperialistic qualities of ecological thinking, which are likewise manifested through its engagement with borders. Those borders may no longer be grounded in previous definitions of natural spaces, but we cannot fail to notice that old definitions of a certain nature reappear under a different mask. Latour introduces a concept of 'time', for instance, which does not seem as carefully theorized as the distinction between 'tangled objects' and clear boundaries. In the passage cited above, Latour is talking about changes, about the future and the present. There, the borders that used to demarcate spatial territories have moved over to a temporal order: even if Latour clearly wishes to avoid linearity and teleological narratives, the time of ecology cannot be radically separated from an imaginary of growth and accumulation. As a strategy for welcoming in formerly excluded entities, moreover, it constitutes a mode of 'reception' of a kind that has increasingly come to dominate systems of aesthetic evaluation. This mode may liberate the individual work of art, or set of works, from the constrictions of space and time imposed on them by systems such as Winckelmann's, which are policed by a whole set of supposedly 'natural' boundaries. Yet it also nonetheless almost invariably proceeds to conscript that work (or works) within its own chronotopic arrangement, which will itself be governed by a specific structure of aesthetic figuration. Both the visibility of Hellenistic art and the aesthetic assessments it has received may have gone up and down across the centuries, but on each occasion it has done so as a result of its belated association with specific forms of aesthetic practice: be they Roman, Baroque or, more recently, Modernist.

In keeping with this last point, we finally, and perhaps most importantly, wonder from which perspective contemporary border-crossers would be expected to acquire the performative power to insist that their transnational works of art belong to networks or that their works of art are 'rhizomatic'.[16] If the dominant paradigm asks us to think of borders and nature in ways that foreclose the development of 'tangled beings', wouldn't such attempts be, by definition, invisible and inaudible?

Would such a change of paradigm ever work as a point of sudden discontinuity given that nature and territory have played such persistent roles in the formation of the social, intellectual, cultural and other terrains which border-crossing actors have traditionally had to cross and experience? To eradicate them as an effect of the 'from today to tomorrow' principle could therefore lead us to abandon genuine attempts to describe, engage with or in any way address contemporary migrants' experience.

In other words, would an ecology of borders enable us to imagine an enlarged community – to take into account what Jacques Rancière calls 'the part of those who have no parts' (Rancière 1999: 9) – and enable those subjects that have been

pushed out and denigrated in an altered democratic global conversation? The current debate on greenhouse gas emissions highlights the difficulty of globalizing standards and rethinking current hierarchies. Historically, industrialized nations and colonizing powers in general have been and still are responsible for practices that they now wish to curb in order to 'save the planet'. Developing countries, whose economic growth is bound to increase their impact on the environment, have not failed to notice the irony of the situation they currently face: they are being asked to contribute to a planetary effort that the Global North was not prepared to demand of itself and that will put limits on their own development. New borders appear at the very moment when ecology is supposed to bring things together: India and China are put in the role of the backward, rebellious bad students of ecology who can thwart global attempts at reducing greenhouse gas emissions by sabotaging the Kyoto, and subsequent, protocols.[17] In this case, the planet includes, in a supposedly egalitarian way, environments that used to be hierarchically divided between developed and underdeveloped. But the so-called planetary thinking risks becoming the voice of a few of those environments precisely because the hierarchy that authorized their supremacy is the same that today guarantees they can push their ecological definitions. The specific ecology of borders of developing countries can only develop in resistance to the Global North's ecology of borders. The struggle is discrepant: it continues to make the previously marginalized country appear backwards and capable of holding up an evolution towards 'a slightly less misshapen *cosmos*' (Latour 2004: 191). The suspicion is that their natural time is the border against which their ecology is blocked. In other words, it is easy to pigeonhole such environments as obsolete before they have even come into being. Once again, the linear and teleological time of 'progress' that its inventors are quite ready, by now, to critique is against them.

Like feminists or ethnicized subjects who resented being asked to celebrate the end of the subject or the end of history at the very moment when their marginal subjectivities were becoming visible enough to enable them to enter an enlarged democratic debate, they will be faced with a curious alternative: to adopt the same universalizing figures and standards that have always kept them in a position of powerlessness, just as these standards pretend to recuse the old simplicity of well-defined hierarchies between clear cut territories.

Conclusions

Compared with the examples discussed at the start of this chapter, in which nature is used to naturalize borders to serve an ideological agenda that is inimical to migrants, migrant thoughts and migrant works of art, an ecological conception of borders, aesthetics and border aesthetics seems promising. Its

deployment of a language and system of figuration oriented around notions of change, development, inclusion, entanglement and interconnectivity indicate its potential to bring to those scenarios which have provided the primary test-cases for our discussion more productive enactments of the senses of aesthetics we are engaging in this volume. Ecologically-inflected aesthetic regimes, that is, promise to render visible, accommodate within systems of knowledge and award greater artistic and ethical value to those border-crossing actors (people, goods and ideas) who traverse inherently shifting and unstable terrains that their journeys alter and thereby help to form.

At the same time, our exploration of the role borders play in ecological conceptions of cultural and political activity – as well as of the aesthetic formations these borders might commonly be assumed to take – has also highlighted a number of possible limitations and restrictions that could be imposed upon the participants in that scenario by such a mode of thinking. More than anything else, there is often an all too palpable affinity between ecological and imperial thinking and their aesthetic formations. An exploration of both the borders and the aesthetics of ecology shows that ecologies would have to be as plural as the borders that they wish to redraw and reconceptualize if they do not wish to betray their potentially democratizing agenda. If only one ecology dominates, or one system of figuration is allowed to control and structure that ecology, the dream of democratic ecologies of borders that would be reversible and egalitarian, that would be constantly evolving and a site of dissensus will already be lost. In both the *Aeneid* and nineteenth-century nationalism, there is no place for a dissensus between discrepant ecologies of borders because the borders of ecology are the latest paradigm to be made invisible and naturalized.

When we ask for a recognition of border-crossing actors as 'equal' partners in the debate on border definition, we also recognize that this current formulation is fraught and is a hostage to the ways in which any currently dominating paradigm appropriates the right to define the community as those who belong and those who prove the existence of those who belong by not belonging. Migrants, perversely, provide the evidence that we need the borders that keep them out. Ecologies of borders have the capacity to encourage us to rethink what border-crossing actors look like when we suddenly found ourselves crossing the border.

This would mean that a different 'collective' would perhaps no longer be tempted to put all its ideological eggs into the same basket – that is, into the demonstration that the conflation between nature and borders creates untenable and persistently problematic theoretical models. The self-contradictory and auto-justifying use of nature could also be part of some ecologies of borders that realize that such models need not be put into the service of undemocratic agendas. The erosion of internal borders has, after all, generated an

increase in the flow of people and ideas. If these internal borders were to become unthinkable, which aesthetic figuration of ecological time do we need to theorize in order to help us think through the historical consequences of the changes thus produced? As paradoxical as it may seem, an incomplete, imperfect set of ecologies of borders might be what we have imagined when, instead of moving from 'nature as border', to the 'borders of nature' and towards an ecology of borders or the borders of ecology, we tried to imagine what kind of discrepant networks all these 'tangled objects' would form in order to function – ecologically – as ecologies of borders.

At the present moment, an ecologically-inflected border aesthetics that sustains and gives form to the multiplicity and mobility to which ecological thinking lays claim remains at best an aspiration rather than an established practice. Even so, it already performs a number of important services. Not the least of these is that it helps bring into view the artificiality and provisionality of several current day border practices and regimes that are grounded in some form or other in nature. Thus, even if ecological conceptions of borders and border aesthetics may themselves ultimately prove too limited to achieve all their ambitious goals, their capacity to contribute to real and valuable change nonetheless remains a promising and fruitful horizon of research.

Mireille Rosello teaches at the University of Amsterdam (in the department of Literary and Cultural Analysis and the Amsterdam School for Cultural Analysis). She focuses on globalized mobility and queer thinking. Her latest works are a special issue of the journal *Culture, Theory and Critique* (on 'disorientation', co-edited with Niall Martin, 2016) and an anthology on queer Europe, *What's Queer about Europe? Productive Encounters and Re-Enchanting Paradigms* (co-edited with Sudeep Dasgupta, Fordham University Press, 2014). She is currently working on rudimentary encounters.

Timothy Saunders is Associate Professor of English Studies at Volda University College. His research focuses primarily on the reception of classical antiquity in European and American culture, on nature, and on issues of literary form. He is the author of *Bucolic Ecology: Virgil's Eclogues and the Environmental Literary Tradition* (Bloomsbury, 2008), co-editor of *Romans and Romantics* (Oxford University Press, 2012), and is currently running the project *Peripheral Figures: British and Irish Receptions of Nordic Literature and Culture*.

NOTES

1. The fact that 'ecology' has split into sub-specializations (cultural ecology [Haennand and Wilk 2006], political ecology [Peet et al. 2011], molecular ecology [*Molecular*

Ecology], eco-linguistics [Fill and Mühlhäusler 2001], industrial ecology [*Journal of Industrial Ecology*], landscape ecology [Burel and Baudry 2003], and so on) reveals the need to re-define the 'house' (*oikos*) that is being studied (*logos*). The bordering of the field of study hides the process of definition of the *oikos*. It may well be that this practice attempts to avoid the possibility of aesthetic chaos caused by the awareness of a constantly changing interaction between the *oikos* and the *logos*.

2. It is striking that Shakespeare and others felt able to characterize England by itself – and not necessarily Britain as a whole – as an island with natural borders, thereby overlooking both Scotland and Wales.

3. See also Sahlins (1989).

4. In his *Journal,* the Marquis of Dangeau writes: 'Le Mercure rapporte ainsi ce mot: 'L'ambassadeur ... s'écria alors: 'Quelle joie! Il n'y a plus de Pyrénées; elles sont abîmées, et nous ne sommes qu'un.' On sait que plus tard le mot 'Il n'y a plus de Pyrénées fut attribué à Louis XIV'. (*Le Mercure* reports that the Ambassador then exclaims: 'How wonderful: the Pyrenees are no more, they have disappeared into the ground and we are one'. We know that later on, the remark 'The Pyrenees are no more' was attributed to Louis XIV.'). See Chennevières (1856: 17, n.1). Dangeau is referring to the issue of the literary magazine *Le Mercure Galant* of November 1700 (237).

5. One of Pascal's *Pensées* (1829 [1670]) ironically denounces the relativism of such supposedly natural (i.e. universal) ideological or political borders: 'Plaisante justice qu'une rivière borne. Vérité en deça des Pyrénées, erreur au-delà' ('Curious justice whose border is a river. Truth this side of the Pyrenees, error beyond', viii: 86), adding: 'Il y a sans doute des lois naturelles; mais cette belle raison corrompue a tout corrompu' ('There may be natural laws but beautiful corrupt Reason has corrupted everything', ix: 87).

6. See J. Hector St. John Crevecoeur's *Letters from an American Farmer* from the 1780s, in which he makes the contrary point that transplantation can lead both to transformation and improvement.

7. For the Greek and Roman idea that the ocean constituted the outer boundary of both the inhabitable zone and the earth, see Romm (1992).

8. For a fuller discussion of this aspect of the *Aeneid,* see Hardie (1993) and Quint (1993).

9. See the chapter on Invisibility for a discussion of Hannah Arendt's distinction between public visibility and natural invisibility in this volume.

10. Throughout the book, Latour uses Plato's myth of the cave to underpin his notion of the 'Two Houses' constitution of nature and politics.

11. Even the term that is increasingly being used to replace a static and restrictive concept of borders in the vocabulary of political and cultural criticism – namely, 'borderscapes' – retains an important sense that the boundaries border-crossing actors continue to encounter have both a spatial dimension and are experienced not least through the physical senses.

12. See also Morton (2007). Latour (2004: 29) makes the powerful and convincing argument that were we to think of natures in the plural, this would disrupt and derail a long tradition of political thinking and practice that dates back at least as far as Plato's myth of the cave. Yet rather than pursuing this line, Latour advocates a rejection of

the category of nature altogether and its replacement by an understanding of ecology that has no connection with nature whatsoever.

13. See, for instance, Gutzwiller (2007: 188).
14. The slogan 'think globally, act locally' would appear to contain seeds of both.
15. Haeckel defines ecology as 'the body of knowledge concerning the economy of nature'.
16. The reference to rhizomes is also a curious return to a natural, biological imaginary. In order to oppose the rhizome to the single root, Deleuze and Guattari had to invent a philosophical garden which is not so different from the Romans' invention of a protective ocean. See Deleuze and Guattari (1987: 3–27).
17. See Grover (2008) and Ellerman et al. (1998).

BIBLIOGRAPHY

Alesina, A., W. Easterly and J. Matuszeski. 2006. 'Artificial States', *NBER Working Paper* 12328.

Bate, J. 1991. *Romantic Ecology: Wordsworth and the Environmental Tradition*. London: Routledge.

Behler, E. 1993. *German Romantic Literary Theory*. Cambridge: Cambridge University Press.

Brambilla, C. 2008. 'New Approach in Border Studies: The Need for Re-Thinking the European-African Borderland Through the Case of the EU-SADC Relationship and the Caprivi Strip', *Borderland Studies* 23(3): 55–68.

Braudel, F. 1972. *The Mediterranean in the Age of Phillip II*, 2 vols, trans. S. Reynolds. New York: Harper and Row.

Buell, L. 2005. *The Future of Environmental Criticism: Environmental Crisis and Literary Imagination*. Malden, MA: Blackwell Publishing.

Burel, F. and J. Baudry. 2003. *Landscape Ecology: Concepts, Methods, and Applications*. Enfield, NH: Science.

Crevecoeur, J. H. St. John. 2013. *Letters from an American Farmer and Other Essays*. Edited by D.D. Moore. Cambridge, MA: Harvard University Press.

de Chennevières, P., L. Dussieux, A. de Montaiglon, P. Mantz and E. Soulié (eds). 1856. *Journal du Marquis de Dangeau avec les additions du Duc de Saint-Simon*. Tome 7 (1699–1700). Paris: Didot.

Deleuze, G. and F. Guattari. 1987. *A Thousand Plateaus: Capitalism and Schizophrenia*, trans. B. Massumi. Minneapolis: University of Minnesota.

Egerton, F. 2012. *Roots of Ecology: Antiquity to Haeckel*. Berkeley: University of California Press.

Ellerman, A.D., H.J. Jacoby and A. Decaux. 1998. 'The Effects on Developing Countries of the Kyoto Protocol and Carbon Dioxide Emissions Trading', *World Bank Policy Research Working Paper No. 2019*. Retrieved 9 May 2016 from http://ssrn.com/abstract=569250.

Fall, J.J. 2010. 'Artificial States? On the Enduring Geographical Myth of Natural Borders', *Political Geography* 29(3): 140–147.

Fill, A. and P. Mühlhäusler. 2001. *The Ecolinguistics Reader: Language, Ecology, and Environment*. London: Continuum.

Grover, V.I. (ed.). 2008. *Global Warming and Climate Change: Ten Years After Kyoto and Still Counting*. Enfield, NH: Science.

Gutzwiller, K. 2007. *A Guide to Hellenistic Literature*. Malden, MA: Blackwell Publishing.

Haenn, N. and R.R. Wilk. 2006. *The Environment in Anthropology: A Reader in Ecology, Culture, and Sustainable Living*. New York: New York University Press.

Hardie, P. 1993. *The Epic Successors of Virgil: A Study in the Dynamics of a Tradition*. Cambridge: Cambridge University Press.

Hardt, M. and A. Negri. 2000. *Empire*. Cambridge, MA: Harvard University Press.

Houtum, H. van. 2000. 'An Overview of European Geographical Research on Borders and Border Regions', *Journal of Borderlands Studies* 15(1): 57–83.

_____. 2005. 'The Geopolitics of Borders and Boundaries', *Geopolitics* 10(4): 672–679.

Kroeber, K. 1994. *Ecological Literary Criticism: Romantic Imagining and the Biology of Mind*. New York: Columbia University Press.

Latour, B. 2004. *Politics of Nature: How to Bring the Sciences into Democracy*, trans. C. Porter. Cambridge, MA: Harvard University Press.

Morton, T. 2007. *Ecology Without Nature: Rethinking Environmental Aesthetics*. Cambridge, MA: Harvard University Press.

Newman, D. and A. Paasi. 1998. 'Fences and Neighbours in the Postmodern World: Boundary Narratives in Political Geography', *Progress in Human Geography* 22(2): 186–207.

Pascal, B. 1829. *Pensées*. Paris: Emler Frères.

Peet, R., P. Robbins and M. Watts. 2011. *Global Political Ecology*. London: Routledge.

Quint, D. 1993. *Epic and Empire: Politics and Generic Form from Virgil to Milton*. Princeton: Princeton University Press.

Rancière, J. 1999. *Disagreement: Politics and Philosophy*, trans. Julie Rose. Minneapolis: University of Minnesota Press.

Romm, J. S. 1992. *The Edges of the Earth in Ancient Thought: Geography, Exploration and Fiction*. Princeton: Princeton University Press.

Rorty, R. 2009. *Philosophy and the Mirror of Nature*, Thirtieth-Anniversary Edition. Princeton: Princeton University Press.

Sahlins, P. 1989. *Boundaries: The Making of France and Spain in the Pyrenees*. Berkeley: University of California Press.

Schlegel, F. 1841. *Lectures on the History of Literature, Ancient and Modern*, trans. J.G. Lockhart. Edinburgh and London: Blackwood and sons.

_____. 2001. *On the Study of Greek Poetry*, trans. S. Barnett. Albany, NY: State University of New York Press.

Winckelmann, J. J. 2006. *History of the Art of Antiquity*, trans. H.F. Mallgrave. Los Angeles: Getty Publications.

Imaginary

Lene M. Johannessen and Ruben Moi

This chapter sets out to read for the aesthetic representations of borders as they transpire in literature. All that such ventures can hope to achieve, of course, is to merely suggest some ways that the multifaceted nature of borders are refracted within the specific aesthetic frameworks of a few, selected poems and pieces of prose. It also bears pointing out that with 'representation of borders' we do not have in mind the representation of concrete, man-made borders per se, so much as the figurations that condition their manifestations into, say, fences, walls or gates. What this means is that we pursue the contours of the kind of pre-figurations and the pre-conditions that enable the creation of material borders in the first place, since without these more intangible, ideological movements a fence is simply that, a fence. As we hope to illustrate in the pages that follow, the literary text provides a fertile ground for such excavations.

These considerations of the imaginary, within the perspective of this book, position themselves primarily in an aesthetics focusing on the hermeneutics of art works that present and produce cognitive borders, as much as those imaginative texts which represent metaphorically and creatively borders already manifest in the physical world. This chapter, thus, connects directly with the 'b/ordering and othering process' elucidated in the chapters of this book on Sovereignty and Waiting. Our discussion of the imaginary also anticipates the next chapter in which 'audio-visual borderscapes create and constantly re-create different in/visibilities' within cultural texts and ideological formations. How literature imagines human existence and the world in which we live, past, present and future, also corresponds with an examination of changing thought systems and the emergent of new ones in the previous Ecology chapter.

Kant's *Critique of Judgment* (1790) remains important for the discourses of the imaginary and its presentation, and for the representation and manifestation of physical and cognitive borders in aesthetic works of art. This chapter on the imaginary corroborates to a large extent, in its intimate attention to

literature, the privileged place Kant gives the arts within human existence. Kant's understanding of imagination as a power of *a priori* intuitions also resonates in the frequent ineffable and inscrutable elements of ingenious literature that distinguish art from culture, and which characterize the three chosen literary texts under analysis in this chapter. Kant's account of the aesthetic as *a priori*, universal, autonomous and disinterested formed the prevailing orthodoxy of aesthetics for almost two centuries. The importance and vibrancy of Kant's *Critique of Judgment* still held sway over a large number of theorists, but in more recent times, especially since the Second World War, some have argued against his ideals. Such opposition also informs the existential, social and linguist conditioning of the imaginary in the theoretical discourses of this chapter, and, to a large extent, in the literary texts themselves.

The borders that come into view in literature are, as their real-life counterparts, the preliminary end products of pre-figurative modes that constitute what we may think of as culturological tropes. The term culturological emphasizes an approach to culture that is diverse and dialogic, as what Bakhtin calls 'organic unity' with the capacity of 'transcending itself, that is, exceeding its own boundaries' (Bakhtin 1986: 135). Culturological tropes are not essentially different from literary tropes, but we want to emphasize in particular one shared property. This is what Hayden White describes as follows: 'a trope is always not only a deviation *from* one possible, proper meaning, but also a deviation *towards* another meaning, conception, or ideal of what is right and proper *and true* in "reality"' (1985: 2, author's emphasis). If we stay with the particular configuration of borders in aesthetic practices, we could add that as tropological constructs, borders are consequently at the same time confirmations and interrogations of the very construct that they are: constructs which simultaneously include and exclude, echoing spatially the double movement of 'deviation from and toward'.

Both prefiguration and culturological tropes are necessarily orchestrated by the broader structures of any given place and time from where the former derives its energy, and the latter thus obtains. It is precisely this relation between the concrete, appraisable aesthetics of emerging borders on the one hand, and, on the other, the vaguer, epistemological and ideological scaffoldings that facilitate such emergence that we are interested in here. For the readings that follow we posit this triad of conceptual nodes for analyses: imaginary, institution and tradition. Their interconnections are both compelling and observable in a number of contexts, not least in the social histories of culture and the ensuing politics of society, but it is a triad that also brings out interesting calibrations of the aesthetic work. We will engage in a more detailed discussion of each node as they can be brought to bear on our literary texts. With reference to a selection of literary samples, Robert Frost's 'Mending Wall' (1914), Dag Solstad's *Comrade Pedersen* (1982)[1] and Paul

Muldoon's 'Quoof' (1980), we consequently examine how aesthetics is able to carry the complex representations of bordering, and at the same time how the ethics of aesthetics gives pause for reflections on the workings of the borders of our own imaginaries in the encounter with that of Others. As such, our discussion of imaginary, institution and tradition in these writers and works also reflects different spatio-temporal and geo-political borderings of these nodes.

A good place to begin is precisely with the imaginary. Jean-Paul Sartre's *The Imaginary* (1940) offers the first groundbreaking, philosophical treatise in the modern period to formulate a unified theory of the relations of imagination and imaginary to aesthetic appreciation. Sartre (2004: 3) defines imaginary as the 'noematic correlate' of imagination. To a large extent the world as we know it is already structured by the constructed objects of our thought and imagination. Sartre deems the awareness of these constructed objects, imaginaries, and their intellectual processes of coming into being as central to the existentialist tenets of human freedom. His treatise is of primary significance to, for example, Jacques Lacan's (2006) psychoanalytic theories, where 'the symbolic' and 'the real' complement 'the imaginary' as the three intersecting orders of human psychology, or to Benedict Anderson's demonstration of the power and contention of imaginaries in the formation of futures in his classic *Imagined Communities* (1983).

Jacques Derrida also responds to Immanuel Kant's idealism and Sartre's text in his attempts to deconstruct the order and systems of the imaginary and choice, and his attempts to apprehend, to the extent this may be possible, a future beyond imaginaries and their formative, cognitive processes. From his early writing, he battles with a future that cannot be imagined by ordinary language or the traditional thought systems of Western metaphysics:

> Here there is a kind of question, let us call it historical, whose *conception, form, gestation* and *labor* we are only catching a glimpse of today. I employ these words, I admit, with a glance toward the operations of childbearing – but also with a glance toward those who, in a society from which I do not exclude myself, turn their eyes away when faced by the unnameable which is proclaiming itself and which can do so, as is necessary whenever a birth is in the offing, only under the species of the nonspecies, in the formless, mute infant, and terrifying form of monstrosity. (Derrida 1978: 293, author's emphases)

For all the projected monstrosity and apocalyptic rhetoric of Derrida's dystopian future, his eccentric discursions in philosophy question incessantly the possibility of gesturing towards an outside of logics and language, and the problem of bordering imagination, logics and language, as well as the relations between them. Derrida argued that futures, ideas and writing on and of Western metaphysics established ideologies and systems of communication that created the borders of the possible and the impossible. Such a possible

existence of novelty in a yet incomprehensible form can appear menacing and monstrous to contemporary cognition and setting. Novel apprehensions of times to come, radical changes in thinking and explorations of language on the margins of the known and unknown are frequently unrecognized and such creative future formations can only appear as informed, deformed and mal-formed – a monster in the present forms and categories of cognition and communication, but a monster that might bring new beginnings.

We encounter the concept of the imaginary in various contexts, and quite often in only more or less defined terms; hence it often assumes a place in a register of designations referring to vague ideas of how communities think of themselves collectively, or to communal, epistemological spheres presum-ably anchored in imaginations' invocations. These can obviously be fruitful approaches to discourses of and on cultural provenances and trajectories, but for our purposes here, that of fastening on to how aesthetics reproduces such ideas of fitting together, we employ the imaginary in more particular ways. We take our cue from philosophers Charles Taylor and Cornelius Castoriadis, whose thinking complements and diverges from each other in interesting ways, and remain secured in already existing as well as emerging realities and their ideological frameworks. Taylor refers specifically to the social imaginary, as 'the ways', he says, 'in which people imagine their social existence, how they fit together with others, how things go on between them and their fellows, the expectations that are normally met, and the deeper normative notions and images that underlie these expectations' (2004: 23). Such prerogatives are shared by all societies as a necessary proviso for recognizing the 'glue' that keeps the village, the group, or nation reasonably culturally and politically coherent in relation to other and different recognitions and glues.

Here we may pause and add a note regarding the word imaginary and its occasionally slippery relation to the affiliate image, imagine and imagination, a relation that is addressed specifically by Cornelius Castoriadis. He considers the difference as being crucial: 'The imaginary of which I am speaking is not an image *of*. It is the unceasing and essentially *undetermined* (social-historical and psychical) creation of *figures/forms/images*, on the basis of which alone there can ever be a question of something. What we call "reality" and "ratio-nality" are its works' (Castoriadis 2005: 3). Needless to say, we are here sim-plifying Castoriadis' exposition, but would like to take the idea of unceasing creation and its works as a key to address the relation between imaginaries and institutions. Elsewhere Castoriadis elucidates the proximity of imagi-nation and imaginary in the passage below, which also speaks to his general stance on the concept of the imaginary:

> I talk about the imaginary because the history of humanity is the history of
> the human imaginary and its works (*oeuvres*). And I talk about the history

and works of the radical imaginary, which appears as soon as there is any human collectivity. It is the instituting social imaginary that creates institutions in general (the institutions as form) as well as the particular institutions of each specific society, and the radical imagination of the singular human being. (Castoriadis 2007: 123)

Of particular interest to border aesthetics is the notion of the instituting imaginary, for the way it 'works' and is 'working' means that it inhabits the space of aesthetics, and that of border aesthetics specifically. This seems to be a good place to shift the discussion to look at a concrete example of how the imaginary and its institutionalization can be read for and examined in a concrete, poetic work.

As our first example of 'fieldwork', we go to the opening lines of American poet laureate Robert Frost's 'Mending Wall':

> Something there is that doesn't love a wall
> That sends the frozen-ground-swell under it,
> And spills the upper boulders in the sun,
> And makes gaps even two can pass abreast (Frost 1914: lines 1–4)

'Mending Wall' depicts the mundane and trivial yearly ritual of inspecting and repairing the fence enacted between the speaker and his neighbor's properties. On the immediate level, the poem evokes the ancient Roman festival of the Terminalia, which, in brief, served to celebrate the borders of property, and also, as William Dunstan (2011: 39) says, to 'honor Terminus and commemorate the symbolic border of the earliest territory of the city'. 'Mending Wall' thus directs the reader to a concern with walls as concrete borders, to the maintenance of a literal fence that runs between two pieces of land.

Considering, in Frost's characteristically straightforward style, the manifest ways in which a fence holds up through the year's seasons, the poem is however also a profound contemplation on the ways of institutions, on loyalty to the particular reproduction of an imaginary's certainty of its own right, and on the ways in which we configure our co-existence and the kind of boundaries we erect between what is ours and what belongs to others. As the speaker tries to persuade his neighbor that the fence may not be necessary everywhere,

> There where it is we do not need the wall:
> He is all pine and I am apple orchard.
> My apple trees will never get across
> And eat the cones under his pines… (lines 23–26)

the other merely responds, famously: 'Good fences make good neighbors'. (line 27)

The proverb in Frost's poem is familiar to most, and it is complex, since, as Wolfgang Mieder suggests, its 'metaphor contains both the phenomenon

of fencing someone or something in while at the same time fencing that person or thing out'. He goes on to observe that the proverb also essentially refracts the 'irresolvable tension between boundary and hospitality, between demarcation and common space, between individuality and collectivity, and between other conflicting attitudes that separate people from each other, be it as neighbors in a village or as nations' (2003: 155). The duality that Mieder points out interestingly echoes that in White's description of tropes, which we quoted initially in this chapter, of how tropes simultaneously deviate from and towards proper and true meaning. The ambivalence in how 'good fences make good neighbors' can be said to behave tropologically in a similarly fraught manner. The effect, to reader as well as to speaker, is to suggest a kind of filter of interpretation. It implicates us as well as Frost's neighbor in a deeply problematic discourse on the nature of any wall, any border, as simultaneously excluding and including.

Of course, as Mieder reminds us, proverbs 'are not universal truths, and their insights are not based on a logical philosophical system. Instead, they contain the general observations and experiences of humankind, including life's multifaceted contradictions' (155). It follows that, in the interest of a kind of functionality, certain essentializing shortcuts have to be made in order for the transmissions of any given imaginary's culturological knowledge to be carried out effectively. This expediency relies however on the 'correct' interpretation by the speaker as well as its addressee, which in turn presupposes a proper and shared understanding of what direction the 'deviation' should move in. Doubt is, in a sense, antithetical to the very nature of borders.

If 'Good fences make good neighbors' works as a culturological shortcut configured as a proverb, it is clear that its way of seeing the world is not immediately obvious to the poem's speaker. He wonders if he

> could put a notion in [the neighbor's] head:
> Why do they make good neighbors? (lines 29–39)

and thinks to himself that

> Before I built a wall I'd ask to know
> What I was walling in or walling out
> And to whom I was like to give offense (lines 32–33)

But the neighbor is not open to such hesitation:

> he moves in darkness as it seems to me,
> Not of woods only and the shade of trees,
> He will not go behind his father's saying
> And he likes having thought of it so well (lines 41–44)

These lines are followed by the final repetition of the proverb, which this time shifts the initial rendering of a trivial spring ritual to a rite of a far more serious kind.

For the neighbor's firm belief (in 'his father's saying') both carries and is carried by the imaginary that frames him as the individual moderator of a loyalty to boundaries of a certain kind, and it is not for him to question its veracity. The imaginary's institution in this case is, firstly, that of the fence itself, secondly that of loyalty to its long-standing practice. The two facets combine into what we commonly think of as tradition, as the carrying over of a set of beliefs and customs over time. We could thus rephrase and simply say that the neighbor and his proverb express a certain tradition. This would align fairly seamlessly with Castoriadis' earlier remark, that it is the 'instituting social imaginary that creates institutions in general (the institutions as form) as well as the particular institutions of each specific society' (2007: 123). And yet, tradition is complicated. Closely linked as it is etymologically to treason, conceptions of tradition bring us right back to uneasy ambiguity, not entirely unlike White's 'deviation from one possible, proper meaning, but also a deviation *towards* another meaning, conception, or ideal of what is right and proper *and true* in "reality"' (1985: 2), or that between boundary and hospitality that orchestrates the very proverb itself.

Tradition and treason form, as any dictionary will tell you, a doublet. Massimo Leone notes that, '[i]n Latin … the verb *tradere* and the noun *tradition* have absorbed the concepts of both tradition and treason', and he goes on to comment that 'every tradition is a form of treason; it is the transmission of a cultural object to someone who is different, and therefore potentially hostile' (2004: 53–54). It is consequently fairly evident that if border aesthetics broadly speaking amounts to something like the way principles of composition and representation make accessible the appreciation of configuring borders, then, within its fold, 'Mending Wall' accomplishes this on several levels in the art of poetry.

But we do not want to leave tradition/treason quite yet. Commenting more elaborately on this uneasy kinship, professor of law Jack M. Balkin notes the following three ways in which ideas of 'tradition and betrayal are closely linked'. We quote him at some length:

> First, [to respect tradition] is to forsake other alternatives for the future … Second, to respect tradition is also to betray other existing and competing traditions, to submerge and extinguish them. It is to establish through this suppression the hegemony of a particular way of thinking … Third, a tradition is often, in an uncanny way, a betrayal of itself. … To establish and enshrine a tradition is thus at the same time to establish a counter tradition – a seamy underside consisting of what society also does and perhaps cannot help but do, but will not admit to doing. The overt, respectable tradition depends upon

the forgetting of its submerged, less respectable opposite, even as it thrives and depends on its existence in unexpected ways. (Balkin 1990: 7)

With this in mind, let us consider again the above lines from 'Mending Wall':

> He moves in darkness as it seems to me,
> Not of woods only and the shade of trees,
> He will not go behind his father's saying
> And he likes having thought of it so well.

The 'darkness' the neighbor 'moves in' may be understood precisely as the hegemony of one, particular way. Mechanically, he repeats a kind of blind knowledge that, in Charles Taylor's discussion of the imaginary (see below), 'embeds and enables him' as a participant in the tradition he belongs to, and it is inconceivable, 'having thought of it so well', that there can be an outside available to him from where its veracity and validity may be interrogated. Tradition must therefore not be understood simply as the transmission 'carried in the ebb and flow of everyday life', and as the 'temporal happening of human thought and its vicissitudes within human life' (Marshall 2005: 2). Tradition is far more dangerous, as Balkin so convincingly suggests, and the neighbor's 'darkness' is but a metaphor canvassing all three of his points: darkness in the sense of the oblique and the obscure forsakes other alternatives (of not putting the fence up), betrays other competing traditions (the speaker's suggestion), and it establishes a counter tradition (by negation – why?).

All of this is not to say that tradition is static, once and for all; time and again it shows itself to be malleable, subject to change and even causes or forces erasures over time. Its first resort when questioned, however, is invariably that of reverting to ideas of origin and legitimacy, as Frost's neighbor so well exemplifies. When sounded out, carriers of tradition retreat to the often imagined source whence tradition derives its authority, located somewhere in an originating and originary past. For, somewhat lethargically, tradition and the genres that carry it – for instance proverbs – move and obtain from a point that precedes their actual institutionalization. Castoriadis thus also reminds us of a directive that can be said to underlie the gestalting of both:

> Everything that is presented to us in the social-historical world is inextricably tied to the symbolic. Not that it is limited to this. Real acts, whether individual or collective ones – work, consumption, war, love, child-bearing – the innumerable material products without which no society could live even an instant, are not (not always, not directly) symbols. All of these, however, would be impossible outside of a symbolic network. (Castoriadis 2005: 117)

This description of the relation between real acts and the 'symbolic' bears immediately on our discussion here of 'Mending Wall'. Keeping in mind also

that symbol can mean 'creed' as well as 'token, or mark', the fence can now be figured as the demarcation of legitimate creeds; it is precisely a 'real act', transitioned from symbol and constituted and configured as simultaneously mark and creed. The proverb in the poem is also such an act – a figure of speech, a trope, summoned into existence by the pre-figurative network that carries it, to articulate the one, particular way. Its life, so to speak, relies in turn fully on the social imaginary that embeds and enables its repetition.

We now turn to Taylor's exposition:

> (i), my focus is on the way ordinary people 'imagine' their social surroundings, and this is often not expressed in theoretical terms, but is carried in images, stories, and legends. It is also the case that (ii) theory is often the possession of a small minority, whereas what is interesting in the social imaginary is that it is shared by large groups of people, if not the whole society. Which leads to a third difference: (iii) the social imaginary is that common understanding that makes possible common practices and a widely shared sense of legitimacy. (Taylor 2004: 23)

Taylor's delineation of the social imaginary speaks meaningfully, not only to the discussion of how 'good fences make good neighbors', but also to the peculiar intimacy of tradition and treason. The interpretation and execution of the directives that define treason from tradition rely wholly on an agreement among the imaginary's participants of what 'common understandings' are. The social imaginary, as Dilip Parameshwar Gaongar elaborates on it, is 'an enabling but not fully explicable symbolic matrix'; it is, however, also always open to a certain level of possible readings (2002: 1–19).

While tradition could be said to try to make sense of the 'not fully explicable', obtaining as it does from a 'widely shared sense of legitimacy' that pertains to the symbolic sphere's always-already verging on its own institutionalizing (as soon as the symbolic formulates itself, it is always already bordering on its formation), treason on the other hand is that which comes un-rooted, surfacing from what Balkin calls the 'seamy underside', expressive of the illegitimate. The fence in 'Mending Wall' is certainly the 'real act', a concrete wall that needs repair, but more fundamentally it is the wall between grammars of legitimacy, between authenticated vocabularies of an authorial past, between loyalties to the institution of traditions, and then the treason that may come from adherence to those very loyalties.

Struggles of and over social imaginaries and their bordering take place in philosophical discourses as much as in imaginative poetry and prose. Derrida tends to question the very premises of a large variety of imaginaries, as much as he gestures towards radical imaginaries of and for the future as menacing and monstrous. 'Before the Law' (1992) analyses critically the construction of legitimacy and jurisdiction in general, in genres, and in the relations between

them. 'White mythology' (1982) dissects the philosophical production of light and darkness that we touch upon in our reading of 'Mending Wall', and can also be read in relation to the discussion of in/visibility and borderscapes in the chapter on Invisibility. 'Living On: Border Lines' (1979), perhaps Derrida's most obvious text on aesthetic borders and their contextual tangentiality, can be read as an alternative to Castoriadis' dichotomy of the inside and the outside of symbolic networks. And, as argued in the introduction to this essay, to Derrida radical future eventualities come into being on the borders of present social imaginaries, institutions and traditions, and appear conceivable only on the margins of articulation, form and normalcy: 'only under the species of the nonspecies, in the formless, mute, infant, and terrifying form of monstrosity' (1978: 293). Derrida's philosophical horror suggests that any structure of thought based upon commonality, selfsameness of subjectivity, centralization of ideas and appeal to shared legitimacy will only anticipate the future with flawed imagination and closure.

These premises foreclose radical changes in imaginaries and possible futures by their unquestioning repetition of their own basic premises: the ceaseless mending of walls, the absolute certainty of the one way and the habitual reversion to common ideas, obfuscating metaphoricity of light and dark and unapproachable law. To imagine a different social formation or other futures unshackled by such automatic recirculations is a challenge and, as Derrida indicates, will struggle to find a form, to find a voice and to be acknowledged otherwise than as an unrecognizable monster. The possibility of such imaginings depends upon the ability to question our own sense of self, social cohesion and common law. It is also risky and it takes courage. Alternative social imaginaries could also depend upon, in a simplistic negational rephrasing of Taylor's definition of social imaginary quoted earlier in this chapter, 'the way in which people imagine their social *difference*, how they *do not* fit together with *their own* and others, how things *fail* between them and their fellows, the expectations that are *hardly ever* met, and the deeper normative notions and images that underlie these expectations' (2004: 23). These are some of the possible questionings that rupture and put into crisis the recirculations of the premises of the borders of traditions and social imaginaries, questionings that 'Mending Wall' and, as we shall see below, Solstad's novel *Comrade Pedersen* and Muldoon's poem 'Quoof' also breach. Such a search for other social imaginaries, which may not easily be found, recognized or understood, can possibly open up for the alternative futures that dominant tradition forsakes, and help to recover the competing traditions that have been submerged and extinguished. Imaginaries contradict and complement each other. They create, maintain and change their own borders and the processes upon which they are predicated. Resuscitations of old imaginaries, or the arrival of radical ones, challenge prevailing imaginaries, traditions and

institutions to such an extent that they can often only be conceived as danger-
ous, deformed and deranged: monstrosity.

A struggle over social imaginaries and the menace of monstrosity inform
Comrade Pedersen, a significant novel in the discussion of social imaginaries
in Norway by the prominent novelist Dag Solstad, perhaps the contemporary
writer who has imagined critically the ideas behind the social development in
Norway most astutely over the last forty years. Aschehoug Agency cites the
Times Literary Supplement: 'Dag Solstad's eminence in Norway is abundantly
justified by this profound and courageous study of solitude in society, and
despair within enviable security'. *Comrade Pedersen* deals with why the polit-
ical movement of Marxism that swept over Norway in the 1970s fell far short
of any revolutionary action. It begins with astute semi-ironic paraphrases of
the Norwegian imaginary, and the traditions it rests on, as it defined Norway
in 1982, and to some extent still does. Solstad writes, and we quote a few lines
from four of the early pages as examples:

> I think I need to begin by saying a few words about my country and its
> peculiar history. Norway is one of the world's richest countries, despite its
> displaced location far up north ... a country that has always been placed on
> the outskirts of the centre of events ...
>
> The world we live in is created by war, and changes by the war's fatal logic,
> war between nations ... But only to a very small degree have such events
> shaken my country. Yes, it is probably more precise to say that we have only
> taken part in such events from a distance, they have only reached our country
> as echo and gloom ... My country's history is remarkably peaceful, also in
> war. In fact, there has not been a single massacre in the history of the country
> for more than 700 years... Basically, formal democratic rights hold a strong
> position in my country ... I also need to emphasize that the citizens in my
> country enjoy a high degree of social security. (Solstad 1982: 5–9)

Solstad describes Norway as prosperous, marginal and peaceful. The distri-
bution of wealth, the distance from wars and international conflicts, and the
lack of war on its own territory – and the myriads of ways these conditions
have been imagined, of which these opening statements in Solstad's novel are
paradigmatic – have shaped the social imaginary, not only since the discovery
of oil in the 1960s, but rather as this builds on already existing premises and
dispositions. *Comrade Pedersen* takes its point of departure from the perpet-
uating social imaginary of Norway as a culture whose history has been quite
peaceful and harmonious, despite the fact that it, as is the case with so many
other countries, has gone through events such as struggle for independence,
two world wars, depression, cold war and so on. A key factor is the perception
of distance and stability, of both spatial and temporal remoteness, or, as poet
Rolf Jacobsen puts it in his poem 'Anderledeslandet' ('Othercountry'): 'this
othercountry / North, north without end' (2012 [1985]; English translation

our own), an imaginary defined by a sense of separateness. The imaginary thus entails a certain level of innocence in the sense of naivety as well as sheltered lives: we do not commit evil acts and if such acts are committed elsewhere, they never reach our country. This Manichaean worldview, which also formed many of our institutions, traditions, policies and the individual mind – 'the instituting social imaginary that creates institutions in general (the institutions as form) as well as the particular institutions of each specific society, and the radical imagination of the singular human being', in the words of Castoriadis (2007: 123) – constituted a prevailing imaginary in Norway after the Second World War, an imaginary that institutionalized itself in social formations and bordered common mentality, and still retains a firm position.

Comrade Pedersen, then, to a large extent affirms a dominant social imaginary, but Solstad's novel also stages a struggle for alternative, social imaginaries in its account of the fate in Norway of radical Marxism: his novel endeavours to rewrite the borders of the dominant social imaginary. The traditional view of Norway – the summary of Norwegian history and the synthesis of its social imaginary at the beginning of the book quoted earlier – is questioned and humorously undermined by the counter-imaginary of radical change. To challenge the imaginary of Norway as a traditional, stable, rational, sound, well-functioning social democracy deviates from one possible, proper meaning, but also deviates towards another meaning, conception, or ideal of what is right and proper and true in 'reality'. Such a challenge would amount to new ideas in some communities, treason in others. The novel, either way, reconceptualizes the borders of the presiding social imaginary. Solstad's book speaks of revolution, traditionally the everlasting menace of philosophical discourse and historical development, Balkin's 'seamy underside' and Derrida's monstrosity.

The novel thus presents a serio-ludic history of the country's cognitive contours. In theme and form it captures an interesting moment in an analysis concerned with the immaterial sources of social formation, their definitions, possibilities and failures. In its imaginative critique of an ideology that might have come into being, *Comrade Pedersen* opens for future change by rewriting the ideas of the immediate past. The ironic tone of parts of the opening pages reveals impatience with the traditional imperatives: they are narcissistic, stifling and counterproductive. Radical change, reform and possibly revolution offer alternatives. But the rest of the novel also lays bare the flaws of the Marxist movement itself, the reasons for its failure: the idealism, the party despotism, the self-proletarization, the disregard of individuality, the generalization of people, the growing disaffection and the subsequent defection. This double critique combines the process of confirmation and change. New futures require transformations in perceptions of self, of social structures and of national identification. Solstad's *Comrade Pedersen* revaluates

our immediate past for the sake of novel imaginaries; the borders are deconstructed in a way that facilitates new imaginings.

Clashes over borders, imaginaries, traditions and institutions tend to articulate themselves more vociferously in Northern Ireland than in America and Norway due to its bilateral relations to the traditions and institutions of Ireland and England, and the decades of crisis euphemistically referred to as the Troubles. 'Poetry and politics, like church and state, should be separated', Edna Longley declares in 'Poetry and Politics in Northern Ireland' (1986), in order to protect poetic purity from the contamination of ideological discourses, political agendas and social concerns. A range of critics, for example Eagleton et al., in *Nationalism, Colonialism and Literature* (1990), Kiberd in *Inventing Ireland* (1995) and Kirkland in *Literature and Culture in Northern Ireland since 1965* (1996), refute Longley's stance as the most political one of all. The poetry of Paul Muldoon, 'the distant master of evasive involvement' and 'a poker-faced player of orange and green cards', in the words of 1995 Nobel Laureate Seamus Heaney (1989: 52), appears hard to place within this hermeneutic bordering. 'Quoof', his enigmatic poem from *Quoof* (1983), supplements old imaginaries, traditions and institutions for other alternatives, and questions the roles of the main medium of constituting imaginaries in poetry and prose as well as critical discourse: language.

The problems and possibilities of articulating in language other imaginaries, and the questioning of the medium of articulation of these imaginaries, is a typical Derridean preoccupation that Taylor and Castoriadis are not really concerned with, but Muldoon seems to focus upon. A sharp linguistic self-awareness appeared crucial in Northern Ireland at the time, because the use of language was just as contested as the conflictual ideologies, religious affinities, views of history, social formations and imaginings of futures it tried to conceive or conceal.

Quoof

How often have I carried our family word
for the hot water bottle
to a strange bed,
as my father would juggle a red-hot half-brick
in an old sock
to his childhood settle.
I have taken it into so many lovely heads
or laid it between us like a sword.
An hotel room in New York City
with a girl who spoke hardly any English
my hand or her breast
like the smouldering one-off spoor of the yeti
or some other shy beast
that has yet to enter the language. (Muldoon 1983: 17)

Muldoon's quoofing around with language, his yeti to Western rational-
ity and his little beast in linguistic order and in the many socio-political
discourses in Northern Ireland at the time, contributes to imaginings on
the borders of the comprehensible, known and articulate and the incom-
prehensible, unknown and inarticulate. 'Modernism begins with the search
for a Literature which is no longer possible', Roland Barthes (1998: 38)
argues in search of a new language that has yet not materialized, and in his
Trilogy and experimental plays the Irish expatriate Beckett attempts indefat-
igably but unsuccessfully to arrive at some reassuring form of closure. The
impulse to imagine something new, to capture the future and to utter the
unknown is not always easily understood or particularly appreciated on its
first arrival.

'Quaat?' asks Derek Mahon (1983: 27) in his review of *Quoof* and catches
in the rebound the linguistic enigma of quoof and the enigmatic quality of
the magic visions in Muldoon's baffling term. Edna Longley also admits to
Muldoon's unpresentability: 'Paul Muldoon's poetry carries its own antibodies
against literal-minded critics' (1983: 31). These critics, despite the piecemeal
insights of their evaluations, testify unanimously to a perplexity in *Quoof* that
resists the ordinary apparatus of analytical approaches. Critical uncertainty
opens up new interpretations. This poem of coming of age meditates upon the
mysteries of life, sex and birth. This meditation also works as an analogy for
the mysteries of language. Furthermore, the intercourse of two partners who
lack a common language envisions on a symbolic level an intimate union of
the opposing sides of a divided community. The uncanny title, 'Quoof', sig-
nals flagrantly the attempt to put forward the unutterable in utterance itself.
Muldoon's poem contains a questioning of the borders of language itself.

Muldoon's testing of the borders of language in this idiosyncratic nonce-
word thus induces a sense of enigma and *ostranenie* as well as an inventive
linguistic drive and phonetic relish. The mysteries of sex, bestiality and birth
might be some of the elusive and the unknown the alienated and alienating
neologism attempts to capture. But the word is also a linguistic beast itself,
entering into language. As a sexy sonnet, 'Quoof' glows with quoof, with
the 'red-hot, half-brick in an old sock', with traditional passion and modern
connotations of contraceptives. In like manner Muldoon's innovative sonnet
stands upright in the sonnet tradition. The unscanned lines and subtle sound-
ing dissociate ordinary metre and rhyme, and this deconstructed sonnet blends
with Muldoon's critical creativity in continuously exploring what makes a
sonnet a sonnet. To the extent that the conventional sonnet consists of two
separate stanzas with intricate prosody and distributions of sounds within a
continuously evolving tradition, 'Quoof' represents on new levels aesthetic
approaches to the structural binaries of Northern/Ireland. 'Quoof', in its ques-
tioning of articulacy and poetic form, deconstructs the borders of language

and traditional form to open up new and linguistic and artistic possibilities – frequently denounced as treason, monsters and madness by many established institutions of border policing. Muldoon's linguistic and imaginative marking of the borders of language and literary aesthetics expands when the border-marking and the border-making imaginary of 'Quoof' is compared to two canonical poems by his literary predecessor William Butler Yeats.

The intertextuality of Muldoon's 'Quoof' with the poetry of the Irish Nobel Laureate of 1923, W.B. Yeats, reveals other representations and refractions in language – so often considered to be translucent and neutral – and in poetry – regarded as apolitical aesthetics by Longley, and always a political imaginary site by so many others. Few poets have contributed to the imaginary of Ireland in such formidable ways as W.B. Yeats. The Nobel committee (2016 [1923]) awarded him the laurels 'for his always inspired poetry, which in a highly artistic form gives expression to the spirit of a whole nation'. The statement appears ironic in retrospect as the partition of Ireland took place the same year. Still, the poetry of Yeats and Muldoon came into being at a time of volatile controversies over counteracting imaginaries, traditions and institutions, the bordering of nation, social imaginaries, language and literature. Many of Yeats and Muldoon's poems overlap in their contextuality of contesting social imaginaries and formal innovation, and Yeats's 'The Second Coming' and 'Leda and the Swan' provide textual semen for Paul Muldoon's 'Quoof'. The ending of W.B. Yeats's 'The Second Coming' (1990: 211) from 1921 appears Derridean *avant la lettre* and as a poetic sibling of 'Quoof': 'And what rough beast, its hour come round at last, / Slouches towards Bethlehem to be born?' Yeats's apocalyptic vision reverberates with 'the blood-dimmed tide' of the Easter Rising of 1916 and the Russian revolution, as much as it anticipates ominously the Second World War – the extreme results of fixed imaginaries. Yeats's prophetic verses also intimate the partition of Ireland and the consequent Troubles, Muldoon's situation of creative writing. A second reference to Yeats' iconic sonnet 'Leda and the Swan' corroborates this reorientation of tradition and imaginary. 'Leda and the Swan' and 'Quoof' overlap in their presentation of sexual encounters, their bestial imagery and their innovation of the sonnet tradition. However, where Yeats's broken sonnet stresses aggression and division in language content and form, Muldoon's suggests intimacy and integration. Yeats's sonnet draws upon the grand narratives of the past – classic mythology and national wars – whereas Muldoon's one-night stanza presents the fumbles and mumbles of two new and unlikely bed fellows. Yeats' aesthetics, in 'The Second Coming' and 'Leda and the Swan', captures Ireland on the cusp of war and partition; Muldoon's aesthetics in Quoof strives for an unheard of language and a novel form fifteen years before the Good Friday Peace Agreement – a mere monstrosity to custodians of tradition of all kinds, and to polemical politicians and war lords. In the fraught, conflictual contexts

of Northern Ireland, 'Quoof' distinguishes itself from the habitual borders of language, form, literary tradition and the bipartite social imaginaries of Northern Ireland at the time. 'Quoof' offers an imaginary of integration that is pregnant with the idea that new language, syntax and literary aesthetics could possibly break borders, spur on other social imaginaries and articulate in new ways a future situation for Northern Ireland.

Literature, together with the arts – music, drama, visual arts, etc. – and aesthetic concerns and discourses, defends a crucial position – the exalted status that Kant established – in the articulation as well as the transformation of borders and social imaginaries – as the many opponents of Kant have maintained during the last century. For, as Bieger, Saldívar and Voelz (2013: x) observe, 'the notion of the imaginary ... draws attention to the potentials – unrecognized by official discourses – slumbering in a given social formation'. They go on to note that 'literary and cultural studies are particularly drawn to the concept of the imaginary since it allows them to claim a privileged role for the fiction, and cultural texts more generally, in the unfolding and assessing of these potential worlds'. The works by Robert Frost, Dag Solstad and Paul Muldoon, which we have only briefly examined here, are but some examples of such 'unfolding and assessing'. Their readings make clear the tenuous process by which the imaginative and the imagined transition into representations of emerging worlds and worldviews might take place, how the prefiguration that underlies tropological processes comes to mark stages in the development whereby boundaries are spatialized. They also mirror, often calibrate, and sometimes also re-route the processes by which boundaries materialize in the real world.

Lene M. Johannessen is professor of American literature at the University of Bergen. She teaches and publishes in the general area of American studies (*Horizons of Enchantment: Essays in the American Imaginary*, UPNE 2011), but also specifically in Chicano Studies (she contributed to *Routledge Handbook of Chicano Studies*, forthcoming) as well as in Postcolonial studies ('Palimpsest and Hybridity in Postcolonial Writing', in Ato Quayson (ed.), *The Cambridge History of Postcolonial Literature*, 2012).

Ruben Moi is Associate Professor at UiT – The Arctic University of Norway, where he is also a member of the Border Aesthetics research group. His most recent book is *The Crossings of Art in Ireland* (2014) and forthcoming publications include *The Language of Paul Muldoon's Poetry*. He has also published widely on the work of writers such as Seamus Heaney, Derek Mahon, Ciaran Carson, T.S. Eliot, Samuel Beckett, Martin MacDonagh and Irvine Welsh. He holds positions as treasurer of the Nordic Irish Studies Network,

vice-chairman of the Norwegian Academic Council for English, and chairman of Ordkalotten – Tromsø's International Literature Festival.

NOTE

1. The full title of Solstad's novel, *Gymnaslærer Pedersens beretning om den store politiske vekkelsen som har hjemsøkt vårt land* (1982), may be translated as 'Secondary School Teacher Pedersen's Account of the Great Political Awakening which has Afflicted our Country'. We here refer to it using the English title of the 2006 film as *Comrade Pedersen*. The novel has not appeared in English translation, and we have translated the short examples from the opening pages on page 17.

BIBLIOGRAPHY

Anderson, B. 2006. *Imagined Communities.* Revised edition. London: Verso.

Aschehoug Agency. 'Dag Solstad'. Retrieved on 10 May 2016 from http://www.aschehou-gagency.no/Authors/Oktober/Solstad-Dag.

Balkin, J.M. 1990. 'Tradition, Betrayal, and the Politics of Deconstruction', *Cardozo Law Review* 11(5–6): 1613–1630.

Bakhtin, M. 1986. *Speech Genres and Other Late Essays*, trans. V.W. McGee. Austin: Texas University Press.

Barthes, R. 1988. *Writing Degree Zero*, trans. A. Lavers and C. Smith. New York: Farrar, Strauss and Giroux.

Bieger, L., Ramon Saldivar and Johannes Voelz. 2013. *The Imaginary and Its Worlds: American Studies after the Transnational Turn.* Hanover, NH: Dartmouth College Press.

Castoriadis, C. 2005. *The Imaginary Institution of Society*, trans. K. Blamey. Cambridge: Polity Press.

———. 2007. *Figures of the Thinkable.* Stanford, CA: Stanford University Press.

Derrida, J. 1978. *Writing and Difference*, trans. A. Bass. London: Routledge.

———. 1979. 'Living On: Borderlines', trans. J. Hulbert, in Harold Bloom et al. (eds), *Deconstruction and Criticism.* New York: Continuum, pp. 75–177.

———. 1982. 'White Mythology', trans. A. Bass, in *Margins of Philosophy*. New York: Harvester Wheatsheaf, pp. 207–273.

———. 1992. 'Before the Law', trans. A. Ronell and C. Roulston, in Derek Attridge (ed.), *Acts of Literature.* New York: Routledge, pp. 181–221.

Dunstan, W.E. 2011. *Ancient Rome.* Plymouth: Rowman & Littlefield.

Eagleton, T., F. Jameson and E. Said. 1990. *Nationalism, Colonialism and Literature.* Minneapolis: University of Minnesota Press.

Frost, R. 2011 [1914]. 'Mending Wall', in *Norton Anthology of American Literature Volume Two.* Shorter eighth edition. New York: W. W. Norton & Company.

Gaonkar, D. Parameshwar. 2002. 'Toward New Imaginaries: An Introduction', *Public Culture* 14(1): 1–19.

Jacobsen, R. 2012. 'Anderledeslandet' [1985], *Kulturverk*, 23 March 2012. Retrieved on 10 May 2016 from http://www.kulturverk.com/2012/03/23/anderledeslandet/.

Heaney, S. 1989. *The Place of Writing*. Atlanta: Scholars Press.

Kiberd, D. 1995. *Inventing Ireland*. London: Jonathan Cape.

Kirkland, R. 1996. *Literature and Culture in Northern Ireland since 1965*. London: Longman.

Lacan, J. 2006. *Écrits: The First Complete Edition in English*, trans. B. Fink. New York: W. W. Norton & Co.

Leone, M. 2004. *Religious Conversion and Identity: The Semiotic Analysis of Texts*. London: Routledge.

Longley, E. 1983. 'Uncovering Deadly Depths', *Fortnight* 200: 31–32.

_____. 1986. 'Poetry and Politics in Northern Ireland', in *Poetry in the Wars*. Newcastle upon Tyne: Bloodaxe, pp. 185–211.

Mahon, D. 1983. 'Quaat?', *New Statesman*, 11 November 1983: 27–28.

Marshall, D.G. (ed.). 2005. *The Force of Tradition: Response and Resistance in Literature, Religion, and Cultural Studies*. Lanham, MD: Rowman & Littlefield.

Mieder, W. 2003. '"Good Fences Make Good Neighbours": History and Significance of an Ambiguous Proverb', *Folklore* 114(2): 155–179.

Muldoon, P. 1983. *Quoof*. London: Faber and Faber.

Nobelprize.org. 2003. 'The Nobel Prize in Literature 1923'. Retrieved on 6 April 2016 from http://www.nobelprize.org/nobel_prizes/literature/laureates/1923/.

Sartre, J.-P. 2004. *The Imaginary: A Phenomenological Psychology of the Imagination*, trans. J.M. Webber. London: Psychology Press.

Solstad, D. 1982. *Gymnaslærer Pedersens beretning om den store politiske vekkelsen som har hjemsøkt vårt land*. Oslo: Oktober.

Taylor, C. 2004. *Modern Social Imaginaries*. Durham: Duke University Press.

White, H. 1985. *Tropics of Discourse*. Baltimore: Johns Hopkins Press.

Yeats, W.B. 1990. *Collected Poems*. London: Picador.

▶• 3 •◀

In/visibility

Chiara Brambilla and Holger Pötzsch

This chapter addresses the relationship between borders and audio-visuality. It draws upon a de-territorialized and process-oriented concept of the border and focuses on the ways in which audio-visual borderscapes create and constantly re-create different forms of in/visibility.

We use the concept of the 'borderscape' as it enables a productive under-standing of the processual, dis-located and dispersed nature of contemporary borders, their regimes, and ensembles of practices (Brambilla 2015a). Borderscapes are not static, but resemble a constantly evolving 'zone of varied and differentiated encounters' that are always 'invested with a certain aesthetic and moral value' (Rajaram and Grundy-Warr 2007: xxx–xxxiii). The various contingent identities afforded by borderscapes are actualized, negotiated and potentially subverted at the level of everyday practice (Brambilla 2015a). As such, a borderscape functions as a tacit frame that predisposes particular reproductive performances and shapes subjectivities. It is enmeshed in imaginary geographies and dynamically adapts to possible challenges and changes.

In the present chapter, we work on the premise that borderscapes also function at an audio-visual register in that they veil certain subjectivities and their respective articulations while promoting others. As such, we argue, the borderscape concept plays into a politics of in/visibility in the sense of Hannah Arendt and becomes conceivable as an important element of a particular distribution of the sensible in the sense of Jacques Rancière. Initially, however, a closer look at the etymology of the suffix '-scape' is useful in order to better understand the immediate connection between the borderscape and aesthetic practices and politics of in/visibility.

The suffix '-scape' derives from an old Germanic verb meaning 'to create'. The term subsequently morphed into an Old Dutch term, '-schap'. Through the Dutch combination 'landschap' the term acquired the meaning of 'a tract of land, a region'. The English word landscape is derived from this Old Dutch term and first appeared in the late sixteenth century. Through this transition, though, the word 'landscape' had acquired a meaning distinct from its Dutch

and Germanic origins. In English it did not refer to a region but was used as a technical term for the description of paintings (Webster and Gove 2000). The word landscape had turned into an adjective to describe an artistic genre – 'landscape painting' – which the Dutch pioneered and excelled at. It is this painterly definition of the term landscape that migrated into the English language, and morphed into the term we use today. What is interesting to our inquiry is the fact that the English language first appropriated the term in an aesthetic sense.

Following Kenneth Olwig (1993) we can now distinguish between two potential meanings of the suffix '-scape'. The first is concerned with the sense of creative work – 'shaping and carving'. In this sense landscape is 'the land "scaped", "shaped" or created ... as place and polity by people through their practices of dwelling – their 'doing ... undoing [and] redoing' (Olwig 2008: 82). The second meaning of the suffix '-scape' reduces the term to a perspective: the artistic representation of a specified type of view or a scene. We will connect this second sense to the function of the visual in contemporary, technologically mediated borderscapes.

Reflecting on the role of audio-visual borderscapes in contemporary dis-located processes of 'b/ordering' (van Houtum, Kramsch and Zierhofer 2005), we will attempt to elaborate a distinction between various ways through which such borderscapes and their scopic regimes impact upon the lives and day-to-day practices of political subjects. In first critically interrogating the work of Hannah Arendt, we conceptualize the ways through which a politics of in/visibility frames political subjects as either relevant or negligible. Subsequently, we engage the thought of Jacques Rancière to gain a terminology for the description of the various interactions between politics and aesthetics in such processes of 'b/ordering'. We argue that audio-visual borderscapes either reinforce and stabilize, or challenge and subvert, particular regimes of the sensible. We will provide the examples of drone warfare and migrants' audio-visual self-representations to illustrate hegemonic and counter-hegemonic articulatory practices. Initially, however, a few words on the audio-visual nature of contemporary borderscapes will align this chapter to the conceptual basis provided in the general introduction of the volume.

Audio-Visual Borderscapes

The function of the visual in processes of b/ordering is an important field of inquiry. Throughout modernity the visual representation of borders has played a crucial role in the invention and imagination of the nation state. Maps were instrumental to the process of occupation through the inscription of borders, functioning as cartographic in(ter)ventions that abetted the

imposition of a homogenizing order at an increasingly global scale. The cartographic representation of borders can be connected to Olwig's second sense of the term 'landscape' presented in the opening section of this chapter that reduces its meaning to a perspective or specified type of view. 'The space of the map, like that of the landscape scene, is an extent, with various objects plotted in terms of its coordinates. On the quadratic space of such a map life is enclosed with property boundaries' (Olwig 2008: 83).

These considerations highlight how the present chapter relates to the first definition of 'aesthetic' used in this volume, namely aesthetic as involving sensory perception in general (see Introduction). Specifically, we problematize the role of the visual in processes of b/ordering, by proposing that, to function properly, borders are intimately connected to various culturally and technologically mediated forms of visibility and invisibility. This aesthetic dimension of borders in its widest possible meaning has profound political, cultural and societal implications for subjectivities submitted to its peculiar gaze and regime. Following from this, we employ the concept of audio-visual borderscapes to critically interrogate the role played by audio-visual media in processes of b/ordering. Audio-visual media constitute an important component of contemporary borderscapes that predispose and frame processes of in/exclusion. We will now investigate the ways through which media technologies act upon politics and either maintain and stabilize, or subvert and change, existing regimes of b/ordering and in/exclusion. In the former case media technologies function as components of what we term hegemonic audio-visual borderscapes, while they serve in a counter-hegemonic fashion in the latter instance.

Hegemonic borderscapes reproduce given positions of power through staging and ritualizing performances in a pre-established hierarchical social space. These positions derive primarily from a monocular perspective that is fixed and at a distance. Maps and other forms of border representations are important for naturalizations of such power-laden processes of bordering (Gregory 1994). On the other hand, subversive forms of in/visibility and practices of in/visibilization can feed into counter-hegemonic frameworks that question and undermine such naturalized social practices and discursive positions. Thus, the borderscape concept suggests an interrelation between b/ordering and visibility that entails the understanding that vision (and perception in general) is not universal. Visibility can be thought of as framed social practice that is based on contingent discursive determinations and can be either oppressive or progressive in its effects.

On the basis of an 'epistemological aesthetization' posited by Wolfgang Welsch (1997: 84) and mindful of a dis-located, process-oriented and constructive understanding of borders (Brambilla 2010a), the present chapter explores the interrelation of technologically mediated borderscapes and

various forms of in/visibility and processes of in/visibilization as they occur at the constantly evolving intersection between politics and aesthetics. To do this we will draw upon the thought of Hannah Arendt and Jacques Rancière, who posit a 'politics of in/visibility' and a distinction between a 'politics as police' and a 'politics as process' respectively.

In this way, the chapter relates to the second meaning of aesthetics used in the present volume. More precisely, the chapter contributes to a critical reflection on 'the arts' capability to relate meaningfully to the political and social spheres that surround them (Pötzsch 2015c). Establishing a connection between the aesthetic sphere and the political sphere, the notion of in/visibility gives aesthetics a crucial role 'as a mediator' between lived experience of the world and 'the ideal world to which we aspire' (see Introduction).

Politics of In/Visibility

For Arendt (1958) the political world is the space of appearances, the space where I appear to others and others appear to me. Consequently, public visibility is the precondition for active political participation and citizenship. This *vita activa* foregrounds action and speech within the public space, that is civic involvement in politics. When seen from this vantage point, visibility can oscillate between an empowering pole (visibility as recognition) and a disempowering pole (visibility as control). The opposition between recognition and control highlights the fact that visibility is a paradoxical notion. Processes of making in/visible are related to regimes and apparatuses of in/visibility that capture the paradoxical movement between a conferring and retracting of power at the shifting threshold between what is worthy of being seen and what is not. The concept of audio-visual borderscapes enables a critical investigation of the complex relationship between border regimes and regimes of in/visibility.

Arendt asserts that '[t]he most elementary meaning of the two realms [the private and the public] indicates that there are things that need to be hidden and others that need to be displayed publicly if they are to exist at all' (1958: 73). This quote points to the core of Arendt's idea of politics that is based on the phenomenological concept of appearance (Borren 2010: 82–90). As already stated above, according to Arendt, political participation is dependent upon appearance in the public sphere, a form of political involvement she terms public visibility. To be publicly visible, however, can only be seen as progressive as long as other identity markers remain invisible. This means public visibility is predicated upon a private sphere that ensures natural invisibility.

To be naturally invisible but publicly visible means to be able to enunciate political articulations that are received independently from involuntary

markers of racial, ethnic, class or other belonging. Natural invisibility protects the political subject from unwarranted intrusion, and ensures a private sphere of refuge and seclusion that constitutes the necessary basis for political involvement. This makes public visibility and natural invisibility fundamental preconditions for citizens' active participation in politics.[1]

In her work on the thought of Hannah Arendt, Marieke Borren (2008, 2010) identifies two 'pathologies of in/visibility' (Borren 2010: 151). With reference to, for instance, illegal migrants, refugees and stateless persons, she asserts that individuals belonging to these groups suffer from a public invisibility that is wedded to natural visibility, i.e. they do not gain a standing or voice in processes of public deliberation while their individual and personal traits at the same time become publicly visible markers of identity, political or juridical position. As a result, the stateless, refugees and illegal migrants remain removed from the sphere of appearance. They are articulated within a particular political discourse rather than being able to enunciate their own position. Public invisibility takes away the agency of political subjects and reduces them to sets of natural traits that are articulated in a public sphere of appearance.

Pathologies of in/visibility, for instance, assume a crucial, often disquieting role in the dramatic staging of refugee crises and migrant deaths in the Mediterranean, but also in the discursive framing of terrorism, migration pressures and religious conflict. Due to the pathologies of in/visibility that predispose the border spectacle in the Mediterranean, migrants suffer from a public invisibility that is tied to natural visibility. In this sense, pathologies of in/visibility participate in creating an imaginary for the Mediterranean that is based on simplifying assumptions devoid of historicity and any geographical depth.

Similar assertions are true for the ultimately imagined spaces and subjectivities of presumed terrorists targeted in drone warfare (Gregory 2006, 2010, 2011). Peculiar regimes of in/visibility excessively visualize the alleged enemy in ever-more detailed video footage fed to operators by remote controlled UAVs (Unmanned Aerial Vehicles) creating the impression of an all-encompassing perspective on the Other as such. At the same time, access to competing forms of life that fall outside the pre-established matrices of othering and exclusion are precluded, thereby denying the enemy the form of public visibility that would enable an emergence of their competing perspectives and points of view in the hegemonic discourse. As such, the hegemonic audio-visual borderscape of the global war on terror entails at once a pathologic visibility of one particular version of the Other's complex and dynamic subjectivity – the terrorist – and renders competing and problematizing potentials for identification publicly invisible, thereby denying agency and self-articulation.

Public invisibility combined with natural visibility reduces the Other to a mere object of communication and political performances. In the terms of Mieke Bal (1999: 8–9), Borren's pathologies of in/visibility prevent the emergence of a productive and potentially subversive first-to-second person discourse where the response of the Other actually matters. Instead, public invisibility and natural visibility allow for an objectifying exchange about the Other, who is bound to remain silent – a form of discourse that narrowly frames the Other rather than enabling a potentially subversive form of self-articulation. As such, 'performative encounters' in the sense of Mireille Rosello (2005: 1) that would entail 'the creation of new subject-positions' are precluded. As a consequence, hegemonic discursive frames remain unchallenged and unquestioned.

The relevance of this thought for an analysis of hegemonic and counter-hegemonic audio-visual borderscapes and their relationship with processes of in/visibilization and regimes of in/visibility becomes apparent. The illegal migrant, the refugee, the stateless and, as one might argue, the dis-located presumed terrorist in a global war on terror are all deprived of appearance in the public sphere in the sense of Arendt. At the same time, certain natural traits and individual markers of identity and belonging are to a growing extent articulated in the public sphere by others, as such inviting monolithic forms of identification that apparently unanimously point to a potential threat to the physical, economic or cultural well-being of a given reified collective. By these means, the concept of the hegemonic audio-visual borderscape highlights the form and functioning of an increasingly exclusionary Western politics and economics.

As such, even though they enjoy an at times seemingly ubiquitous visibility across the various channels of globalized mass media, the stateless, the refugee, the illegal migrant and the global terrorist largely remain publicly invisible and are, as such, articulated by others rather than becoming the source of a competing counter-hegemonic discourse. The pervasive visibility of these subjects on a mediated public sphere does not, as such, entail a position of agency or facilitate an inherently inclusive first-to-second person discourse. Rather, it amounts to a form of public invisibility that b/orders the socio-political sphere, the impact of which can only be grasped when extending Arendt's concepts along a crucial axis. This brings us to Rancière's argument regarding an aesthetically afforded progressive form of politics as process that is realized in and through the articulation and inclusion of new, and potentially subversive, alternative subjectivities. The emergence of the Other in the public sphere, the importance of letting the Other speak in a way that matters, can be understood with reference to the Rancièrian idea of politics as process.

Redistributing the Sensible: Politics as Process

In an analysis of a documentary film about migrants in Europe, Sudeep Dasgupta (2008: 182) argues for 'the productive power of visuality' and posits an opposition between Jacques Derrida's suspicion against vision articulated in *The Gift of Death* and Rancière's notion of aesthetics of potentially liberating and progressive. Dasgupta (2008: 189) writes that according to Derrida '[s]eeing the other and assigning him a "proper" place in the confines of a host-guest relationship … undermines the possibility of a non-violent and non-appropriative relationship'. As such, Dasgupta continues '[f]or Derrida, to make the other the object of the eye is precisely to identify and objectify him, to calculate his value within the regime of the Law' (ibid.). The imbalanced relation between host and guest makes it possible for the one to articulate the Other within given hegemonic frames, rather than being exposed to the Other's appearance in a public sphere and the potentially subversive effects of its self-articulation. Dasgupta goes on to enlist Rancière's understanding of the interrelation between politics and aesthetics to redeem the sensible, and vision in particular, as a suitable tool for a progressive and inclusive politics.

Indeed, Rancière (2004a: 39) argues for the imminently political role of an aesthetic regime of the arts, i.e. the particular way through which the arts 'draft maps of the visible, trajectories between the visible and the sayable, relationships between modes of being, modes of saying, and modes of doing and making'. He theorizes the relation between politics and aesthetics as a tension between the policing of a particular distribution of the sensible and a constant struggle of subversive and progressive redistribution. Rancière follows an understanding of aesthetics that is comparable to that of Welsch (1997, 2003). Accordingly, Rancière includes all the human senses when analysing contemporary re/distributions of the sensible. While also being aware of the multi-sensual qualities of his concepts, we will nevertheless direct exclusive focus on the role of the visual in contemporary practices of b/ordering in order to treat one particular sense in sufficient detail.

For Rancière, oppressive politics resembles a form of counting in which community is understood as nothing more than the sum of its parts, where each part plays an assigned function. This is what Rancière calls 'politics as police', where there is constant production and reproduction of a contingent division between relevant and irrelevant, 'grievable' and 'ungrievable lives' (Butler 2009). 'Politics as process', on the other hand, involves the constant inclusion of something new that ultimately prevents the emergence of a sedimented, objectified political structure. As such, constant processes of contingent negotiations and renegotiations replace the reified idea of neatly bounded socio-political entities. Politics as process is, as such, built upon the

articulation and inclusion of 'the demos – the political subject as such' that 'has to be identified with the totality made by those who have no "qualifica-tion". I call it the count of the uncounted – or the part of those who have no part' (Rancière 2004b: 305). While politics as police aims at stabilizing the social body in a particular objectified configuration, politics as process retains the necessarily temporary, partial and precarious nature of any social order and entails continuing processes of re/negotiation on contingent terrain. Hegemonic audio-visual borderscapes create a stabilizing politics of exclu-sion, while counter-hegemonic borderscapes entail the inclusion of new and potentially subversive subjectivities into the constantly evolving realm of the social.

According to Rajaram and Grundy-Warr, 'Rancière demonstrates that society is in process, that the political order is always contingent and that the border between norm and exception, belonging and non-belonging, is in a state of flux and dispute' (2007: xxiv). Political and aesthetic practices 'intro-duce dissensus by hollowing out that "real" and multiplying it in a polemical way' (Rancière 2010: 149). In re-articulating connections between signs and images, these practices let plural borderscapes emerge that 'invent new tra-jectories between what can be seen, what can be said and what can be done' (ibid.).

By combining Arendt's and Rancière's theoretical frameworks in our approach, we guard against recent criticism of Arendt's thought. John Lechte and Saul Newman (2012) alert us to the fact that Arendt's idea of a public sphere of appearance where subjects acquire the right to have rights is inti-mately connected to the nation state that, through processes of exclusion, establishes a public arena where a given reified collective can negotiate its political identity and sets of commonly accepted rules. This way, human rights become 'humanitarian rights' (Rancière 2004b) that are donated to the Other, who consequently is included in a political order solely through its implied exclusion from political rights proper. To avoid this implicit reification of the nation state, Lechte and Newman – drawing on the thought of Blanchot, Esposito, Bataille and Levinas – propose that 'true community must be under-stood as a complete openness to the Other, not as a union of egos ... a com-munity [that] approximates an emergent state ... where the exact outcome (the actual forms of community at a given moment) is indeterminate' (2012: 529).

This post-foundational thought draws attention to the process-oriented and constantly evolving character of the social. In other words, every form of community by necessity remains a partial, precarious and merely tempo-rary result of b/ordering processes in contingent socio-political and cultural terrain. As a consequence, any hegemonic borderscape that gives rise to a temporarily objectified and reified community will necessarily be opposed by

counter-hegemonic discourses and practices of 'dissensus' (Rancière 2010) leading to the eventual subversion and breakdown of the static exclusivity of hegemonic borderscapes. The resulting new hegemonic order, however, will not usher in a utopian era of inclusion, but remains dependent upon its own specific form of in/exclusion that renders it as partial, precarious and temporary as the preceding one.

Audio-visual media play an increasingly important role in such processes of b/ordering and the connected acts of distributing and redistributing the sensible. Consequently, as we have argued earlier in this chapter, it is worth delving into the ways in which audio-visual media participate in the creation and functioning of contemporary borderscapes. In what follows we will explore how audio-visual media promote and support b/ordering processes and the discursive regimes these are interconnected with. In so doing, we will consider the ways through which media technologies are able to affect politics by either supporting and preserving hegemonic regimes of b/ordering and othering or challenging them and fostering counter-hegemonic alternatives to dominant borderscapes of existing regimes of in/exclusion. In this way we connect specific distributions and redistributions of the sensible, in Rancière's terms, to varying forms of public and natural in/visibilities, in the sense of Arendt.

In/Visibilities

Hegemonic audio-visual borderscapes constitute predominantly scopic regimes of the sensible that order the political world in a particular manner. These regimes render certain individuals publicly and naturally in/visible, while at the same time framing the articulations emanating from publicly visible subjects as either significant or negligible. While the distinction between public and natural in/visibility is useful in directing attention towards the exclusory mechanisms that draw a distinction between politically relevant and merely biological life, we suggest also investigating processes of in/visibilization and strategies of in/visibility that cause the contingent discursive framing, not of life as such, but of the political articulations voiced by publicly visible subjects, i.e. the exclusion of formally included groups and individuals, by diminishing their ability to speak publicly. The lives of these individuals, as subjects of the state, still matter and are protected by state apparatuses, yet their competing points of view remain unrepresented. To highlight both these regimes of in/visibilization, we will provide the examples of drone warfare and migrants' audio-visual self-representations.

The examples provided here specifically relate to the third use of aesthetics embraced in this volume. Both drone warfare and migrants' video

self-representations facilitate a consideration of the ways in which audio-visual representations play into processes of bordering, de-bordering and re-bordering that are inextricably interwoven with, and connected to, processes of identification and subject formation. In so doing, our examples also highlight borders as spaces of images and symbols that beg to be analysed and as spaces that divide grievable and ungrievable forms of life. At the same time the cases presented show how borders impact on subjects while also being implemented through the social and cultural performances of subjects (see Introduction).

Hegemonic Dronescapes: Framing the Other in the Kill Zone

In their introduction to a special edition on aerial warfare, Adey, Whitehead and Williams (2011) write that 'practices of air-targeting [are] not merely a product of developments within the technologies of vision, but also of developments within ... wider scopic regimes of visuality ... and other dominant ways of seeing'. Thus, they continue later on, 'refining the object of the target's sights ... also filters out the ethical decisions and orientations' (176–177, 180) that a face-to-face encounter with the Other would entail. Aerial targeting works 'because it subjects its users to a distanced and rational bureaucratic orientation, so that effects of their actions can never fully be realized' (ibid.). These quotations make apparent that the practice of aerial warfare is based on an often implied distinction between relevant and irrelevant life. This distinction is again the result of a complex interplay between military technologies of visualization and discursive techniques of othering that are deployed to violently uphold particular socio-political b/orders and their ensuing regimes of in/exclusion. As such, aerial warfare emerges as one key practice of hegemonic late modern audio-visual borderscapes. We will use the scopic regime of contemporary US drone warfare as an example.

Drone warfare is today the military practice of choice for US governments of either denomination. Greg Miller (2012) asserts that 'targeting lists that were regarded as finite emergency measures after the attacks of Sept. 11, 2001, are now fixtures of the national security apparatus', while Michael Hastings (2012) claims that 'Obama's drone program ... amounts to the largest unmanned aerial offensive ever conducted in military history; never have so few killed so many by remote control'. Hastings (2012) also notes the irony in the fact that in their attempts to defend acts of extra-legal killing, the lawyers of the Obama administration today have recourse to the same emergency law implemented after the September 11 attack that they fiercely condemned when it was employed to legally back the practice of extraordinary rendition and torture in clandestine black sites operated by the CIA during the presidency of George W. Bush.[2]

In a recent speech, President Obama's Assistant for Homeland Security and Counterterrorism, John O. Brennan, articulated the discursive mechanisms of othering and exclusion at play in globalized processes of b/ordering of life. He outlined the 'efficacy and ethics' of drone warfare and commended this practice for its 'surgical precision, the ability with laser-like focus, to eliminate the cancerous tumor called an al-Qaida terrorist while limiting damage to the tissue around it'.[3] In a similar vein of de-humanization President Obama's security advisor Bruce Riedel compares drone warfare to the use of a 'lawn mower' that you have to use 'all the time' to prevent 'the grass' from growing back again (quoted in Miller 2012), while drone operators refer to acts of extra-juridical killings executed via remote control as 'bug splat, since viewing the body through a grainy-green video image gives the sense of an insect being crushed' (quoted in Hastings 2012).

What is interesting in these quotations by high-ranking US government officials and military operators is the interconnection between visibilization and de-humanization. In allegedly wielding the power to make the enemy-Other entirely visible in all its facets and to clearly distinguish it from innocent bystanders, US administration and military personnel presume an elevated enunciatory position that allows for the technologically afforded and culturally mediated objectification of its various opponents as simply evil and, therefore, devoid of rights and of even the most fundamental form of legal protection. As Grégoire Chamayou (2013: 74) puts it, the 'problem [with automated target acquisition in drone warfare] – epistemological as well as political – resides in the alleged capacity to adequately convert an image constructed through a compilation of probabilistic indices into an ascertained status of legitimate target'.[4] As a consequence of this assumed epistemological supremacy (combined with the desensitizing effect of cross hairs and grainy video footage), subsequent acts of killing are framed as both a legitimate and, indeed necessary, means of protecting the American public from what is framed as imminent and deadly threats kept at a safe distance.

However, the metaphors invoked in the citations above also invite a different interpretation. Lawn mower, tissue and bug splat all point toward a certain proximity between the actor and those acted upon. Using a lawn mower one walks on the grass to be cut. Removal of tissue requires the extreme close up of a microscope, while a bug splat implies a direct contact with an insect, or at the least the remains of one. These double meanings, invoking proximity and distance at the same time, direct attention to an increasingly intimate relationship between drone pilots and their victims that is, unintentionally, afforded by the heavily improved resolution of digital imageries 'that bring all those in the network much closer to the killing space' (Gregory 2011: 196). As Chamayou (2013: 165) has observed, in drone warfare 'physical distance no longer with necessity implies perceptual distance'. Rather, the enhanced video

feeds make the remotely deployed violence 'more graphic and more personalized' (ibid.: 166) for drone pilots.[5]

How deadly the threat posed by those blown to pieces via remote control really was, however, is somewhat difficult to assess. Quoting a *New York Times* report on civilian victims of drone strikes, Benjamin (2013: 8) for instance explains that the US administration is only able to claim low casualty figures among civilians as it 'automatically defines as a combatant any male of military age who lives in the area where the US is using drones unless there is explicit intelligence posthumously proving them innocent'. Combined with the increasingly automatized targeting procedures of signature strikes, it becomes apparent that visualizing the enemy is as much about legally and discursively constructing it, as it is about actually making someone visible who was hidden from sight before (Chamayou 2013; Pötzsch 2015a).

Digitally enhanced video footage produced by drones or helicopters in specific local contexts brings into sight the (allegedly hostile) bodies of the Other, yet consistently precludes access to the subjectivities and alternative frames of meaning of these targets from the air. The efficiency of aerial and drone warfare is, as such, predicated upon making visible the bodies of the alleged enemy while at the same time retaining the invisibility of the potentially subversive subjectivities of the Other. In feeding these subject-less imageries into the various channels of global media networks, discursive strategies and technologies of b/ordering are brought into effect that narrowly frame the Other as merely an incomprehensible and dangerous threat. This conjunction of globalized media and imaging technologies with the practice of increasingly automated clandestine aerial warfare serves the policing of a hegemonic distribution of the sensible that makes certain subjects invisible and confines them to the status of ungrievable life that can be taken without juridical or other consequences. In this way aerial warfare becomes a core practice in contemporary hegemonic Western borderscapes.

Similar considerations lead Derek Gregory (2006: 95) to speak of the contemporary late modern battlescape as 'a space of both constructed and constricted visibility' that is embedded in inherently colonial 'imaginative geographies ... that disable any critical politics of witnessing' (ibid.). These imaginative geographies are underpinned by the abstraction and hollowing out of the enemy's various subjectivities, lived spaces and everyday experiences. This hollowing out, again, can be described as a form of making invisible enacted in and through the discursive practices and apparatuses of a hegemonic audio-visual borderscape. As such, aerial warfare creates a 'convenient distance' between 'their' space of chaos and insecurity and 'our' space of sanity and civilization that enables a constant reinforcing of a constitutive division between our own reified identities and hegemonic frames on the one hand, and a confined outside inhabited by the threatening and potentially

subversive enemy on the Other (Gregory 2010: 158). As a practice afforded by a hegemonic borderscape, aerial warfare is predicated upon, and constantly reinforces, particular b/orderings of political and conceptual space that increasingly divide the globe into zones of varying degrees of exceptionality.

According to Gregory (2010: 172–179), processes of zoning in late modern war are realized in and through three intersecting 'spatializing practices' that discursively shape threats, enemies and means of war: locating, inverting and excepting. While the practice of locating plays out on a techno-cultural register and creates the 'abstract space' of a grid that enables the visibilization of the enemy as a target, the practice of inverting takes place within a cultural-political register and gives rise to an alienated space of the enemy-Other that effectively makes competing subjectivities and frames of meaning invisible. Lastly, operating on a politico-juridical register, the practice of excepting creates a legal-lethal space of the exception that renders the Other publicly invisible in the sense of Arendt. Together these practices form a hegemonic borderscape of late modern war that zones political space and divides bodies according to varying degrees of visibility and, thereby, scaled value (Pötzsch 2015a).

The instances of b/ordering life identified above become palpable even in articulations that overtly attempt to oppose the practice of remote warfare. As such, it is not the fact that approximately 800 civilians have been killed in drone strikes during the recent years which has led to a public outcry in the US, but the fact that the CIA had killed one American citizen and Al-Qaida suspect in Yemen in 2011 (Hastings 2012). Apparently, the value of a life is heavily scaled indeed. This scaling is the contingent, yet sedimented, result of the discursive technologies and structures of hegemonic audio-visual borderscapes and the globally dispersed zones of the exception they imply and reiterate.

It appears that 'late modern wars' (Gregory 2010) are embedded in a particular imaginary geography that frames self and Other, asserts juridical or moral rights of intervention, and veils the human and economic costs of military endeavours, as well as denying potential alternative frames that point beyond the narrow confines of a mutually exclusive friend-foe relationship. This is achieved through the deployment of discursive strategies and technologies that do not deny the enemy-Other certain forms of visibility, but narrowly frame their images and articulations as irrelevant, abject or merely a sign of hostile intentions. Such actions suggest the right to kill for the sake of a greater good. In other words, late modern war is predicated upon, and constantly reinforces, hegemonic audio-visual borderscapes that police a particular distribution of the sensible and, thereby, retain the invisibility of the Other as a potential alternative to sedimented hegemonic frames and practices.

Counter-hegemonic Videoscapes: Migrants' Audio-visual Self-representations

We will now direct our attention to counter-hegemonic borderscapes: discursive practices and technologies that articulate alternative subjectivities and points of view and thus afford the potential subversion and replacement of reified and sedimented frames and discursive positions. We will do so with reference to migrants' audio-visual self-representations through participatory video at the Mediterranean Euro/African frontier.

African migrants' video self-representations serve an inclusive political purpose that entails a creative and progressive redistribution of the sensible. These participatory videos can be regarded as the core of a strategy for empowerment and advocacy. Plurivocal migrant agencies of mimicry, *bricolage*, tactical resistance, and nomadic *savoir faire* make visible the previously excluded fates and subjectivities of these migrants and help to insert these into mainstream media discourses and channels. In making visible the publicly invisible complexities of their experiences across the Mediterranean Euro/African borderlands, migrants challenge the invisibility of their lives, and (re)-appear on the public sphere as they act in concert claiming to have the 'right to have rights'. Migrants' participatory videos therefore offer a good example of the way in which audio-visual media can become part of 'a new landscape of the visible, the sayable and the doable' (Rancière 2010: 149).

Migrants' audio-visual self-representations involve resistance strategies that are not simply forms of resistance against 'socio-technological regimes of visibility' (Brighenti 2010: 182). On the contrary, these strategies express novel forms of resistance through visibility. Thus, as parts of counter-hegemonic audio-visual borderscapes these videos contribute to a re-distribution of the sensible that creates migrants as visible subjects out of excluded bare life (Brambilla 2010b). This counter-articulation is based on the agency of invisible subjects who implement strategies of in/visibility as a form of resistance against European Union border and migration regimes across the Mediterranean (Brambilla 2015b). These regimes constitute spaces that are continuously crossed and at the same time remain inaccessible; a space of differential inclusion accessible for someone and uncrossable for others. Accordingly, migrants' acts of being in such a space imply an acceptance of a condition of invisibility while at the same time they point to a deviation from this condition by adopting what can be regarded as strategies of in/visibility. Precisely in articulating their crossing-in-invisibility, migrants in their videos reconstitute themselves as publicly visible subjects (in Arendt's sense) in spite of their institutionalized invisibility. Migrants' agency as such involves a re-distribution of the sensible that creates visible subjects out of publicly invisible illegal border-crossers.

Within this framework, reference can be made to two associations in Italy that, through a number of often interwoven activities and initiatives, offer good examples of migrants' participatory videos focusing on Mediterranean Euro/African borderscapes: the *ZaLab Association* and the *Archivio delle Memorie Migranti* (Archive of Migrant Memories – AMM).[6] Focusing on the work of these two associations, one can come across the life story of the Ethiopian filmmaker Dagmawi Yimer, who landed in Lampedusa at the end of July 2006. After taking part in a participatory video workshop for the first time in 2007, Dagmawi decided to become a professional video-maker. He co-directed (*Like a Man on Earth*, 2008; *Nothing but the Sea*, 2011) and directed (*C.A.R.A. Italia*, 2010; *Va' Pensiero – Walking Stories*, 2013) different films and participated in the production of participatory videos (*The Desert and the Sea*, 2007; *Welcome to Italy*, 2012).

Dagmawi's collaboration with the Archive of Migrant Memories has led to the realization of the participatory video *Welcome to Italy* (*Benvenuti in Italia*, 2012).[7] He directed the video with four other migrants (Aluk Amiri, Hamed Dera, Hevi Dilara and Zakaria Mohamed Alí) after having participated in an audio-visual training workshop promoted by the Archive. What emerges from the film is a new perspective from within the migratory experiences of the authors, who through their stories successfully communicate the human complexity of migrants' experiences, often hidden by mainstream media and political discourses. In addition to recalling the experiences of those who, for the first time, arrived in Italy as migrants, the documentary depicts a country and a welcoming system that is very different from the one that is usually portrayed by the mainstream media, the latter usually displaying just lists of statistics. In this sense, *Welcome to Italy* not only represented a chance for migrants to make their migratory experiences visible, but the participatory video also makes it possible for Italy to know and acknowledge itself through the eyes of migrants. Thus, constituting an important strategy to assert visibility, the visual self-representation of African migrants as seen through participatory video is becoming an increasingly influential tool that can empower migrants, allowing the inclusion of new subjectivities into the changing realm of the social.

Migrants' agency toward empowerment involves creating representations of the self and 'us' that are resistant to the categorical naming determined by EU border and migration policies. These policies ultimately manifest themselves as the misrepresentation of the 'absent agents' (Sousa Santos 2001), meaning that the biographies of migrants are often ignored or denied. In this regard, Dagmawi stated in an interview that 'migrants are often perceived as passive. They are regarded as the object of representation. On the contrary, participatory video enables migrants to free themselves of the constriction to be the object of representation and they can move from the role of being observed to the role of being active narrators'.[8]

Following this, migrants' participatory videos are a useful tool for high-lighting another theme that is crucial for the emergence of counter-hegemonic audio-visual borderscapes while contributing to a redistribution of the sensible: the 'emancipated spectator' (Rancière 2009). Emancipation is possible since migrants' participatory videos highlight the fact that the spectator can also act, thereby becoming an active narrator of her own story. Specifically, video self-representation offers the opportunity for emancipation since it challenges the opposition between viewing and acting while showing that 'the self-evident facts that structure the relations between saying, seeing and doing themselves belong to the structure of domination and subjection' (Rancière 2009: 13). Thus, migrants' participatory videos point to the capacity of contemporary border subjects to enact new strategies of in/visibility, which enable them to move from a position of passive spectators to that of active agents telling their stories.[9]

Consequently, migrants' participatory videos can act as a force that has transformative potential for modern thought, culture, society, self-identity, memory and social science. In this regard, it is worth mentioning the ways in which the distribution of participatory videos is organized. The Archive of Migrant Memories and ZaLab deal with the distribution of the documentaries to the public or private organizations (associations, municipalities, ONGs, universities, local cinemas, and so on) that are interested in screening the videos and discussing them during public events. These organizations have the chance to rent these documentaries for free, with the only condition being that the event organizers are willing to invite at least one of the authors at their expense. This video distribution strategy is useful, because it ensures the presence of the authors at each screening, while creating a space for one of the storytellers to encounter, engage with, and discuss their stories with their Italian and migrant audience members. It is also important to note that there has been an increasing number of requests from many schools and other educational organizations for video projection and discussion. Furthermore, Italian newspapers and news media have been showing greater interest in these participatory video projects. After the release of *Welcome to Italy* on Holocaust Memorial Day (27 January 2012), some columns and articles on the documentary were published by *La Repubblica* (27 January 2012) – one of the most widely circulated daily newspapers in Italy – as well as by other relevant newspapers and journals (*Internazionale*, 25 January 2012; *Corriere del Mezzogiorno*, 25 January 2012; *Cinemaitaliano*, 30 January 2012). The Italian national newscasts on RAI3 – TG3 – has devoted attention to the release of the film, and Radio3 – an Italian national broadcasting service – has presented a debate on the documentary in a show entitled *Zazà*.

What is particularly relevant is the fact that the experiences of Dagmawi and other migrants bring attention to the ways in which participatory video

can empower migrants by rearticulating the locus of power within individuals, communities and ultimately politics. Participatory video is a social strategy of advocacy and a deliberate process that brings about incremental change. Thus, individual empowerment is perhaps the first step to political transformation since it brings about collective advocacy. In this regard, it is worth mentioning what Dagmawi argued in an interview made by one of this chapter's authors with him in 2012:

> Participatory video highlights that it is important to tell personal migration stories in order to tell the story of contemporary migration. … What is worth considering then is the political effect of video making: one is committing himself to a wider political action. This experience does not involve only me, Dag, as director of the video, but it cannot but cause political consequences that is to say, collective consequences. This is the reason why I decided to tell my personal migration story and my pain. There are no other reasons.[10]

In this sense, migrants' participatory videos illustrate the function of Rancieran politics as process, 'the activity that breaks with the order of the police by inventing new subjects' (Rancière 2010: 139). According to Rancière, 'politics [as process] invents new forms of collective enunciation; it re-frames the given by inventing new ways of making sense of the sensible, new configurations between the visible and the invisible'. Such politics as process begins when 'what was deemed to be the mere noise of suffering bodies' can be 'heard as a discourse concerning the "common" of the community' (Rancière 2010: 139). Taking this one step further, we can argue that migrants' participatory video is an audio-visual way of constructing new relationships between reality and appearance, the individual and the collective. For this reason, migrants' video self-representations can be located in the very heart of the interaction between what Rancière calls respectively the 'aesthetics of politics', which 'lies in the re-configuration of the distribution of the common through political processes of subjectivation', and the 'politics of aesthetics' lying 'in the practices and modes of visibility of art that re-configure the fabric of sensory experience' (ibid.: 140–141).

In/Visibilities: The Dialectics of Blindness and Seeing

In the present chapter we have argued for an interconnection between aesthetics, politics and seeing. Borders are contingent objects – subjected to constant negotiation and change – that determine temporary orders. All possible orders are dependent on borders and therefore on an implicitly constitutive outside, 'where be dragons'. To retain its stabilizing function this outside has been at once excessively visualized as all that which we are not, and carefully

veiled to hide potentially threatening, disruptive alternatives. The present chapter introduced the concept of the hegemonic borderscape to account for this particular logic of constitutive exclusion through in/visibilization. Counter-hegemonic borderscapes, on the other hand, employ various forms of visibilization to enable the emergence of this outside within the naturalized frames of established orders, thus destabilizing and potentially subverting them. Drawing upon advances made by Hannah Arendt and Jacques Rancière, we developed a language with which to grasp these processes as the contingent and constantly evolving result of a tension between politics and pathologies of in/visibility and the struggles for a distribution and redistribution of the sensible. Borders, as such, emerge as intimately interwoven with the senses and therefore with aesthetic objects and practices.

Finally, we want to briefly relate the ideas advanced in the present chapter to what Boaventura de Sousa Santos (2001) terms an 'epistemology of blindness'. In his terms, this epistemology represents a hegemonic form of knowledge that facilitates a contingent b/ordering of the world by tacitly predisposing what can be seen or heard and what cannot. An epistemology of blindness as constitutive of a particular form of in/exclusion emerges as intrinsically connected to particular pathologies of a politics of in/visibility. The particular distribution of the sensible of a certain contingent order undermines the opportunity of various groups and individuals to live a life of active political participation – a *vita activa*. Instead, the epistemology of blindness and its discursive regimes and apparatuses 'have reduced the variety and wealth of social agency to two types of individuals – docile bodies and strangers – neither of which is fit to sustain a social practice based on knowledge-as-emancipation' (Sousa Santos 2001: 272). In this sense, pathologies of in/visibility manifest themselves as the public invisibility and natural visibility that form 'ubiquitously absent' agents (Pötzsch 2013), the life stories of which are ignored and denied, and the articulations of which are framed as merely denoting arbitrary and baseless threats grounded in evil intentions, rather than signifying alternative frames of seeing, thinking and doing that point to the ultimate contingency of the social.

However, the concepts and strategies of in/visibility elaborated in this chapter can point to a way of advancing from an epistemology of blindness towards an epistemology of seeing. Counter-hegemonic audio-visual borderscapes invite the subversion of existing border regimes through strategies of in/visibility that include formerly excluded subjects, positions and articulations in the public discourse, and that potentially threaten the stability of pre-established hegemonic frameworks. Thus, an epistemology of seeing constitutes an enabling precondition for potentially subversive 'performative encounters' (Rosello 2005) with the previously confined other (Brambilla 2015b). This entails, in the words of Sousa Santos (2001: 270), 'the invention

of a new emancipatory common sense based on a constellation of knowledges oriented towards solidarity' – not with the objective of establishing a final utopian order of ultimate inclusion, but of keeping in motion the constant processes of negotiation and renegotiation of the social in a contingent political terrain, i.e. a constant process of b/ordering that retains the ultimate indeterminacy and temporariness of any possible regime of in/exclusion, and that ensures a non-violent transition between them.

Chiara Brambilla, PhD, is Research Fellow in Anthropology and Geography at the University of Bergamo, Italy. Her research focuses on anthropology, critical geopolitics and the epistemology of borders; the Mediterranean border-migration nexus; borders in Africa; colonialism and post-colonialism. She has published extensively in her research focus areas within Italian and international journals and volumes. She has edited, with J. Laine, J. Scott and G. Bocchi, the volume *Borderscaping: Imaginations and Practices of Border Making* (2015 in the Border Regions Series with Ashgate). She is Associate member of the Nijmegen Centre for Border Research (NCBR), Radboud University Nijmegen, the Netherlands; member of the Association for Borderlands Studies (ABS) and of the African Borderlands Research Network (ABORNE).

Holger Pötzsch, PhD, is Associate Professor in Media and Documentation Studies at UiT Tromsø, Norway. His research focuses on the war film, war games, and the role of culture and technology in politics. He has published in journals such as *Environment & Planning D: Society & Space, New Media & Society, Games & Culture, Nordicom Review*, and the *Journal for Borderlands Studies*.

NOTES

1. For the consequences of this line of thought for identity politics and collective formation of interests in democracies, see, for instance, Hammer 1997 and in particular Borren 2010: 207–236.
2. For a detailed account of the Obama administration's drone programme in Pakistan, see for instance IHRCRC and GJC 2012.
3. Full speech retrieved on 8 March 2016 from http://www.wilsoncenter.org/event/the-efficacy-and-ethics-us-counterterrorism-strategy#.
4. Translation by Holger Pötzsch. The French original reads: 'Mais tout le problème – problème épistémologique, problème politique – réside dans cette capacité revendiquée de convertir adéquatement une image construite par compilation d'indices probables en statut certain de cible légitime'.

5. Translation by Holger Pötzsch. The French original reads: 'La distance physique n'implique plus nécessairement la distance perceptive' Chamayou 2013: 165 and 'ne rend plus ici la violence plus abstraite ou plus impersonelle, mais au contraire, plus graphique et plus presonnalisée' ibid.: 166. For more on the technologically afforded intimacy of late modern warfare, see Pötzsch 2015b: 88–89.

6. For more details about the ZaLab Association and the Archive of Migrant Memories, see http://www.zalab.org/ (accessed on 8 March 2016) and http://www.archiviomemoriemigranti.net/ (accessed on 8 March 2016).

7. See http://www.archiviomemoriemigranti.net/filmgallery/show/1206 (accessed on 8 March 2016).

8. Interview with Dagmawi Yimer by Chiara Brambilla, 11 February 2012. The recorded text of the interview was translated from Italian by Chiara Brambilla.

9. These reflections lead us to consider another important feature of the borderscape, that is to say its ability to bring together representations and practices. This highlights the fact that 'the construction of borders "takes place" through representations, through performative acts, through acts of narration, visualization, and imagination including their interpretations – and can be conceived as borderscaping' (Strüver 2005: 170). In so doing, the borderscape allows us to move beyond the often criticized gap between representations and practices, by bringing the concept of performativity into the foreground. See Strüver 2005: 167–170 on the interrelations between representations and practices with particular reference to the Dutch-German borderscape.

10. Interview with Dagmawi Yimer by Chiara Brambilla, 11 February 2012. The recorded text of the interview was translated from Italian by Chiara Brambilla. On the role of audio-visual technologies and devices in mediating memories in a global age, see Van Dijck 2007.

BIBLIOGRAPHY

Adey, P., M. Whitehead and A.J. Williams. 2011. 'Introduction: Air-Target: Distance, Reach and the Politics of Verticality', *Theory, Culture and Society* 28(7–8): 173–187.

Arendt, H. 1958. *The Human Condition*. Chicago: The University of Chicago Press.

Bal, M. 1999. 'Introduction', in M. Bal (ed.), *The Practice of Cultural Analysis. Exposing Interdisciplinary Interpretation*. Stanford: Stanford University Press, pp. 1–14.

Benjamin, M. 2013. *Drone Warfare. Killing by Remote Control*. London: Verso.

Borren, M. 2008. 'Towards an Arendtian Politics of In/Visibility: On Stateless Refugees and Undocumented Aliens', *Ethical Perspectives: Journal of the European Ethics Network* 15(2): 213–237.

———. 2010. 'Amor Mundi. Hannah Arendt's Political Phenomenology of World', PhD dissertation. Amsterdam: Faculty of Humanities, University of Amsterdam.

Brambilla, C. 2010a. 'Borders Still Exist! What Are Borders?', in B. Riccio and C. Brambilla (eds), *Transnational Migration, Cosmopolitanism and Dis-located Borders*. Rimini: Guaraldi, pp. 73–85.

_____. 2010b. 'Pluriversal Citizenship and Borderscapes', in M. Sorbello and A. Weitzel (eds), *Transient Spaces. The Tourist Syndrome*. Berlin: argobooks, pp. 61–65.

_____. 2015a. 'Exploring the Critical Potential of the Borderscapes Concept', *Geopolitics* 20(1): 14–34.

_____. 2015b. 'Navigating the Euro/African Border and Migration Nexus through the Borderscapes Lens: Insights from the *LampedusaInFestival*', in C. Brambilla et al. (eds), *Borderscaping: Imaginations and Practices of Border Making*. Farnham: Ashgate, pp. 111–121.

Brighenti, A.M. 2010. *Visibility in Social Theory and Social Research*. Basingstoke: Palgrave Macmillan.

Butler, J. 2009. *Frames of War. When is Life Grievable?* London: Verso.

Chamayou, G. 2013. *Théorie du drone*. Paris: La Fabrique éditions.

Dasgupta, S. 2008. 'The Visuality of the Other: The Place of the Migrant between Derrida's Ethics and Rancière's Aesthetics in "Calais: The Last Border"', *Thamyris/Intersecting* 19: 181–194.

Gregory, D. 1994. *Geographical Imaginations*. Cambridge, MA: Blackwell.

_____. 2006. '"In Another Time-Zone, the Bombs Fall Unsafely…": Targets, Civilians, and Late Modern War', *The Arab World Geographer* 9(2): 88–111.

_____. 2010. 'War and Peace', *Transactions: Journal of the Royal Geographic Society* 35: 154–186.

_____. 2011. 'From a View to a Kill: Drones and Late Modern War', *Theory, Culture, and Society* 28(7–8): 188–215.

Hammer, D. 1997. 'Hannah Arendt, Identity, and the Politics of Visibility', *Contemporary Politics* 3(4): 321–339.

Hastings, M. 2012. 'The Rise of Killer Drones: How America Goes to War in Secret', *Rolling Stone*, 26 April 2012. Retrieved on 8 March 2016 from http://www.rolling stone.com/politics/news/the-rise-of-the-killer-drones-how-america-goes-to-war-in-secret-20120416.

International Human Rights and Conflict Resolution Clinic at Stanford Law School and Global Justice Clinic at New York University School of Law. 2012. 'Living under Drones. Death, Injury, and Trauma to Civilians from US Drone Practices in Pakistan'. September 2012. Retrieved on 8 March 2016 from http://chrgj.org/wp-content/uploads/2012/10/Living-Under-Drones.pdf.

Lechte, J. and S. Newman. 2012. 'Agamben, Arendt, and Human Rights: Bearing Witness to the Human', *European Journal of Social Theory* 15(4): 522–536.

Miller, G. 2012. 'Plan for Hunting Terrorists Signals U.S. Intends to Keep Adding Names to Kill Lists', *Washington Post*, 23 October 2012. Retrieved on 8 March 2016 from http://articles.washingtonpost.com/2012-10-23/world/35500278_1_drone-campaign-obama-administration-matrix/4.

Olwig, K. 1993. 'Sexual Cosmology: Nation and Landscape at the Conceptual Interstices of Nature and Culture, or: What Does Landscape Really Mean?', in B. Bender (ed.), *Landscape: Politics and Perspectives*. Oxford: Berg, pp. 307–343.

_____. 2008. 'Performing on the Landscape versus Doing Landscape: Preambulatory Practice, Sight and the Sense of Belonging', in T. Ingold and J.L. Vergunst (eds), *Ways of Walking. Ethnography and Practice on Foot*. Aldershot: Ashgate, pp. 81–91.

Pötzsch, H. 2013. 'Ubiquitous Absence: Character Engagement in the Contemporary War Film', *Nordicom Review* 34(1): 125–144.

_____. 2015a. 'The Emergence of iBorder: Bordering Bodies, Networks, and Machines', *Environment & Planning D: Society & Space* 33(1): 101–118.

_____. 2015b. 'The Emergence of iWar: Changing Practices and Perceptions of Military Engagement in a Digital Era', *New Media & Society* 17(1): 78–95.

_____. 2015c. 'Art across Borders: Dislocating Artistic and Curatorial Practices in the Barents Euro-Arctic Region', *Journal of Borderlands Studies* 30(1): 111–125.

Rajaram, P.K. and C. Grundy-Warr. 2007. 'Introduction', in P.K. Rajaram and C. Grundy-Warr (eds), *Borderscapes: Hidden Geographies and Politics at Territory's Edge*. Minneapolis: University of Minnesota Press, pp. ix–xl.

Rancière, J. 2004a. The *Politics of Aesthetics*, trans. G. Rockhill. London: Continuum.

_____. 2004b. 'Who Is the Subject of the Rights of Man?', *South Atlantic Quarterly* 103(2–3): 297–310.

_____. 2009. *The Emancipated Spectator*, trans. G. Elliott. London: Verso.

_____. 2010. *Dissensus. On Politics and Aesthetics*, trans. S. Corcoran. London: Continuum.

Rosello, M. 2005. *France and the Maghreb: Performative Encounters*. Gainesville: University Press of Florida.

Sousa Santos, B. de. 2001. 'Toward an Epistemology of Blindness. Why the New Forms of "Ceremonial Adequacy" neither Regulate nor Emancipate', *European Journal of Social Theory* 4(3): 251–279.

Strüver, A. 2005. Stories of the 'Boring Border': the Dutch-German Borderscape in People's Minds. Berlin: LIT Verlag.

Van Dijck, J. 2007. *Mediated Memories in the Digital Age*. Stanford: Stanford University Press.

Van Houtum, H., O. Kramsch and W. Zierhofer (eds). 2005. *B/Ordering Space*. Aldershot: Ashgate.

Webster, N. and F.B. Gove (eds). 2000. *Webster's Third New International Dictionary of the English Language, Unabridged, and Seven Languages Dictionary*. Springfield, MA: Merrian-Webster.

Welsch, W. 1997. *Grenzgänge der Ästhetik*. Stuttgart: Reclam Verlag.

_____. 2003. *Undoing Aesthetics*. London: SAGE.

►• 4 •◄

Palimpsests

Nadir Kinossian and Urban Wråkberg

The concept of palimpsest is used in this chapter to interpret symbolic landscapes, public spaces and signs in Norwegian-Russian and Lithuanian-Russian borderlands. The cultural palimpsest is based on an analogy with the original concept of a palimpsest as a palaeographic object created by the recycling of scarce parchments of vellum used for writing books in the medieval period. Chemical agents were applied to bleach away the original text of the parchments to be re-used and an apparently unrelated new text was written and illuminated on it. Over time, the pigments and ink of the old text wandered or 'bled' back on to the surface of the parchment causing the new and the old texts to merge together into a confused but often still readable double narrative of texts.

Sarah Dillon's seminal work *The Palimpsest* (2007) explores the questions of reading in its broad sense using the palimpsest as a research lens to interrogate 'the way in which we read texts (be they historical, literary, critical, theoretical, political, cultural, etc.)' (Dillon 2007: 3). The palimpsest is viewed as 'an involuted phenomenon where otherwise unrelated texts are involved and entangled, intricately interwoven, interrupting and inhabiting each other' (ibid.: 4). When applied to a text, the palimpsest entails a perceptual shift whereby the palimpsestic text

> is no longer regarded as a layered phenomenon in which the hidden text is of the only significance, and can be uncovered and separated from the layer it lies beneath. Rather, the perception of the text as 'something woven' corresponds to the figuration of the palimpsest as a surface phenomenon in which two or more texts are inextricably entangled and intertwined. (Dillon 2007: 82–83)

This analogue can provoke further theoretical reflections on intertextuality and on the continuity between the past and the present. In the modern world the traditional notions of past and history have been revised: 'national traditions and historical pasts are increasingly deprived of their geographic and political

groundings ... The form in which we think of the past is increasingly memory without borders rather than national history within borders' (Huyssen 2003: 4). As the previously stable links between the past, the present and the nation state have eroded, there is a need to develop new approaches to understanding the past as constructed by actors who apply aesthetical judgement and imaginaries while selecting elements of the past worth remembering or forgetting.

Great social change is often seen as a process of modernization or revolution in which posterity is believed to break away more or less completely from the past. In reality it has proved difficult to melt down traditions and identities. Attempts to keep social institutions intact over time in a stable hegemonic order have also proved utopian. Expanding and rebuilding material infrastructures is hampered by the sheer capital costs of investments. Likewise, changing mentalities requires different but equally heavy investments. Therefore, re-cycling, reinterpreting and repackaging pre-existing structures, symbols and landscapes often appears to be a more viable way forward, even if the idea of novelty is actively promoted (Czepczyński 2008; Gerlach and Kinossian 2016).

In the metaphorical model of our border-aesthetic palimpsest, it is never a pure coincidence what texts are superimposed on each other, because the succession of layers always mirrors the broader context of historical change. Interpreting the blending of styles and aesthetical effects, e.g. in architectural objects, as a palimpsest of what seems new while still permeated by allusions to the past, facilitates seeing the actual closeness and function of the relationships of the layers and the reasons for the 'return of traditions' often believed/ wished dead (Dillon 2007). In a similar vein, when applied to symbolic landscapes, the palimpsest can shed light on interactions between the past and the present. Historical layers are often perforated, with underlying layers shining through later sediments. Although these layers may not be connected, the emerging picture is ambiguous and contradictory and provokes further thoughts about possible linkages, interdependencies and continuities between them.

Those layers are not entirely defined by, or totally reducible to, 'historical epochs' such as socialism or post-socialism, but are the result of diverse localized processes. In a seminal study, Paasi (1996) demonstrated the connections between personal, regional and national histories and national identity and the perception of space and borders. By studying a small community on the Finnish-Soviet/Russian border, Paasi explored the social construction of 'we-ness' and 'Other-ness' at the local level. At the centre of the study is the notion of 'socio-spatial consciousness' that marks the community's perception of spatial belonging. The socio-spatial consciousness is formed organically in everyday practices and reinforced through education, culture, politics, economy, administration, communication, etc. (1996: 66).

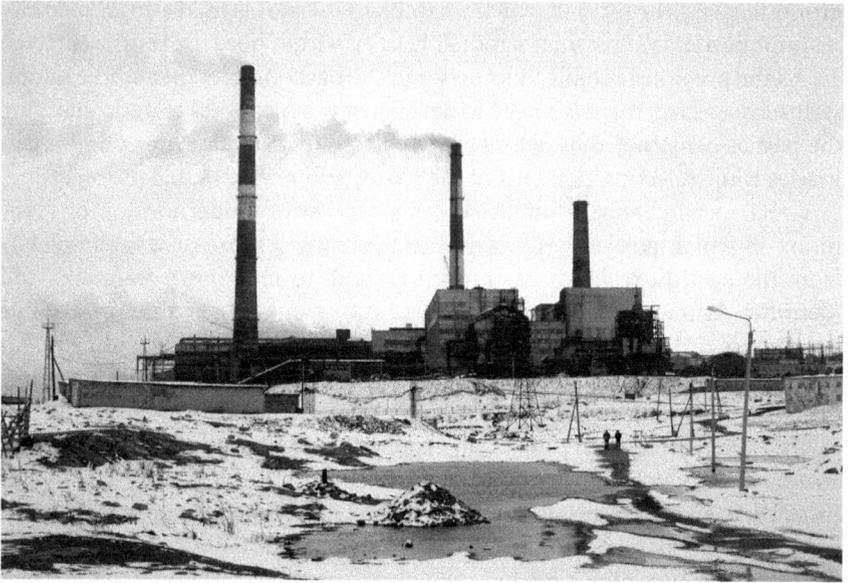

Figure 4.1 The Kolosjoki nickel smelter in the Russian mono-town of Nikel near the border with Norway. Photo by Urban Wråkberg in 2015. Used by permission.

Critical geopolitics and comparative border studies have focused on new social and economic aspects of bordering and the borderland, beside the national and political ones. These predominantly West European research communities have also paid some attention to northern Fennoscandinavia and its borderlands with Russia and suggested innovations such as border zone visa, cross-border twin-towns, and even special economic zones. But the sluggish development of EU-Russian relations in general has hampered such local initiatives (Wråkberg 2009, 2012).

New economic and political realities require new symbolic expression. During the socialist period, Soviet architecture served the goals of propaganda directed towards both internal and external audiences. After the collapse of state socialism, architecture faced new challenges, including strengthening national identities through new symbols of nation and statehood (Anacker 2004; Sir 2008). Architectural monuments always reflect the structure of power in the society and cannot be analysed independently from the social and political factors affecting its production and use (Vale 2008). The 'carved in stone' societal processes make cities, public places and buildings essential for understanding history and political, economic and social changes. Buildings, as 'the visible embodiment of the invisible', manifest and represent certain values and identities (Leach 2002: 88).

It is common in archaeology to refer to a cumulative palimpsest when considering cases where older intact or partly eroded buildings have been reused and enlarged without any active attempts to destroy the original structure (Bailey 2007). The textbook example of this is Angkor Wat, a large Hindu temple in Cambodia, constructed during the Khmer empire in the early twelfth century AD which was rebuilt and enlarged towards the end of that century into a Buddhist shrine. In Russia, a mosque was recently 'resurrected' inside the Russian-built Kazan Kremlin, with the purpose of celebrating the Tatar history of the pre-Russian period and mirroring the current ethnic and religious diversity of the region (Kinossian 2012).

This chapter uses the post-Soviet elements of the Norwegian-Russian and Lithuanian-Russian borderlands to trace the border aesthetic effects within these landscapes. We will apply the concept of palimpsest and the cumulative palimpsest to interpret symbolic sites, monuments, architecture and infrastructure in post-Soviet Russia and post-Cold War Norway and Lithuania. We will draw attention to the process of scalar zooming on the post-Soviet borderlands – from the global to the local and back – not least in forecasts on their politico-economic futures. We will also discuss the social 'negotiation' around the legitimacy in the public eye of any appropriation of aesthetic and ideological elements of the Euro-Arctic cultural palimpsest for new purposes. The credibility of posing as successor in providing, for example, social responsibility, or in following the tradition of European integration, seems to depend on successfully negotiating public acceptance for the acts of appropriating and re-shaping ideals of the past.

The Russian Northwest

The 'opening' up of the militarized Arctic met with consternation at first. Its contested spaces accommodated pre-existing borders, networks of infrastructure, cities and settlements with different economic rationales and symbolic meanings. Within the Euro-Arctic, contested space, and the scaling and nestedness of symbolic resources used by various entrepreneurs and interest groups are rarely discussed. Powerful imaginaries have been used in alarmist and optimistic scenarios alike, in business lobbying and marketing in attempts to gain credibility and support among important stake-holders, policy-makers and the general public. The aesthetics of spaces, structures and buildings, including ruins and lacunas, provide sensible components in this. This is not to say that these are the same among different groups or individuals; aesthetic impacts are under constant production, especially so in the borderland, in its utopian and dystopian border-zones, and in the minds of its residents, border-crossers and tourists. Post-Soviet spaces and ideals play

a paradoxical role in the contemporary construction of cultural and societal symbols. This process is compelled materially, but is also ideologically motivated, in its reuse of structures from a common political, cultural and material palimpsest. But palimpsesting contemporary cultural signs on to the surface of society from such a past has proved unworkable in terms of social popularity and economic viability.[1]

In Russia, the attempts to critically rework the Soviet past have not been successful, and, as we will show in the following, the official narratives of the past have swung from denial to hailing it and relabeling some of its elements as modern and desirable. Elsewhere in the new borderlands of northern and central Europe, recent shifts in regional politics and economic outlooks have entailed not only the superimposing of new neoliberal approaches, but also a re-negotiation of earlier symbols and metaphors identified with the pre-Second World War integration of the Nordic and Baltic states into a multi-cultural Europe based on open networks of knowledge, capital and labour.

During the Soviet period, the Arctic held a prominent place in the USSR's mythic landscape. The discourse on conquering the Arctic implied bringing progress and the light of civilization to the most remote wilderness. The heroic Soviet people were destined to overcome the hostile conditions and to extend the boundaries of communism into the Arctic frontier (McCannon 1998). The Russian northwest has always held a special position in Russia because of its proximity to Western Europe and its direct sea-links to the world's oceans from its year-round ice-free ports on the Atlantic. During the pre-industrial period, its cross-border trade with neighbouring sub-Arctic Fennoscandinavia developed, based solely on regional initiatives, while during the USSR and especially the Cold War period the region and its ports were of important domestic industrial and military strategic significance which for many decades isolated it from the West (Jackson and Nielsen 2005; Wråkberg 2013).

Within the Soviet 'colonial' paradigm, the traditional tasks of the northern borderland administration were to send reports, taxes and raw materials to the national centres and from there receive plans, investment and labour (Kryukov and Moe 2006: 127). Remote border towns remained terminal points of the extensive communication network stretching from the centre, but at the same time, they formed the façade of the Soviet state oriented towards its neighbours. This outward/inward terminus status of the Euro-Arctic borderland was perceived differently by the local sub-cultures of indigenous peoples and other migrants and permanents settlers.

As a result of the market reforms of the 1990s, the mind-set in the political centres changed, and the North came to be viewed as a costly burden to the shrinking economy. As reforms have progressed, profit and loss have become a key factor in the new spatial division:

> One part, 'the profitable North', consists of the areas rich in oil, gas, and minerals ... The other, 'the unprofitable north', is the one currently dependent on state transfers. Instead of the hitherto across-the-board subsidizing of the North, the government has argued that incentive schemes and federal programs should be targeted, unprofitable settlements scaled down or liquidated altogether, and resources focused on developing economically viable industries. (Blakkisrud 2006: 38–39)

Nonetheless, the Russian north still relies on the extractive industries it has inherited from Soviet times. Several old mines and metallurgical combines have been integrated into large business conglomerates under the new ownership of Moscow and St Petersburg-based 'oligarchs'. Today the northern Russian counties depend to a large extent on tax incomes collected from such enterprises. This has led to social and ideological 'negotiation' regarding the repossession of economic assets by the new owners. They try to present themselves not only as a source of tax revenues for the government but also as providers of local income, opportunities, social services, and a cohesive social structure under conditions of monetization of state benefits and the liberalization of the welfare regime. In the absence of a unifying ethnic and national identity, these new agents actively employ the rhetoric and civic symbols of the socialist past in an attempt to strengthen their positions. After the abrupt termination of the Soviet planned economy, the new oligarch and Kremlin-dominated larger cooperations have created a cumulative palimpsest by inscribing their regime on the contemporary landscape between still visible post-Soviet spaces and monuments that have been restored and re-painted by the new rulers.

The disintegration of the USSR has set in motion the processes of regionalization. Within the country, Russia's constitutive regions proved to be strong 'building blocks' for a renewed federation. Although the contours of the majority of regions have remained intact, the content has transformed dramatically. Regional elites have made efforts to acquire political power and control over the economy using various means, including symbolic ones. Russia's ethnic republics were most successful in building sub-national states through bargaining deals with the federal authorities (Castells and Kiselyova 2000).

The processes of political and economic restructuring and of regionalization and internationalization have transformed place identities within the region. In post-socialist cities the urban landscape is being transformed to serve new economic and social realities. At the same time, the persistence of old Soviet imagery is clearly observable. Monuments and slogans celebrating selfless labour, sacrifice and commitment seem to be as present as they were during the state socialism era. Monuments dedicated to the Great October Revolution and the Great Patriotic War (1941–1945) retain their

central positions in the cityscape whereas very little has been done to represent the collapse of state socialism or to celebrate new values except, possibly, for the utilitarian logic of Western-style consumerism. These processes raise questions about the nature of the cultural change and the authenticity of the emerging urban landscape.

The Aesthetics of Folding Borders

Over the centuries Russian statesmen and later Soviet planners tried to establish control over the vast region of the Arctic, to grasp the distances between sparsely located settlements, and to envision ways to manage its logistics, yet many of those grand plans have failed. Local people have tried more modestly to set up functional regional systems. Nevertheless, the planetary, centre-periphery model of the relationship between the national metropolitan core and the northern periphery still seems to be most relevant today.

A usage of new flexible border-concepts can be noticed, including borderlines which may transcend existing political boundaries. These could be frontiers of exploitation of oil and gas deposits but also of widening environmental concerns, or frontiers which enable the union of divided ethnic communities. They all owe some of their persuasive power to the maps on which these scenarios are reproduced. Using the palimpsest as a lens, the observer is able to see both reactionary and revisionary actions, labelled according to the preferences of the observer and by their diffuse patterns from a forgotten past. Communities strengthen their identities and form borders capable of overlapping and diffusing across national boundaries by exploring business opportunities, expanding scientific and cultural collaboration, or searching for models for political consensus. The post-Cold War transition has created new opportunities for urban and regional development projects associated with economic restructuring and the availability of capital from both the public and private sectors. The dramatic political, economic and social transformations in post-socialist countries have created demand for new types of buildings, urban spaces, new spaces of worship, new symbolic meanings – but how new are these?

The former Cold War, now the Schengen, borderland between northern Norway, Finland and Russia contains structures with symbolic meanings. These have sometimes been modified and re-claimed for new purposes, or scheduled for demolition, but most often they have slowly faded from public attention and their relevance has been allowed to erode into ruins. Among these structures are obsolete border guard towers, war memorials or houses of historic interest, such as the one where the first man in space, the USSR hero cosmonaut Yuri Gagarin, and his family once lived in Luostari.

Some innovations in the use of border security paraphernalia made during the turbulent 1990s would not be accepted if proposed today, for instance the cross-border environmental reserve in the Pasvik river valley (in the *Rayakosky zapovednik* [natural reserve]), where scores of international bird enthusiasts are offered look-outs over the sanctuary in disused border guard surveillance towers.

Until recently, commercial development in the border town of Kirkenes was fuelled by the flow of Russian shoppers. New symbols of consumerism are still prevalent; the shopping malls, refurbished boutiques in old worn-down houses, continental bars and the restaurants in Murmansk are all replicated in a smaller scale in the company towns of Kirkenes, Zapolyarny and Nikel. The border-crossing station between Norway and Russia has been modernized. A cumulative palimpsest is developing where local oligarch-owned mining companies contribute to the maintenance of an existing public building of Soviet origin. By doing this and by supporting local culture, they prove their willingness to be seen as the socially responsible successors of the old USSR organizations.

In the process of renovating and expanding local housing and public spaces, many Soviet symbols have been upheld. By being kept they are consciously made part of various architectural and social palimpsests. Their appeal to local citizens is based on their identification with the idea of a good life, both past and present up-North. Nevertheless, the number of employees of these northern mines and metallurgical plants was cut quite considerably during Russia's neoliberal transition of the 1990s. The concept of palimpsest implies that images, layers from the past remain and become re-engaged within a modern context. New elites have failed to create a new symbolic layer or new imagery; instead they have happily used what was inherited from the Soviet era. This manifests itself also in the continued use of socialist slogans of labour heroism on signs and facade paintings facing the streets of northern company towns. The old Soviet ritual of giving prizes to the best workers remains in use. The Russian industrial management thus employs patronizing practices and presents itself as caring about workers, children, the elderly, etc. The contemporary elites have obviously failed to construct an entirely new symbolic foundation to provide social cohesion; instead they have resorted to re-using various items in the regional palimpsest. They acted as *bricoleurs*, taking the materials at hand to create a coherent narrative of tradition, memory and history (Forest and Johnson 2002: 542).

In the mining town of Barentsburg, located on the archipelago of Svalbard, Norway, and operated by the Russian State Trust 'Arktikugol', Soviet monuments and imagery also seem to be highly appreciated and well maintained. The distinctively Soviet look of the town has recently made it a major tourist attraction. During the navigation season, daily boat trips bring dozens of

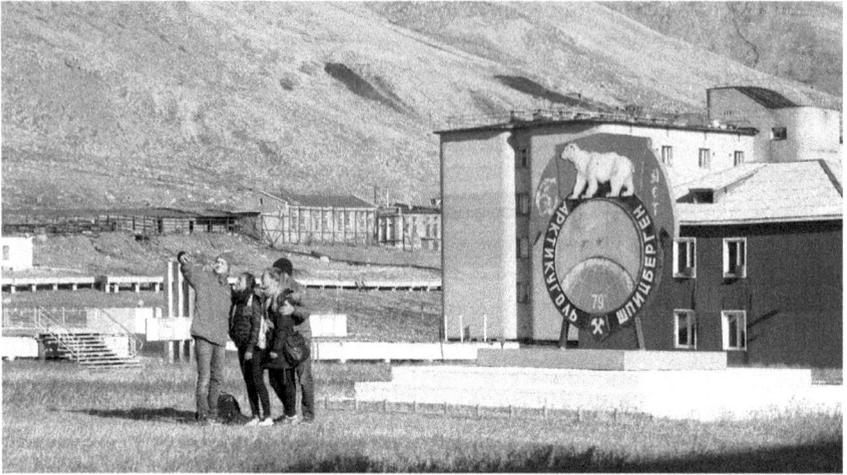

Figure 4.2 Tourists taking selfies in front of the Trust 'Artikugol' company emblem in the former mining town of Pyramiden on Svalbard. Photo by Urban Wråkberg in 2015. Used by permission.

international tourists from the capital town of Longyearbyen searching for the signs of 'authenticity'. In both Svalbard and the Murmansk region Soviet imagery seems to serve pragmatic ends, including strengthening social cohesion or attracting tourists. On the Russian side of the border the old Soviet imagery is being used because many people apparently share the sentiment it stands for. On the Norwegian side of the border its aesthetics is interpreted more ironically or even sarcastically by tourists (Andreassen, Bjerck and Olsen 2010).

Over the last two decades the Euro-Arctic borderland has been the target of policy-making and industrial activities tied to the region's natural resources. This has manifested itself in different northern scenarios prepared by various stakeholders and their media consultants. More alarmist are those including warnings of climate change and an ensuing environmental catastrophe, while business scenarios have revived a northern frontier spirit fired by utopian ideas of an imminent Arctic bonanza based on expanded resource utilization (Dahl 2012). One example of the latter vision from Arctic Russia after the economic transition is presented in the publication titled 'Glacial El Dorado: Spitsbergen' sponsored by the Russian state mining trust 'Arktikugol' (Tsivka 2001).

The area of northwest Russia and northern Fennoscandinavia forms the most populated region of the circum-Arctic rim, with the most developed infrastructure. Thus they have been presented in some development scenarios as an international bridgehead or gateway to expanded mining, fishing and hydrocarbon extraction on the Arctic continental shelves. The

novelty of post-Cold War political conditions and diminishing amounts of ice in the Arctic Ocean has motivated some writers to speak of the 'new north' (Stuhl 2013). Nevertheless, the prospect of opening a northern sea-link between Europe and Asia via the Arctic coastal seas of Russia was the rationale already behind Willem Barents' Dutch expedition to this area in the sixteenth century. In 1993 the northern counties of Norway, Sweden and Finland were empowered, after negotiations conducted by their foreign ministries and that of Russia, to embark on regional people-to-people and public institutional collaborations with the northwesternmost counties (*oblasts*) of Russia. After scalar zooming into the global geo-economic discourse of today, we find old colonial tropes, such as that of the frontier, the bridgehead, the gateway, and the continental or Arctic crossings, especially in the business scenarios of this so-called Barents Region. These enter the minds of speech-writers and marketers by a global palimpsest of terms from the colonial world order of the eighteenth and nineteenth centuries. While globalization is seen as the widest and most modern confluence of economic forces, the phraseology and border aesthetical paraphernalia of the 'new' North contains concepts that were imbued with meanings many centuries ago.

Evocative but selective maps of the Arctic have played a central role in most business scenarios used in policy-making and political campaigns in the Barents Region in recent years. The re-use of imperial concepts of exploitation in the rhetoric and imaginary of the 'opening' of supposedly slumbering and unclaimed northern territories is effective in boosting investments in the resource industry. The old frontier spirit calls forth entrepreneurs in business as well as in research and education for the many tasks waiting to be handled in the North. This utopian vision reverberates with Icelandic-Canadian explorer and writer Vilhjalmur Stefansson's captivating but unrealistic colonial dreams of the future Arctic envisioned back in the 1920. Stefansson presented these in his lengthy but widely read books, *The Friendly Arctic* and *Northward Course of Empire* (Stefansson 1921, 1928). The idea that there is a grand opening up-north for any entrepreneurial individual irrespective of his or her nationality, background and profession is anachronistic and in conflict with local democracy, international environmental governance, and the interests of several acknowledged northern stakeholders. Nonetheless, this palimpsestous rhetoric has been used to create public support for what is the benefit of a rather small circle of private, state or oligarch enterprises. The potential number of real winners in this 'great game' of the north is limited to a handful of international oil and gas mega-cooperations. Their economic and political resources are such that they can outpace not only any regional lobbyists but also national governments (Abdelal 2013).

The Palimpsest of Klaipeda

Historical and political complexity increases as we look south along the east-ern borderlands of northern Europe. The built heritage of the Lithuanian port town of Klaipeda on the south-eastern coast of the Baltic Sea includes a rich mix of renovated, altered or ruined structures and empty spaces, some of which originated during Lithuania's time as part of the Soviet Union from 1945 to 1990. Most of the city's architectural features have palimpsested some-how into the future of today, as have the elements of urban infrastructure that are still of vital importance, such as the energy dependence of the city, and the country, on Russian gas, recently ameliorated by a new import terminal for liquefied natural gas of Norwegian design.

The old border town of Klaipeda is placed at a crossroads of cultures and nations, at an ancient hub between Western and Eastern Europe. Klaipeda was founded in medieval times by the Teutonic and Livonian Orders as Memelburg on the north-south axis of their territory of influence over the towns which were then called in German Riga-Memel-Königsberg-Danzig (contemporary Riga in Latvia, Klaipeda in Lithuania, Kaliningrad in Russia, and Gdansk in Poland). It contains, or rather consists in, a complex material and symbolic heritage, rich in border imagery and symbolism that presents many challenges to contemporary city management.

The German name of Klaipeda was Memel. To the south of the city, inside the Russian enclave of Kaliningrad, flows the Memel River where the northern border of the German-speaking world was once located according to, amongst others, the now forbidden first verse of the German national anthem.[2] In English the name of this formerly economically important river is Neman and in Lithuanian Nemunas (Sobecki 2011). At the end of the Second World War the German population was deported from Memel and all of former East Prussia and the Baltic states. Nevertheless, the German heritage of the infrastructure and city culture of Klaipeda and its role in the spread of com-merce and industrialization to this town, to its surrounding agricultural area the Memelland, and elsewhere in central and northern Europe, had lasting importance (cf. Lindberg 2008; Kopsidis and Wolf 2012).

After Lithuania's independence a large monument was erected in the Atgimimo square in central Klaipeda, shaped like an incomplete arch of stone beams fixed at right angles to each other, where the missing southern pillar, representing Lithuania Minor, is border-aesthetically severed in thin air from the other resurrected monoliths, symbolizing the so far included counties of Lithuania; the broken stone-slab points towards the Russian enclave of Kaliningrad.

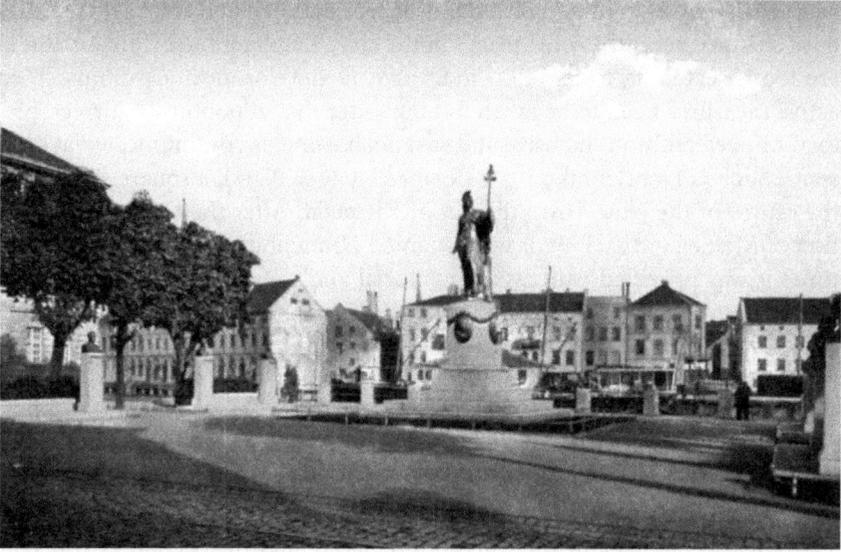

Figure 4.3 The Borussia statue placed in front of the city magistrate of Klaipeda, then Memel, in the beginning of the twentieth century, as shown in contemporary postcard. Source: Wikimedia commons.

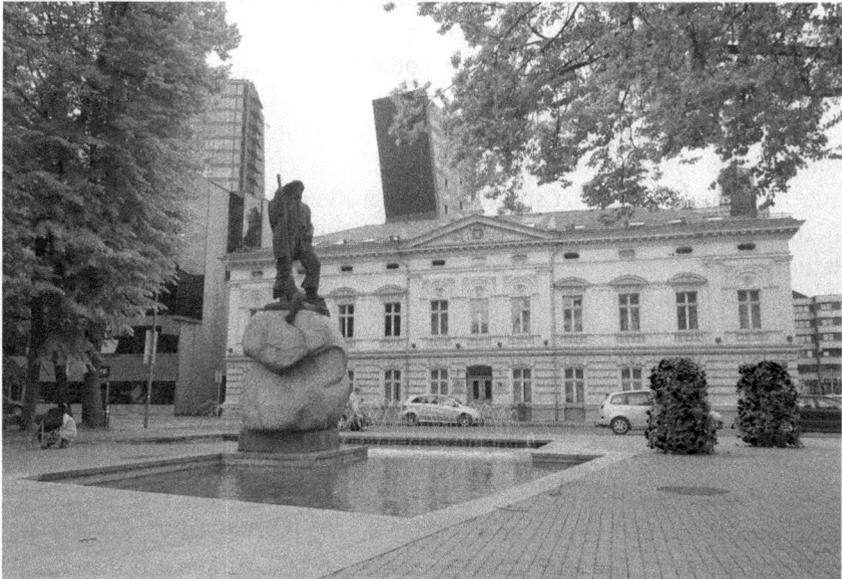

Figure 4.4 The statue in front of the city magistrate of Klaipeda since the 1980s, photographed from the opposite direction than that of the previous view. Some post-1990 real estate is towering in the background. Photo by Urban Wråkberg in 2015. Used by permission.

In Klaipeda, as in other borderlands where national and regional identities have changed recently, some places in the city seem haunted by history; these are too threatening to leave on their own to develop into a palimpsest, so active measures need to be taken to make sure that a 'politically correct' history, or preferably an inclusive and sustainable one, is communicated at such spots. Such is Lietuvininku Platz (former Libauer Platz), a square situated at the centre of the New Town district of Klaipeda. After the German occupation of Memelland in 1939 it was renamed Hindenburg Platz. During Soviet times it was provided with a war memorial and renamed 'Place of Victory'. Today it is called the Square of Lithuania Minor and equipped with a monument of Martin Mažvydas who in 1547 published *Katekizma* (Catechism), the first book printed in Lithuanian. In front of the city administration building, the magistrate of Klaipeda monuments have likewise succeeded each other through the turbulent centuries in this part of Europe. A statue of Borussia, the mythical female protector of Prussia, was pulled off its foundation in 1923 by Lithuanian patriots during the period of Lithuania independence (1918–1940). It was put back by the Nazis but replaced after the Second World War by a distinctly Soviet-styled statue of a socialist fisherman. It has been possible to re-interpret the border aesthetics of this monument as the commemoration of an anonymous Lithuanian or local hero, symbolizing the fortitude of fishermen, or more generally of the achievements of the fishing industry, and keep it in place. Subsequent EU membership and NATO alliance have made the palimpsest of this and similar sites of contested heritage, somewhat less challenging in terms of domestic stability. With Baltic EU memberships have also followed further directives on non-discrimination regarding all minorities in the Baltic national populations including those of citizens of Russian origin.

Among the post-Soviet spaces in central Klaipeda is an odd narrow park bordering on a non-functional square, non-functional in the sense that the latter was never used as an open market place for the city dwellers to buy daily consumables from local sellers of agricultural products. This space is situated along the small river/canal of Dane, which cuts through central Klaipeda, and which can be crossed by the Stock Exchange Bridge (formerly die Börsenbrücke). This open area once contained buildings which housed the regional chamber of commerce, the stock exchange and a Prussian post office. These former institutions were involved in offering loans and managing the funds of local industry and the farmers engaged in the Memelland agricultural sector. The buildings were damaged during the Second World War and since the regional financial services provided by these capitalist institutions were at odds with the centrally planned economy of the Soviet Union, they were torn down and replaced by a park area along the river, thus introducing a lacuna symbolizing this attempt to conclude the succession of buildings of institutions serving the trade and banking sector of the town.

The return of capitalism to the Baltic states has announced itself in recent decades through the appearance of the signs of major Norwegian and Swedish banks on new and old buildings in Klaipeda but ironically this has not resulted in the reclaiming of this post-Soviet space next to the old Stock Exchange Bridge. The new Nordic-Baltic banking linkage was applauded in Brussels as an eminent northern example of the neighbourly synergies of the union that appeared to be functional without much state involvement. However, the idea that free banking would be able on its own to build a new Baltic economy lost credibility with the bursting of the Baltic real estate bubble which occurred just before the onset of the European recession in 2008. It turned out that the flow of Nordic capital into the Baltics had been inflating real estate prices and had lured many Baltic citizens to borrow in foreign currencies to buy luxury commodities and to participate in the bidding on escalating prices for private housing (cf. Hudson 2008; Hardy 2010; Cocconcelli and Medda 2013).

Following the city skyline from down-town Klaipeda towards the east, the characteristic Soviet design of the stack of the central heating plant of the firm *Klaipedos Energija AB* reminds you that Russian gas has so far been the sole replacement of the energy missing since the shutting down in 2004–2009 of the nearby Ignalina nuclear plant closed due to concerns over its safety. Major capital has been slow in coming to the Baltic states to restructure their basic transport and energy infrastructure, and the cumulative character of the palimpsest of the city material structure of Klaipeda illustrates this (Lowe 2012; Pittman 2013).

On a smaller scale local entrepreneurs and a diligent city management have in recent years transformed many old houses and the characteristic stone pavements of the streets in the older parts of Klaipeda to their 'former glory'. The analytical instruments chosen already for our case studies on border aesthetics in this chapter – scalar zooming, attention to lacunas and to the appropriation by various agents of meanings of visible/invisible/missing, and even counterfeit layers in any palimpsestoid structure – are also useful in interrogating the picturesque qualities of these townhouses of Klaipeda Old Town.

Many pre-war houses in Klaipeda were run-down at the end of the Soviet period. Because of the familiar European aesthetic appeal of these houses it has proved worthwhile to invest sums available to individual owners to renovate them to make them attractive for shop keepers to rent or reside in. Viewed together, the now well-kept houses of Klaipeda Old Town create a recognizable and inviting scene for tourists keen on heritage Europe.

The Old Town of Klaipeda is in many senses a German pre-war memory-scape, but like Königsberg and East Prussia, the town of Memel as a German national entity is gone from any contemporary map. Hence, commenting on the text of the past bleeding through the palimpsest of restored Memel Old Town seems to calls for some careful political consideration on the meaning

and origin of reappearing structures. So far the preferred alternative has been to regard them as Lithuanian, by referring somehow to the few decades of Lithuanian sovereignty in 1918–1940, or as German, without further comments (cf. Egremont 2011). There was even a time (1629–1635) when Memel was under Swedish rule, but those years were tormented by war and heavy taxation and have proved to be of little historiographical use to any kind of revivalism.

Many tourists in Klaipeda arrive across the Baltic Sea by ferries from Kiel in Germany or Karlshamn in Sweden and continue by car, stopping over at the seaside resort of Palanga. They often go on to visit Thomas Mann's summer cottage and to experience the forested sand dunes on the narrow isthmus of the Curonian Spit, separated from the main coast of southern Lithuania by the Curonian Lagoon which extends south into the enclave of Kaliningrad (Königsberg). The tourists are mostly German and Nordic people, which seems uncomplicated considering that few people are aware that the then Chancellor of West Germany, Willy Brandt, signed these territories away in 1972 as part of his new *Ostpolitik*. This was re-confirmed in 1990 in treatises signed as part of the re-unification of West and East Germany. Nonetheless, one of the most industrious among the providers to major photo-sharing sites on the Internet of photos of carefully identified renovated or lost historic buildings of Klaipeda is a person whose pseudonym can be tracked further on the web to political sub-groups who dream of the resurrection of East Prussia.

The moved borders and lacunas of the Memel palimpsest are significant. The prevalence of estranged geography is constitutive of the cityscape palimpsest. Some spaces have been made invisible by physical erasure: all synagogues were destroyed during the Second World War and most other churches shared their fate in the Soviet period. Material sites and features remaining in people's memoryscapes all have flexible and opposing meanings for different groups of residents and various kinds of tourists. Some of the tourists fall prey to the misnomers, omissions and re-labellings found in biased tourist guides on the Internet and elsewhere, others carry with them their own thorough interpretations of the local past and present.

Peace, liberalization and economic growth were not only characteristic of Memel during the times of Friedrich the Great and the interwar decades of the Lithuanian Republic. The short rule of the Entente and its French governor after the First World War, before Memel was annexed by the Lithuanian Republic in 1923, brought with it unprecedented individual and economic freedom to the Memel Territory (cf. Suksi 2011: 39–80). In the nineteenth century, when Russia controlled the Baltic states, railways and telegraph communication reached Memel. Several of the 'German' houses and Art Nouveau buildings of the borough north of the old town of Klaipeda, which were constructed in

the interwar era, were originally built by Jewish merchants, industrialists and bankers. The Jewish population played a crucial role in the growth to affluence of pre-Second World War Klaipeda, as well as during earlier periods of economic growth. All Jewish groups of Lithuanian, Russian and German origin had been discriminated against since medieval times. When they were not barred from business by unfair rules on acquisition of citizenships, residential permits, religious discrimination, etc., their skills and wide European business networks facilitated the important timber and grain trade from the interior of northeastern Europe, including Russia, to the port of Memel and further on to buyers in the early industrialized countries of Western Europe, foremost Britain. In 1910, 9 per cent of the population of Memel were Jews. In 1939, 14 per cent of the total population of 51,000 people were Jews. Their community helped to lessen the animosity between the German and Lithuania portions of the town's inhabitants in which the Lithuanians were outnumbered about one to three by Germans. At that time there were 330 industrial enterprises owned by Jews in Memel which employed 70 per cent of Memel's German workforce (Levin and Rosin 1996).

In March 1939, Memelland was seized by Nazi troops. Jews with lesser economic means, who had not emigrated from Memel during the previous years of rising antisemitism, fled north into Lithuania which was soon occupied. The Holocaust eradicated the Eastern Jewish civilization. After the war a small number of Jewish survivors moved into Soviet Lithuania, though no religious services of any kind were allowed there. The old Jewish cemetery of Klaipeda was destroyed when a radio station was erected on its grounds for the transmission of disturbance signals on frequencies used by Western radio stations. In 1990, there were just 681 Jews among Klaipeda's Russian-Lithuanian population of more than 200,000. In the presentation of the town's history and culture in the online guide 'True Lithuania', there is not one mention of the former Jewish community of Klaipeda/Memel (True Lithuania 2013; Pollin-Galay 2013).

Zooming out into the European post-2008 stagnation and the large-scale geo-economic picture that encompasses both the Barents region and the southeastern coast of the Baltic Sea, European capital so far has been going into railway construction and environmental upgrades. While the EU is spending time discussing in which one of the three Baltic countries, or perhaps in Finland, a new joint Baltic large-scale import harbour for liquid natural gas should be located, as mentioned already, a smaller Lithuanian-Norwegian enterprise has gone ahead successfully to assemble a floating facility for the same purpose in the port of Klaipeda (Masiulis 2012). Rather than capital coming in, a major exodus of people can be noted, from Klaipeda and elsewhere in the Baltic states; labour is heading abroad to find work, not least in the fisheries, real estate renovation and construction industries of Norway.

The Opportunities of a Palimpsestual Aesthetic

This chapter has explored the endurance of the Soviet cultural layer during the post-Soviet period and the return of neo-colonial tropes and imaginary in geo-economic scenarios of the 'new North' and the various heritage resources drawn upon in forming the new facades of some tourist environments on the Baltic Sea. Despite expectations that the collapse of the Soviet Union followed by dramatic transformations of the political and economic order would lead to the creation of a (distinctively) new cultural layer and identity of Russia, Soviet cultural symbols have remained significant elements of its cultural landscape.

Like the palimpsest, the partly erased discursive and material embodiments of the Soviet material and symbolic heritage have re-emerged through subsequent cultural sediments. The complex dynamics of the post-socialist transition, changes in the political and economic structure, and processes of reassignment of external and internal borders of Russia have triggered these processes. Those symbolic layers are not reducible to 'historical epochs', e.g. socialism or post-socialism, because they are embedded in a still readable fabric of social relations and national and international interdependencies.

Russia, as it emerged from the rubble of the USSR, lost territorial and economic control over most, if not all, of its old satellite states. As a result of a radical rescaling of the state power in post-Soviet Russia, the responsibilities of economic development, territorial planning, welfare and social provision have partly or entirely shifted to the regional and local levels, creating various tensions associated with both emerging economic and budgetary responsibilities. A boom in the prices of oil and gas had an ameliorating effect in the first decade of this century.

The economic restructuring and identity crisis have affected the regions of the Russian North particularly hard. The development of the northern frontiers of communism was due to the socialist state which made industrialization and urbanization of the North possible. The curtailment of the budgetary expenditures and the state withdrawal from industrial management created a sense of betrayal by the socialist state among the settlers who moved to the North. They now felt abandoned. For the northern residents, the socialist heritage looked particularly appealing as it was a key element of the collective identity shared by a great number of people who were encouraged to move to the North by the Soviet government.

Faced with population decline and the drift of qualified workers to the south, the authorities in northern regions struggled to create sufficient incentives to make people stay. As many feel 'betrayed' by a Russian government that has embarked on neoliberal reforms, the current project of constructing a

new collective identity around the notion of Rossiysky appears less appealing than the identities associated with the USSR. Regional elites see the benefits of re-using the socialist aesthetic symbols as reminders of the 'good old days'.

This, of course, does not suggest that the socialist past was an unproblematic 'lost paradise'. The USSR's state socialism was based on the authoritarian rule of the Communist Party and powerful industrial ministries and corporations. The population was then powerless and the authorities unaccountable – as they are now. Neoliberalism has appeared in Russia in one of its guises, but camouflaged in old socialist slogans. In post-Soviet material spaces, partly modified Soviet slogans, rituals and rhetoric remain or re-appear through the layers of the new regime to form a palimpsest. As the emerging identity of new Russia is inscribed on its surface, remnants can be seen moving upward to appear as markings on this same surface.

When older layers in the palimpsest of contemporary Klaipeda have been acknowledged and restored for public display, it can be shown that some parts of what these contain have been cut away from the visualized palimpsested border town of an earlier period. This draws attention to the element of opportunism in the typical act of conjuring up traditions and memoryscapes. The German and Nordic tourists are big spenders in Klaipeda and for this reason the German heritage is today hinted at in its Old Town beside the major Lithuanian one. Despite increasing Russian tourism in the Baltic states, the Soviet origin of much of the infrastructure of these countries is seldom presented as anything but a problem to be offset by further EU integration and more direct foreign investments. This historical and aesthetic opportunism works according to a similar logic of political selection. Our research has also found that from a variety of palimpsested ideological heritages in this built environment, all use Soviet symbols of social responsibility within the scripts of modern mega-enterprise and regional administration in the area.

We suggest adding the palimpsest as a model and tool, beside the ones discussed in the other chapters of this book, to facilitate seeing the borders not only between states, economic systems or social identities, but also between the layers in the heritage and memoryscapes of a town or region. Attempts at erasures lead to the re-development and redeployment of the discourses of history writing, tourism and material culture. As we have seen, the process of palimpsesting is neither limited to historical artefacts or still functional material structures, but also to ideology and the accumulation of knowledge.

Nadir Kinossian is a Researcher in the Department of Regional Geography of Europe, at the Leibniz Institute for Regional Geography (IfL) in Leipzig, Germany. His research interests include spatial policy, cultural landscape, spatial polarization and peripheralization. Prior to joining the IfL in 2015, he

was based at the Tromsø and Kirkenes campuses of UiT the Arctic University of Norway (2011–2014). Nadir was awarded a PhD in City and Regional Planning from Cardiff University, for work on urban governance in Russia (2010). He has worked in academia, private consultancy and municipal administration in the UK, Norway and Russia.

Urban Wråkberg is Professor of Northern Studies, Department of Tourism Research and Northern Studies, and leader of the research group in this multidisciplinary and circum-polar field of study at the Arctic University of Norway. His previous work has included studies of cultural, political and scientific issues of the north, with a focus on the Euro-Arctic and the borderlands of the Barents region. He has published in English, Swedish, Norwegian and Russian on the geo-economic drivers of science in the polar regions, on the history and ideology of polar exploration, and on the nexus between scientific and indigenous knowledge-formation in the north.

NOTES

1. On the problematic political and aesthetic palimpsest in postcolonial societies and writing, see Johannessen 2011–2012.
2. *Das Lied der Deutschen* was composed in 1841 by August H.H. von Fallersleben (1798–1874). The song contains the following line: 'Von der Maas bis an die Memel' referring to the 'natural limits' of German territory according to the nationalist dream. Germany was not a unified state at the time.

BIBLIOGRAPHY

Abdelal, R. 2013. 'The Profits of Power: Commerce and *Realpolitik* in Eurasia', *Review of International Political Economy* 20(3): 421–456.

Anacker, S. 2004. 'Geographies of Power in Nazarbayev's Astana', *Eurasian Geography and Economics* 45(7): 515–533.

Andreassen, E., H.B. Bjerck and B. Olsen. 2010. *Persistent Memories: Pyramiden – A Soviet Mining Town in the High Arctic.* Trondheim: Tapir Academic Press.

Bailey, G. 2007. 'Time Perspectives, Palimpsests and the Archaeology of Time', *Journal of Anthropological Archaeology* 26(2): 198–223.

Blakkisrud, H. 2006. 'What's to Be Done in the North?', in H. Blakkisrud and G. Hønneland (eds), *Tackling Space: Federal Politics and the Russian North.* Lanham: University Press of America, pp. 25–51.

Castells, M., and E. Kiselyova. 2000. 'Russian Federalism and Siberian Regionalism', *City* 4(2): 175–198.

Cocconcelli, L., and F.R. Medda. 2013. 'Boom and Bust in the Estonian Real Estate Market and the Role of Land Tax as a Buffer', *Land Use Policy* 30(1): 392–400.

Czepczyński, M. 2008. *Cultural Landscapes of Post-Socialist Cities*. London: Ashgate.

Dahl, J. 2012. 'The Constitution and Mobilisation of Political Power through Utopian Narratives in the Arctic', *The Polar Journal* 2(2): 256–273.

Dillon, S. 2007. *The Palimpsest: Literature, Criticism, Theory*. London: Continuum.

Egremont, M. 2011. *Forgotten Land: Journeys among the Ghosts of East Prussia*. New York: Farrar, Straus and Giroux.

Forest, B., and J. Johnson. 2002. 'Unravelling the Threads of History: Soviet-Era Monuments and Post-Soviet National Identity in Moscow', *Annals of the Association of American Geographers* 92(3): 524–547.

Gerlach, J., and N. Kinossian. 2016. 'Cultural Landscape of the Arctic: "Recycling" of Soviet Imagery in the Russian Settlements on Svalbard (Norway)', *Polar Geography* 39(1): 1–19.

Hardy, J. 2010. 'Crisis and Recession in Central and Eastern Europe', *International Socialism: A Quarterly Journal of Socialist Theory* 128. Retrieved on 18 May 2016 from http://isj.org.uk/crisis-and-recession-in-central-and-eastern-europe/.

Hudson, M. 2008. 'Fading Baltic Miracle: A Dangerous Dependence on the Property Bubble', *The International Economy* Winter, 74–78.

Huyssen, A. 2003. *Present Past: Urban Palimpsests and the Politics of Memory*. Stanford: Stanford University Press.

Jackson, T.N., and J.P. Nielsen (eds). 2005. *Russia-Norway: Physical and Symbolic Borders*. Moscow: Languages of Slavonic Culture.

Johannessen, L.M. 2011–2012. 'Palimpsest and Hybridity in Postcolonial Writing', in Ato Quayson (ed.), *The Cambridge History of Postcolonial Literature*. Cambridge: Cambridge University Press, vol. 2, pp. 869–902.

Kinossian, N. 2012. 'Post-Socialist Transition and Remaking the City: Political Construction of Heritage in Tatarstan', *Europe-Asia Studies* 64(5): 879–901.

Kopsidis, M., and N. Wolf. 2012. 'Agricultural Productivity across Prussia during the Industrial Revolution: A Thünen Perspective', *Journal of Economic History* 72(3): 634–670.

Kryukov, V., and A. Moe. 2006. 'Hydrocarbon Resources and Northern Development', in H. Blakkisrud and G. Hønneland (eds), *Tackling Space: Federal Politics and the Russian North*. Lanham: University Press of America, pp. 125–141.

Leach, N. 2002. 'Erasing the Traces: The "Denazification" of Post-Revolutionary Berlin and Bucharest', in N. Leach (ed.), *The Hieroglyphics of Space: Reading and Experiencing the Modern Metropolis*. London: Routledge, pp. 80–91.

Levin, D., and J. Rosin (eds). 1996. *Encyclopaedia of Jewish Communities: Lithuania*. Jerusalem: Yad Vashem.

Lindberg, E. 2008. 'The Rise of Hamburg as a Global Marketplace in the Seventeenth Century: A Comparative Political Economy Perspective', *Comparative Studies in Society and History* 50(3): 641–662.

Lowe, P. 2012. 'Baltic Energy Infrastructure – from Isolation towards Integration', *Baltic Rim Economies Quarterly Review* 6: 15–16.

Masiulis, R. 2012. 'LNG Terminal in Lithuania – a Small Solution to a Very Large Problem', *Baltic Rim Economies Quarterly Review* 6: 19–20.

McCannon, J. 1998. *Red Arctic: Polar Exploration and the Myth of the North in the Soviet Union 1932–1939.* New York: Oxford University Press.

Paasi, A. 1996. *Territories, Boundaries and Consciousness: the Changing Geographies of the Finnish-Russian Border.* London: John Wiley & Sons.

Pittman, R. 2013. 'The Freight Railways of the Former Soviet Union, Twenty Years on: Reforms Lose Steam', *Research in Transportation Business & Management* 6: 99–115.

Pollin-Galay, H. 2013. 'The Holocaust is a Foreign Country: Comparing Representations of Place in Lithuanian Jewish Testimony', *Dapim: Studies on the Holocaust* 27(1): 26–39.

Sir, J. 2008. 'Cult of Personality in Monumental Art and Architecture: The Case of Post-Soviet Turkmenistan', *Acta Slavica Iaponica* 25: 203–220.

Sobecki, M. 2011. 'The Neman River', in Wolfgang Berg (ed.), *Transcultural Areas.* Wiesbaden: Verlag für Sozialwissenschaften, pp. 95–105.

Stefansson, V. 1921. *The Friendly Arctic: The Story of Five Years in Polar Regions.* New York: Macmillan.

———. 1922. *The Northward Course of Empire.* New York: Harcourt.

Stuhl, A. 2013. 'The Politics of the "New North": Putting History and Geography at Stake in Arctic Futures', *The Polar Journal* 3(1): 94–119.

Suksi, M. 2011. *Sub-State Governance through Territorial Autonomy: A Comparative Study in Constitutional Law of Powers, Procedures and Institutions.* Heidelberg: Springer.

True Lithuania. Retrieved on 18 May 2016 from http://www.truelithuania.com/.

Tsivka, J.V., et al. 2001. *Glacial El Dorado: Spitsbergen.* Moscow: Penta.

Vale, L. 2008. *Architecture, Power and National Identity.* London: Routledge.

Wråkberg, U. 2009. 'Pomor Zone: A Cross-Border Initiative to Further Regional Development in Northern Norway and Northwest Russia', *Transborder Cooperation of Russia with Northern Countries: Conditions and Perspectives on the Development: Proceedings of V Northern Social and Ecological Congress, Moscow, 21–21 April, 2009.* Moscow: Galleria, 19–29 [in Russian].

———. 2012. 'Euroarctic Strategies and Synergies', in L. Hacquebord (ed.), *LASHIPA: History of Large Scale Resource Exploitation in the Polar Areas.* Groningen: Barkhuis, pp. 161–172.

———. 2013. 'Science and Industry in Northern Russia in Scandinavian Perspective', in Sverker Sörlin (ed.), *Science, Geopolitics and Culture in the Polar Region - Norden Beyond Borders.* Farnham: Ashgate, pp. 195–223.

▶• 5 •◀

Sovereignty

Reinhold Görling and Johan Schimanski

'Die Sorge des Hausvaters' (The Cares of the Father in the House) is one of the few stories that Franz Kafka published in his lifetime, in 1919. In English it has been translated several times, for example by Willa and Edwin Muir (as 'The Cares of a Family Man', Kafka 1995). Readers of Kafka in German or in English may forget the title of the one-and-a-half page long story, but the name Odradek will remain in their memory. It is the name for something that the 'Hausvater' (the 'Family Man' or 'Father in the Family', literarily the 'House-Father') tries to describe and about which he wants to tell the reader. Here we will be listening for what he and Odradek (whom we mostly refer to using the pronoun 'it') tell us about sovereignty, borders and aesthetics. Our argument is that the aesthetic (i.e. that which in any specific aesthetics may be called aesthetic) may be able to help us to escape the economy which sovereignty sets up, a binary and hierarchical economy in which we can only choose between objecthood and subjecthood, between being subjected to a sovereign and becoming sovereign ourselves.

Thomas Hobbes's theory of the sovereign is based on the construction that the sovereign represents the Leviathan. The Leviathan is a fiction, a cultural product, made by men who in their rationality develop the idea of a common image, made by each of them by agreement. The sovereign himself is not part of those who make this contract. Indeed, he cannot be part of it, because he only represents it. There is a line of transference of this model to the family contract, which is represented by the Hausvater. As the sovereign is inside and outside of the law, the Hausvater is part of the family and outside the family, representing its idea to the inside as well as to the outside. The sovereign keeps the border under surveillance, the border of the state as well as the border of the house. He decides who pertains to the community and who is alien; he identifies the subjects and the objects, gives names to subjects and objects.

Reflecting on Odradek helps us to understand the unconditionality of the aesthetic, as part of a relationship of what we call 'insovereignty'. This unconditionality, which for Jacques Derrida is 'a question of liberty, gift, pardon,

justice, hospitality' beyond the phantasm of indivisible sovereignty (2009: 302), gives the aesthetic a central role in moving beyond modern categories of sovereignty and transforming the idea of citizenship. Unconditionally may be related to Kantian concepts of the aesthetic as disinterested, or the aesthetic which is defined as being beyond utility, power and politics, opening up to accusations of aestheticization, art for art's sake, or aesthetics as decorative, secondary and hiding realities. Thinking however of the aesthetic as unconditional rather than just disinterested means that it becomes precisely political in the face of sovereign power. That which is unconditional is impossible to determine, and Odradek, who is precisely impossible to determine, furthermore shows the relationship between decision-making and power on the one hand and identity and position on the other. Sovereignty is always trying to determine our position in relationship to the border (are we inside or outside?), and to determine the position of the border itself. It may use the aesthetic in its attempts to attain these goals in its regal ceremony or democratic spectacle, as Giorgio Agamben has recently claimed (2011: xii), but ultimately Odradek suggests that the 'as if' of the aesthetic will not conform to the economy which sovereignty sets up. Thinking of the aesthetic as unconditional is part of that which allows us to speak 'as if', opening the space of the political.

> Some say that the word Odradek comes from the Slavic and seek an explanation there of how the word is formed. Others again think that it comes from the German, and was only influenced by Slavic. The uncertainty of both interpretations probably rightly allows for the conclusion that neither is correct, especially as neither can be used to find the meaning of word.
>
> Naturally, no one would occupy themselves with such studies if a being called Odradek did not really exist. At first glance it looks like a flat, star-shaped spool for thread, and indeed it does seem covered in threads; to be sure, only torn, old pieces of thread different in style and colour; knotted, but also entangled with each other. It is not only a spool however, as from the middle of the star a small crossrod sticks out, and at right angles onto this rod another is joined. By means of this last rod on the one side, and one of the rays of the star on the other, the whole thing can stand upright as if on two legs.
>
> One is tempted to believe that the creature had once had some suitable shape and is now only broken. However, this seems not to be the case; at least there is no sign of it; nowhere are there attachment points or broken surfaces that would indicate anything of the kind; the whole thing looks rather senseless, but in its own way complete. More cannot be said about it, as Odradek is extraordinarily mobile and cannot be caught.
>
> He lurks by turns in the attic, in the stairwell, in the passages, in the corridor. Sometimes he is not to be seen for months on end; at these times he has presumably moved into other houses; but he returns without fail to our house. Sometimes, when one steps out the door and he is leaning on the banister just below, you feel the urge to speak to him. Naturally, one asks him no difficult questions, but treats him – his diminutiveness requires it – like a

child. 'What is your name then?' you ask him. 'Odradek', he says. 'And where do you live?' 'Indeterminate abode', he says and laughs; but this is only a laughter which can be brought forth without lungs. It sounds something like rustling in fallen leaves. With this, the conversation is usually at an end. Also, even these responses are not themselves always forthcoming; often he is long silent, like the wood he seems to be.

I ask myself in vain what will happen to him. Can he at all die? Everything that dies has before had some kind of purpose, some kind of activity, and has been worn out; this is not true of Odradek. Should he therefore at some time roll down the stairs with threads trailing to lie by the feet of my children and grandchildren? He obviously does no harm to anyone; but the idea that he is likely to survive me, almost pains me. (Kafka 1994; our translation)

The Sovereignty to Name, the Sovereignty to Write

The text begins with a reflection on the origin of the name Odradek. It seems to be unknown, unknown in a double sense: it is impossible to determine the name etymologically. It is a name without any genealogy. The text tells us that some think it is of Germanic, some think it is of Slavic origin. However, as the text states, neither explanation works, so we cannot say that the name Odradek is a mixing of the two. It is a name that Odradek itself gives as answer to the question: 'What is your name then?' Did Odradek call itself Odradek? Is this possible?

Naming a child is a task, a right, a *Sorge* of its parents, in patriarchal traditions a *Sorge* of the father. The name is both an expression of a genealogy and an expression of sovereign power. Following the structuralist understanding of language, naming of the things and most of the beings in the world is normally arbitrary and transparent at the same time. But with proper names, it is different. There is no transparency of proper names. Which name a baby should be given is an arbitrary and potentially sovereign decision of the Hausvater. Also, because they are not transparent, proper names are untranslatable. Odradek's name resists the sovereignty of any particular language.

We do not know who gave Odradek its name. It is scarcely possible to say anything about Odradek at all besides the fact that it is called Odradek. Odradek is a singular name, an original, something that has no roots, something that is unconditional. Unconditionality is often associated with sovereign power. But there is an important difference. Sovereignty is something that exists in relation to something. Already the etymological origin of the concept points to this relation: the sovereign is the one who is higher than all others. But it is not a position by itself; it is a position through the existence of others. The sovereign is both inside and outside the law. He is a kind of

hierarchical guarantee for the relation, and therefore also has to be above the relation. But without it, without the reference to the Other, the sovereign would be nothing. A king without a kingdom is nothing. Nor is a god without a world that refers to him. Odradek's unconditionality is different to sovereignty, because it only refers to itself.

What is normally the name a Hausvater gives to his children? A proper name has no transparency. It does not refer to anything general, but at the same time it can always be used again. Everybody who has seen an apple before knows what an apple is like. What a Michael or a Cathy is like, nobody knows. Nevertheless, the child named in that or another way is marked. The proper name is a mark.

Marks are signs that are made, probably never without violence. Marks are inscriptions of something into something different. Yet because Odradek is a unique name, without origin, we do not know if Odradek was marked by anyone. The text will not tell us. Odradek is the mark of not being marked. Odradek does not belong to the order of proper names, and cannot be assigned to a territory. It is a de(-)marcation.

Through the act of marking there is a strong relation between the proper name and the border. Marks are, to use Gilles Deleuze's expression, territorializations. They determine a place and a time and thus make that which is marked part of an order of places or time. In medieval times, borders were called marches, a term which derives from words meaning to mark. Both borders and proper names belong to what they mark, but at the same time escape it. The name Odradek may make us think of Kafka and Prague, and specific linguistic and political borders. The ending *-ek* is common in Czech surnames, and because the Czech lands belonged for most of Kafka's life (and before) to Austro-Hungary, such names have also become part of the German-speaking world. The text tells us however that it does not refer back to specific sovereignties.

The proper name functions as a border surrounding its bearer. We imagine that we can cross it and find out what the bearer is like when we have seen what is on the other side. But the name itself does not tell us anything about the bearer, just as the sign saying 'Norge' ('Norway') at the Norwegian border does not tell us what Norway is like. The name marks out a sovereign territory of meaning, but it functions as a mask to a meaning – a meaning that might not even be there without this performative act of marking. In Odradek's case, it is not there; it is indeterminate.

Insofar as Odradek's name marks not being marked, it is impossible to territorialize Odradek. To the question 'wo wohnst Du?', 'where do you live?', he answers 'Unbestimmter Wohnsitz', 'Indeterminate abode'. *Unbestimmt* in German means 'undecided', 'indeterminate'. He does not say 'No fixed Abode'. It is not necessarily true that Odradek has no residence at all. He is not

a 'vagabond'. He has a residence, but it is not determined, it is undetermined. The text continually locates and then 'unlocates' Odradek.

It is easy to read the text as an allegory, as being about Kafka's own role as a writer. In this case, Odradek has something to do with writing, and the relationship between writing and the author. If, however, Odradek represents writing, wouldn't Odradek then be a transparent name for writing? A metaphor or at least a mark of description of writing? But if Odradek represents writing, it represents writing as something that is precisely not transparent. It is possible, but not compelling, to let Odradek refer to writing. But even when one does it, to what exactly does Odradek refer? To the act of writing? To the written text? To something that cannot be grasped with concepts, which is not marked by them?

If Odradek represents writing, it is a form of writing that escapes the Hausvater. Perhaps this would be a specifically aesthetic, that is to say, literary form of writing. From time to time Odradek laughs, 'es ist aber nur ein Lachen, wie man es ohne Lungen hervorbringen kann. Es klingt etwa so, wie das Rascheln in gefallenen Blättern' ('but this is only a laughter which can be brought forth without lungs. It sounds something like rustling in fallen leaves'; our translation). Odradek's laughter is no proof of the existence of a body. It is not even proof of his activity. It is not the 'Rascheln der Blätter', the rustling *of* leaves (identifying an origin), but the 'Rascheln in gefallenen Blättern', rustling *in* fallen leaves. The words carefully avoid determining whether the rustling is for example made by a child running through the fallen leaves in autumn, or if it is an event that emerges between the leaves themselves. If the second description is more exact, then Odradek's laughter is autonomous and unconditional, so unconditional that it is even independent of a body. At most there is the materiality of the leaves, which in Kafka's time were the material media of literature, or 'writings'. And there is a certain mourning mingled into this laughter: the leaves are fallen, separated from the tree, dead.

The title makes clear that it is the Hausvater who narrates the story. Is the Hausvater a figure for the author? It is interesting to see how the text shifts paragraph by paragraph from the style of a dictionary entry into an autobiographical reflection by the narrator. Only in the last paragraph is there an 'I' who relates to Odradek. The Hausvater begins with a gesture of sovereignty, the authoritative view from above of the encyclopaedia, but ends with a gesture of mortality. The last paragraph is a reflection on mortality. 'Alles, was stirbt, hat vorher eine Art Ziel, eine Art Tätigkeit gehabt und daran hat es sich zerrieben; das trifft bei Odradek nicht zu' ('Everything that dies has before had some kind of purpose, some kind of activity, and has thus torn itself to shreds; this is not true of Odradek'; our translation).

The Hausvater, who gives a name to a child, fancies himself in a kind of assumption of sovereignty – an assumption, because proper names are never

real proper names, since they are names that are already given to others. But this gives this assumption a magical power over the future of the child too. The magical power to name has its origin in the power to decide over whether someone is to be included in or excluded from the circle of those who concern us; ultimately, it is the power to decide over the life or death of the Other. It is not the first border line to be drawn, but it is the most decisive. The *Sorge* of the Hausvater cannot be translated: it means worry, concern and care. *Sorge* vacillates between problems to get rid of and responsibilities to keep. It is connected to the Hausvater's own mortality. It is here that the phantasm of sovereignty is rooted; here lies the reason why it is a fetish, the warding off of death. If the Hausvater were not mortal, he would not be able to decide on the life and death of others. He would not know what the fear of death is like. But in the dependence and helplessness of each and every child, in its need to be cared for, the experience of the fear of death as experience of being abandoned is inherent. In the last paragraph the narrator speaks about his children and the children of his children in a caring manner. The right of the sovereignty to decide about life or death of the Other is therefore a kind of denial and reversal of one's own mortality. The last sentence then, the notion, 'aber die Vorstellung, dass er mich auch noch überleben sollte, ist mir eine fast schmerzliche' ('but the idea that he is likely to survive me, almost pains me'; our translation), is an admission of the narrator's own mortality. In relation to this mortality Odradek is a kind of rival, someone who survives a fight that is deadly to the narrator. There is a development from *Sorge* in the sense of care for another leading to *Sorge* in the sense of being worried.

The M/Other

In the first three paragraphs of the text the narrator avoids a personaliza-tion of Odradek. He speaks of *Wesen* (hardly translatable: being, creature) and *Gebilde* (even more impossible to translate: thing, form, shape, frame, creation, formation, construction, figuration). The sudden mention of the gendered pronoun *he* is surprising. It prepares for the final turn of the text.

Odradek has no determination and no intention. It is there, something that is given, a *Wesen*, an apparition or an event. *Wesen* is not used as a verb form in German, but it is one of the words Martin Heidegger used as if a noun was originally a verb. That something *west* (can we translate as 'performs being'?) is a constructed expression used by Heidegger in relation to art, beauty, truth and even to the *Gestell*, the frame that Heidegger uses as a definition of tech-nique. *Gestell* and *Gebilde* are concepts very close to one another. But in contrast to Heidegger, Kafka's *Gebilde* is not necessarily related to being. Here there is only a kind of presence. And it may be a presence without being.

It is much more likely that it is the presence of the Other that bothers the Hausvater, which sets him into an active as well as passive relation of *Sorge*. (There even is an open erotic dimension in the German expression *es jemandem zu besorgen*.) It is more the presence of the Other in the way Emmanuel Levinas (1981) understands it, a presence that is undefined, even undetermined; a presence that can be absence too. In the same way, Odradek cannot be framed by the difference between presence and absence, which is without territorialization in the topographic as well as in the chronological sense. The Other has no border. Therefore it is impossible to determine how far away or how near Odradek is. Odradek's proximity has nothing to do with a spatial difference between distance and proximity. Odradek is there, even when it is 'in andere Häuser übergesiedelt' (once again a very German and untranslatable word: it means 'moved into other houses', but it is also to be transposed, to settle on another ground).

Another text that was written at the same time, not far from Prague, in Vienna, includes a reflexion on presence and absence that is as important as Kafka's narration: Sigmund Freud's considerations about playing with a spool that his grandson used to perform for a while, published in 1920 as part of his 'Beyond the Pleasure Principle' (1940). The text also connects the question of being abandoned and the experience of death with that of play. Freud's grandson would throw the spool away, accompanied by saying 'ooo'. Often, but not always, he would pull back the spool saying 'aaa'. The spool is an example of what Donald Winnicott (1971) calls a transitional object: it is not an object that has a clear shape which can make it distinct to the child. There is no fixed border between the child and the transitional object, but there are no clear positions either. It is a scene of constant shifts between presence and absence. It is less a matter of the absence and presence of a thing than of the absence and presence of a relation. The spool is not a symbol for the mother, as is often stated, but the relation between the child and the spool has a lot to do with the relation between the child and its mother, or with an emerging self and an Other that is part of the self and different at the same time.

Winnicott's theory of the transitional object is as much a revision of the psychoanalytic theory of objects as it is a topological theory or even an aesthetics of things in-between. The transitional or third space is also called the space of cultural or aesthetic experience, because it is the space in which new things can emerge. The third space has no borders; it is a relational space, not a container. It is a space that cannot be seen; it cannot itself be determined, but gives space to what emerges. It is a space that makes it possible for something to appear without being determined by it. This 'appearance' would be an aesthetic phenomenon. Kafka's text is about 'Die Sorge des Hausvaters'. The Hausvater wants to determine an origin, an identity, wants to set into a topographical order. But he fails. Odradek is different.

Border Beings

Odradek is like a toy or like a pet. Toys and cats are always being found in unexpected places. Part of what cats teach us when we close the door after them, only for them to turn around and want to go back in again, is not that we desire that which is inside the door, but that we do not want to be shut out. The text tells us that Odradek is to be seen in marginal and in-between spaces. The conversation with Odradek takes place on the threshold, on the steps just outside the door. Odradek is like a migrant, he is interrogated at the border of the house, he is asked his name and his abode. One talks to it like a child, the text tells us. Odradek is a border being, and takes with it the border to many places.

A border being, perhaps not a border subject. The border subject would be somebody who both relates to the border and makes the border tangible. Borders only exist inasmuch as they can be sensed, made the objects of aesthesis. This is what makes them both less and more than the principal of sovereignty. In Homi K. Bhabha's terms, one can be 'less than one *and* double' (1994: 100). Perhaps what people call border subjects are not subjects at all (see also the chapter on Waiting). Odradek is both a thing and a person at the same time. With the help of one of its points and a rod, the text tells us, it can stand as if on two legs, and become something which one can speak with.

Because we are asking Kafka's text how sovereignty works, we may ask whether Odradek is bare life or full life. Following Giorgio Agamben (1998), the sovereign is related to the ability to reduce to bare life, and sovereign territory is defined by the in-between spaces of bare life. Yet the notion of bare life does not escape the economy of the sovereign. While bare life is a strategy of denying the position of the subject to another person, Odradek seems not to want a subject position. Odradek does not seem to want to belong or to be acknowledged. Odradek is not something human that has been reduced to bare life. In Louis Althusser's terms (1971: 163), Odradek would not be conditional on being addressed. Odradek does not want to become a sovereign subject by ordinance of the sovereign, by being interpellated by the police. Odradek is rather a fragment without a lack, enough in itself, a figure for something that cannot be named: the manifestation of the border that only exists in its manifestation. There are no lungs behind its voice and no territorializable meanings behind its words. As a fragment, Odradek could be the object of melancholy, but being without a lack, Odradek is an indeterminable, unconditional subject.

While Odradek may be a fragment, the narrator explicitly emphasizes that there are no traces that may be read as results of a fragmentation: 'das Ganze erscheint zwar sinnlos, aber in seiner Art abgeschlossen' (we have given this

as 'the whole thing looks rather senseless, but in its own way complete', translating *abgeschlossen* as 'completed'). Completed (the Muirs translates it as 'finished') suggests that it is something made, but *abgeschlossen* also means 'closed'. Odradek is 'das Ganze', the whole, not only a 'whole thing'. Odradek may be in-between all human categories and borders, but that doesn't mean that it is broken.

There is a cultural and literal history of in-between beings, of beings in-between life and death and of beings in-between geographical borders. Very often they are in-between in both senses: like Kafka's own 'Jäger Gracchus', which belongs to the long tradition of the figure of wandering Jew; like Heinrich von Kleist's 'Bettelweib von Locarno' who drives the Marquise (the one who marked her!) into madness; like Maxine Hong Kingston's Chinese and American ghosts in her *The Women Warrior*; like Toni Morrison's 'hot thing' in *Beloved*; or like Gibreel Farishta and Saladin Chamcha in Salman Rushdie's *Satanic Verses* who survive the crash of their aeroplane as angel and devil; just to mention some of them. All of them are marked by a traumatic experience. They are wounded, murdered, or at least have witnessed death. They all have lived as human beings in their vulnerability.

Many ghosts appear on borders, chronological as well as topological borders. They appear at midnight, at doors, at crossroads or hills, or on certain ships like 'Jäger Gracchus'. There always is a strong connection between the border and the traumatic experience. Kleist's Bettelweib appears in the room in which she died. Even 'the old mole', Hamlet's father, is bound to his castle. Odradek also appears in the in-between, but it is not a fixed in-between of a certain house, rather it is the everywhere: 'Er hält sich abwechselnd auf dem Dachboden, im Treppenhaus, auf den Gängen, im Flur auf' ('He lurks by turns in the attic, in the stairwell, in the passages, in the corridor'; our translation). Once again the German expressions are barely translatable. *Dachboden* is a word that links the roof and the floor immediately together; *Treppenhaus* is not only a staircase but a house of stairs; *Gang* is derived from walk; *Flur* is etymologically linked with the English floor, but it is used to signify a region of a landscape, a meadow, as well as a corridor in a house. The word 'lurks' is an over-interpretation of the more neutral 'sich aufhalten'. It attributes a kind of intention, as if Odradek wanted to play peekaboo, or something more sinister. Nor can we say that Odradek 'haunts' the house, if we are to follow the text: Odradek is radically different, even to the ghosts of the in-between cited above.

The text makes clear that Odradek has no sign of a wound, nothing broken. Although the story was written during the First World War and published immediately afterwards, Odradek is seemingly not part of a world that is marked by vulnerability, by loss or the need of territorial realization of existence. Odradek has probably never experienced what we may call lack, because

he has never had a kind of aim, a kind of work or function. Again: 'Alles, was stirbt, hat vorher eine Art Ziel, eine Art Tätigkeit gehabt und daran hat es sich zerrieben; das trifft bei Odradek nicht zu', says the narrator. We translate: 'Everything that dies has before had some kind of purpose, some kind of activity, and has been worn out; this is not true of Odradek'. Death is not merely a border that mortal beings have to cross someday. Death for mortals seems to be a product of an everyday experience of work, of *sich zerreiben*, of friction with something else.

The narrator says it is 'natural' to treat Odradek like a child. 'Natürlich', 'naturally', he writes. Children are objects of *Sorge*, of care. But Odradek doesn't need any care. There are several child ghosts in literature: Morrison's Beloved is one of them. Beloved insists: 'I want to join'. Beloved is the memory of a history of violence. It is like the memory that reappears in a kind of repetition compulsion of the repressed, of the isolated, of the denied. Following Sigmund Freud, the repressed is always driven by the wish to be integrated in life, by the wish to join, to belong to. But again: this is not Odradek's story.

The Sovereign and the Aesthetic

Odradek seems to us to be a broken tool, a flat, star-shaped spool for thread. There are threads on it, but they are broken-off and tangled. A crossbar pokes out of its centre, joining on to the before-mentioned rod. It is in Heidegger's terms a *Zeug*, a tool and also a thing. But it cannot be used for anything. Its shape suggests borders in itself, the borders to something missing, the star-rays and broken threads suggesting the possibility of connections across borders, but then also a border to something missing. There is both proximity and distance in its form or lack of form. It combines an image of practical use with a lack of practical use. In German, tools are *Zeug*, *Werkzeug*, but toys are also *Zeug*, *Spielzeug*. 'Mit Hilfe' – 'by means' – of one of its points and a rod, it can stand on two legs, but it cannot be used for anything except itself. We are invited again to think of Odradek, with its star-shape and colourful threads, as something aesthetic. In Kantian terms, the aesthetic (as disinterested) cannot be used for something else. But in Kafkian terms it does relate to the idea of use, even though it is undecidable. It is part of a relational web which has been broken.

Jacques Derrida (2009) shows that theories of sovereignty constantly return to images of the beast and the sovereign, and to the similarity between the sovereign and the subaltern as both being simultaneously inside and outside the law (see also the chapter on Waiting). Kafka's text shows us a way towards a theory of insovereignty, through the sovereign's responsibility to an indeterminable subject, Odradek. By insovereignty we do not mean lacking

in authority or rights, but a quality that cannot be the object of sovereignty, or subject to sovereignty. It is unconditional. It is something that escapes the desire of the sovereign – who is then revealed as precisely not sovereign, for it is in need of something outside itself.

For the Hausvater, Odradek is an aesthetic object, an object that cannot be mastered, and an object that does not allow the Hausvater to position himself and that ultimately makes him feel beside himself. He cannot locate Odradek as something Other, with clear-cut borders or identities. Odradek is different and places the Hausvater in an uncanny situation, leading him to think about the difference of death. The aesthetic thing, neither a subject nor an object, can be defined as something that has no need for sovereignty, and can therefore be experienced as uncanny. Maybe it has wishes rather than needs, for it cannot be located beside or outside itself, because it is not bordered. One cannot separate a theory of borders from a theory of the aesthetic.

There is another untranslatability in the title, in addition to those mentioned earlier. The Muirs translate 'Hausvater' as 'a family man', which means a man whose life is in the family. This gives emphasis to his *Sorge* as positive responsibilities. Yet the Hausvater in German, the house-father, is also 'the man in the house', the *pater familias*, the owner of the house. The Hausvater has the power to decide, which could also be a negative or despotic form of sovereignty. Yet as the text progresses, the Hausvater relinquishes his authority, transformed from objective some/Others, first to 'one', and then to a subjective and relative 'I'. His sovereignty is shown to be an assumption, with Odradek in the end standing for death. The Hausvater addresses Odradek as a 'he', transforming Odradek from a thing to a speaking being. Odradek retains its indeterminacy.

Initially it seems there are two parallel processes at work in Kafka's text, with the Hausvater and Odradek moving towards each other towards the end, gaining subjectivity. Such a double movement would mirror a crisscross historical process by which sovereign power has been disseminated and transformed into disciplinary power, while the marker of sovereign territory, the sovereign-as-territory, the border, has been disseminated into an indeterminate borderscape (see also the chapters on Imaginary and In/visibility). However, Odradek is only fleetingly subjected to a projection of subjecthood on the father's part, quickly moving beyond into the sphere of the immortal. It is impossible to localize Odradek at any one point on this range of positions between a non-thing and the god the Hausvater attempts to figure Odradek as.

The author similarly claims sovereignty over the text and thus over the past and future of Odradek. But what he decides is that the genealogy and death of Odradek are undecidable. He decides that they are not within his jurisdiction. His writing escapes him. What does Odradek tell us? That the aesthetic,

by situating itself in border spaces, may entice the sovereign into a state of insovereignty, making it possible for itself to become an undetermined and unconditional subject.

The Politics of the (In)Sovereign

We read in theories of sovereignty that there is an intimate connection between the sovereign and bare life. The sovereign constitutes itself by excluding an Other, by depriving an Other of all its rights and possessions. The sovereign is dependent on bare life, and there would certainly be no bare life without a sovereign. Both the sovereign and bare life exist both outside and inside the law. The sovereign has to go outside the law to make humans into bare life, but through this act the sovereign confirms its status as sovereign, as the guarantor of the law. Moreover, such structures result in times that are both inside and outside of the law, like the state of exception, and spaces that are both inside and outside the border, like the camp. Since the passing of the absolutist sovereign, inside/outside times and spaces have come to haunt modern forms of democratic and national sovereignty. The sovereign, the Hausvater, has become an anonymous principle, sovereignty, with no regal garments or indivisible political body. The Hausvater has no outer or aesthetic appearance, but rather inner responsibilities and power crossed by a net of relations. In daily language, sovereignty, once referring to the king or emperor, has long been used as a metonym for an indivisible territory (national sovereignty over a territory), within marked borders, but is now increasingly used as a term for democracy (the sovereign people), as in national debates on European integration.

These shifts can be understood as the historical product of both the American and French Revolutions. These revolutions replaced the sovereignty of the king with the sovereignty of the people. An archaeological interpretation of history would probably understand the terror of the French Revolution as result of these shifts. They continue to determine all democratic constitutions that allow the death penalty. The United States as a nation state is the most important current example of this kind of shifted sovereignty.

Moreover, these shifts are intimately connected with the dark side of the democratization of European nation states, namely their continued despotic arrangements in relationship to their overseas and internal colonies (see the chapter on Palimpsest). This despotism became an obvious and grotesque relic of a pre-Revolutionary conception of sovereignty in which territory is sovereign because it is seen as part of the king's body (the absolutist king *is* the state).

It is still at the borders that the paradox of sovereignty – both democratic and violent – is made visible, in the zones of exception from such rights as

habeus corpus that exist around them (Görner 2007: 62–63). Odradek in his unconditionality questions such relations in something of the same way that Derrida questions the analogies made between the two extremes of the sovereign and the beast. It wears the broken threads of sovereign spectacle. It presents us with post-human images of the border as a marker of unconditionality and a space to be inhabited without being hybrid.

And there again is the fundamental difference between the sovereign and the unconditional. The sovereign needs to relate itself to something that is dependent on him, that is in opposition to him, like the outlawed, following Agamben's theory, or is at least dependent on his power to decide about life and death. The independence of the sovereign is an illusion that only functions as long as there is a difference between the inside and outside of the law. But Odradek is neither inside nor outside of the law, Odradek is independent from every law.

Odradek in not unique in figuring the aesthetic in relationship to sovereignty in this way. In Herman Melville's 'Bartleby', for example, the narrator is presented as being in a similar position to his object, which escapes every attempt to be framed.

The Displaced and the Visibility of the Juridically Undetermined

Is it at all possible to follow Odradek and its logic of unconditionality out of Kafka's text, into other texts and discourses on borders and aesthetics? Before Kafka, Herman Melville presents his narrator as being in a similar relationship to Bartleby (in the story 'Bartleby, the Scrivener: A Story of Wall Street', 2004 [1853]), who escapes every attempt to be framed, and whose name is just as unique as Odradek's. Can we also find Odradek in the 'Saturday people' crossing the internal borders of the apartheid society in Nadine Gordimer's *My Son's Story*, crossing the boundaries around the 'white' town, compared to the territorial markings of 'some lordly wild animal' (1990: 12), crossing into the town libraries so as to be able to read Kafka? Can we find Odradek in the cashless exchanges of debt crisis in Greece in 2012 and its precarious existence on the borders of the Euro zone? Where is Odradek in the cross-border airspace of unmanned drones in the war on terror? In the spectacular building of border 'fences' in North America or the Middle East, and their subsequent transformation into resistant and melancholic art works? Perhaps we may at least learn something by reading such situations with Odradek's unconditionality in mind. This would be the true meaning of an aesthetics 'of' politics, that is, the aesthetics which politics needs, but which is unconditional.

What if we read J.M. Coetzee's *Life & Times of Michael K* (1985 [1983]) having Odradek and its unconditionality in mind? What if we start to read

Djuna Barne's *Nightwood* (1995 [1936]), and all the other stories of becoming animal, in this way?

Perhaps Odradek is there, in all these places and times. One only has to see it. There is another reading of Odradek possible, perhaps even necessary – for us, not for Odradek. Odradek's immortality seems to be a kind of utopian counterfigure to the experience of violence and death of the First World War. Some 15 to 20 million died in these years because of the war, more than a third of them civilians. And millions survived in psychologically traumatized and bodily disabled states. A new industry of prosthesis emerged during these years. The artificial arms and legs of Odradek are made of wood. Odradek's sticks that allow him to stand like on two legs, 'wie auf zwei Beinen', seem to be made of wood, Odradek even seems to be wood, 'wie das Holz, das er zu sein scheint' (that is 'the wood he seems to be', not the Muirs' 'as wooden as his appearance'!). Odradek seems to be 'mit Zwirn bezogen', covered or clothed with thread or twine (not the Muirs' 'thread wound upon it'). *Zwirn* is a highly polysemous expression in German, especially in Kafka's time. Grimm's etymological dictionary lists examples where *Zwirn* is used to signify the continuity, power or strength of life, even of masculine sexuality, or, in Austrian German, a rigid military behaviour (Grimm and Grimm 2016). The last signification probably derives from another use of the word: *Zwirn* also signifies a special kind of fabric, a rough fabric that was used for uniforms. But Odradek's pieces of twine or fabric are rotten fragments, they are of different colours and materials, they are not woven, but 'ineinanderverfilzt', 'felted' into each other, inextricably linked. They are not brought together in a planned, structured way or through the intention of a third person, they just happen to be connected. They could be fragments of uniforms of all kinds, just as they could be fragments of other written texts.

If we continue to remember that this text was written during the First World War it becomes less and less possible to read the introductory passage about the origin of the name Odradek as a peaceful or academic discussion. One of the two main front lines of the war was between German and Slavic-speaking people. Kafka was writing in a time of crisis for the Austro-Hungarian empire in which he had grown up, a crisis which seemed to be a direct result of conflicting German and Slavic nationalisms pointing towards the assassination of an Austrian crown prince by a Bosnian Serb which marked the beginning of the war. The Hausvater bears traits of Franz Kakfa's sovereign until 1916, the Emperor Franz Joseph I of Austria, stereotypically portrayed as the imperial *pater familias*, the imperial bureaucrat dutifully bearing the burdens or the *Sorge* of his enormous double monarchy (Decloedt 1995: 89, 99, 104).

But what is Odradek then if he bears the traits of war victims, which nevertheless are neither disabled nor traumatized? In her *Origins of Totalitarianism*, in its first English translation published as *The Burden* [Sorge] *of Our Time*,

Hannah Arendt (see also the chapters on Ecology and In/visibility) says that the twentieth century brought a phenomenon into the world which was previously unknown to history: the refugees, the displaced persons, those that have no citizenship, that belong to no state, that have no rights which are guaranteed by a state power (Arendt 1979). The existence of the refugee whose need to live in another country is not immediately accepted, who has no possibility of migrating to a 'free' country, is followed by the existence of the concentration camp, of territories, where no legal right is applied. The refugees, the camps change the global political relationships in a profound way. If nation states cannot guarantee their lives, it is necessary to limit the sovereignty of the nation state. And if there is only one world without blank spaces, without an outside, this problem cannot be solved by a 'higher sovereign'. Human rights must be independent of a nation state. There has to be a right to have rights without a nation state that guarantees this right.

There are only three words in Kafka's text which actually stem from Odradek: Odradek's name and Odradek's answer to the Hausvater's question about where he has his residence: 'Unbestimmter Wohnsitz'. This is not a juridical category. 'Unbestimmter Wohnsitz', '[i]ndeterminate abode', is very likely a unique expression never used before its appearance in this text. It refers to the established juridical category *unbekannter Wohnsitz*, 'unknown abode', which is used when a person refuses to identify themselves. Another juridical expression would be 'ohne Wohnsitz', 'without abode', which is used for people who have no residence. What then is an 'unbestimmter Wohnsitz'? At first sight it seems to be a contradiction or oxymoron, because the word *Wohnsitz* addresses a form of fixing: it sits (*sitzen*), it is not moving. Is it possible that something sits and does not determine the ground it is sitting on? Or is not determined by the ground? The juridical definition would be that the *Wohnsitz* is determined by the nation state and by the commune: it determines that we are Norwegian, German or English citizens, that we live in Tromsø, Düsseldorf or London. Odradek says about himself that he has a *Wohnsitz*, but none determined by a third party. Odradek lives in a place that is neither determined by juridical concepts, nor by topographical concepts that identify an existence with the place that is inhabited by it. But Odradek belongs to a place, to a milieu, to the relation he is living in. Perhaps Odradek then gives an idea of what a right to have rights could be in times of globalization. Perhaps it helps us to start to see those that are made invisible by the nation state.

With the act of establishing a border and a difference between an inside and an outside, the sovereign also establishes an order of visibility, an epistemological border. It is not so much that all that is outside has become completely invisible. There is always some news of the other side. But what is outside has lost the right to be seen, the right to be acknowledged as being

worthy of protection. In this respect, the visibility that is established by the sovereign is always accompanied by the denial of the visibility of what came before, of what is earlier to each and every act of the sovereign: an in-between or transitional space of relationality. This space has no borders that would shape it. It is constantly moving with the things that constitute it through their relations. And these things look different from the things that are the objects of the sovereign's discourse. Like Odradek, aesthetic objects are unfinished and fragmented but nevertheless wholes, lacking in nothing.

The aesthetic object often fascinates the sovereign. As the sovereign refers to the outside of law as the origin of his supremacy, as the sovereign has to present himself as the one who is inside and outside the law at the same time, he tries to assimilate the aesthetic object by adorning his power with monumental architecture or decorative garments. There is an uncanny parallel between the presidential or royal box in the opera house and the fact that musicians were forced to play Beethoven in the concentration camps. But what Kafka says with his 'Odradek' is that the aesthetic thing or object cannot be appropriated by the sovereign, that it confronts the sovereign with his own limitation, with his desire and his mortality.

When Derrida (2009) sets unconditionality in opposition to the sovereign, he attempts to think through something, which is neither based on a contract nor on reversibility, replaceability or repeatability. It has to be something that is of a social nature, but not subsumed to a law, and something that is not part of the system of representation: visible, but not identifiable. Derrida tried to think this using different concepts – gift, given time, forgiveness, the figure of the Other – but over and again the aesthetic – literature, poetics, painting. But art often dramatizes the difference between the unconditional of the aesthetic experience and that of the sovereign, who has the power to decide the attribution of signification. This is the case in Kafka's little story about Odradek. In his vulnerability and his fragmentation, he retains a moment of utopia. He is able to detach and evade; one cannot not frame him, not border him, and perhaps he even is immortal.

Reinhold Görling has been Professor of Media and Cultural Studies at Heinrich-Heine-Universität Düsseldorf since 2002. He has taught Comparative Literature at the University of California, Irvine, the Universität Innsbruck, and the Universität Hannover. His research interests include media philosophy, aesthetics and ecology, visual culture and transitional justice. His publications include *'Dinamita cerebral': Politischer Prozess und ästhetische Praxis im Spanischen Bürgerkrieg*, Frankfurt 1986; *Heterotopia: Lektüren für eine interkulturelle Literaturwissenschaft*, Munich 1997; and *Szenen der Gewalt: Folter und Film von Rossellini bis Bigelow*, Bielefeld 2014.

Johan Schimanski (Dr. art.) is Professor of Comparative Literature at the University of Oslo and Adjunct Professor of Cultural Encounters at the University of Eastern Finland; he was, while working on contributions to this book, Adjunct Professor at UiT The Arctic University of Norway. He has co-cordinated research projects on Arctic discourses, border aesthetics, Arctic modernities and within the EU FP7 project EUBORDERSCAPES. He has co-edited the volumes *Border Poetics De-Limited* (2007), *Arctic Discourses* (2010) and *Reiser og ekspedisjoner i litteraturens Arktis* (2011). Recent publications include 'Border Aesthetics and Cultural Distancing in the Norwegian-Russian Borderscape' (*Geopolitics*, 2015) and (with Ulrike Spring) the monograph *Passagiere des Eises: Polarhelden und arktische Diskurse 1874* (2015).

BIBLIOGRAPHY

Agamben, G. 1998. *Homo Sacer: Sovereign Power and Bare Life*, trans. D. Heller-Roazen. Stanford, CA: Stanford University Press.

———. 2011. *The Kingdom and the Glory: For a Theological Genealogy of Economy and Government (*Homo Sacer II, 2*)*, trans. L. Chiesa and M. Mandarini. Stanford, CA: Stanford University Press.

Althusser, L. 1971. 'Ideology and Ideological State Apparatuses (Notes towards an Investigation)', trans. B. Brewster, in *Lenin and Philosophy and Other Essays*. London: NLB, pp. 121–173.

Arendt, H. 1979. *The Origins of Totalitarism: New Edition with Added Prefaces*. New York: Harcourt Brace & Company.

Barnes, D. 1995. *Nightwood: The Original Version and Related Drafts*. Illinois: Dalkey Archive Press.

Bhabha, H.K. 1994. *The Location of Culture*. London: Routledge.

Coetzee, J.M. 1985. *Lifes & Times of Michael K*. London: Penguin.

Decloedt, L.R.G. 1995. *Imago imperatoris: Franz Joseph I. in der österreichischen Belletristik der Zwischenkriegszeit*. Vienna: Böhlau.

Derrida, J. 2009. *The Beast and the Sovereign: Volume I*, trans. G. Bennington. Chicago: The University of Chicago Press.

Freud, S. 1940. 'Jenseits des Lustprinzips', in *Gesammelte Schriften*. London: Imago, vol. XIII, pp. 1–69.

Gordimer, N. *My Son's Story*. London: Bloomsbury, 1990.

Görner, R. 2007. 'Notes on the Culture of Borders', in J. Schimanski and S. Wolfe (eds), *Border Poetics De-limited*. Hannover: Wehrhahn, pp. 59–74.

Grimm, J. and W. Grimm. 2016. 'Zwirn', in *Deutsches Wörterbuch von Jacob Grimm und Wilhelm Grimm auf CD-ROM und im Internet*. Retrieved on 21 May 2016 from http://woerterbuchnetz.de/DWB/?sigle=DWB&mode=Vernetzung&lemid=GZ13743.

Kafka, F. 1994. 'Die Sorge des Hausvaters', in *Ein Landarzt und andere Drucke zu Lebzeiten*. Frankfurt am Main: Fischer Taschenbuch, pp. 222–223.

_____. 1995. 'The Cares of a Family Man', trans. W. Muir and E. Muir, in *The Complete Stories*. New York: Schocken Books, p. 473.

Levinas, E. 1981. *Otherwise than Being: or, Beyond Essence*, trans. A. Lingis. The Hague: Martinus Nijhoff.

Melville, H. 2004. 'Bartleby, the Scrivener: A Story of Wall Street', in *Great Short Works of Hermann Melville*. New York: Perennial Classics, pp. 39–74.

Winnicott, D.W. 1971. *Playing and Reality*. London: Tavistock Publications.

�� 6 ⊷

Waiting

Henk van Houtum and Stephen F. Wolfe

To a large extent a border can be considered a waiting act. A border causes a standstill, a distance and difference in time and space. As any border is a Janus face (Van Houtum 2010) consisting of two mutually reinforcing faces of inclusion and exclusion and of openness and closure, so too the waiting consists of two categories which are mutually reinforcing. Waiting is both an inclusion and an exclusion at the same time. One the one hand, there is the waiting in terms of waiting for the 'final border', which involves degrees of subjectification and internalization of the state by those who are based in a given territorial order, and through which citizens are included and being made ('citizenizing'). And on the other hand, there are the exclusionary waiting practices as authorized by a border guard (the b/ordering and 'state-ization' of territory and people in the name of the 'law'), which goes hand in hand with the Othering for others who wish to enter (Van Houtum and Van Naerssen 2002).

To aesthetically illustrate and exemplify the first kind of waiting, inclusionary self-bordering, we will use the powerful parable 'Before the Law' (1914–1915) by Franz Kafka. In this short piece, using his typical Kafkaesque both intriguing as well as estranging style, he portrays an individual who waits to come before a state system of authority, and the limitless postponements and adjustments society makes through its officials to subjectify and control the expectations and rights of such individuals. For this latter exclusionary category of waiting, we will consider the allegorical presentation of waiting at the border in J.M. Coetzee's *Waiting for the Barbarians* (1980). In this novel, a border community identifies their citizenship with a settlement in a border zone, while they await a perceived transgression of their borders by an invading 'barbarian force'. The borders they construct and those protected by the Empire's army embody societal and personal insecurities on the periphery of 'the Empire'. In Coetzee's text, the border security force must discipline the citizenship and must 'spy' on both its citizens and the 'barbarian' Other. The imaginary geography is a borderscape that contains, both outside it and

within it, the 'barbarian' Other who figures a desire for and the fear of political authority. It is a practice of b/ordering and Othering in which, as is often the case when it comes to anti-migration, security and anti-terrorism, border policies make an appeal to an 'exceptional state of emergency' as a necessity (Arendt 2007). And in turn this potentially further provokes the first waiting practice, the inclusionary self-encaging of ourselves. What we are waiting for then crucially is dependent on our own fears and desires, as we will make clear. But let us first begin with Kafka's parable on waiting, in which he portrays a man from the country who is waiting his entire life.

Kafka's Waiting

Before the Law
Before the law sits a gatekeeper. To this gatekeeper comes a man from the country who asks to gain entry into the law. But the gatekeeper says that he cannot grant him entry at the moment. The man thinks about it and then asks if he will be allowed to come in later on. 'It is possible', says the gatekeeper, 'but not now'. At the moment the gate to the law stands open, as always, and the gatekeeper walks to the side, so the man bends over in order to see through the gate into the inside. When the gatekeeper notices that, he laughs and says: 'If it tempts you so much, try it in spite of my prohibition. But take note: I am powerful. And I am only the most lowly gatekeeper. But from room to room stand gatekeepers, each more powerful than the other. I can't endure even one glimpse of the third'. The man from the country has not expected such difficulties: the law should always be accessible for everyone, he thinks, but as he now looks more closely at the gatekeeper in his fur coat, at his large pointed nose and his long, thin, black Tartar's beard, he decides that it would be better to wait until he gets permission to go inside. The gatekeeper gives him a stool and allows him to sit down at the side in front of the gate. There he sits for days and years. He makes many attempts to be let in, and he wears the gatekeeper out with his requests. The gatekeeper often interrogates him briefly, questioning him about his homeland and many other things, but they are indifferent questions, the kind great men put, and at the end he always tells him once more that he cannot let him inside yet. The man, who has equipped himself with many things for his journey, spends everything, no matter how valuable, to win over the gatekeeper. The latter takes it all but, as he does so, says, 'I am taking this only so that you do not think you have failed to do anything'. During the many years the man observes the gatekeeper almost continuously. He forgets the other gatekeepers, and this one seems to him the only obstacle for entry into the law. He curses the unlucky circumstance, in the first years thoughtlessly and out loud, later, as he grows old, he still mumbles to himself. He becomes childish and, since in the long years studying the gatekeeper he has come to know the fleas in his fur collar, he even asks the fleas to help him persuade the gatekeeper. Finally his eyesight grows weak, and he does not know whether things are really darker

around him or whether his eyes are merely deceiving him. But he recognizes now in the darkness an illumination which breaks inextinguishably out of the gateway to the law. Now he no longer has much time to live. Before his death he gathers in his head all his experiences of the entire time up into one question which he has not yet put to the gatekeeper. He waves to him, since he can no longer lift up his stiffening body. The gatekeeper has to bend way down to him, for the great difference has changed things to the disadvantage of the man. 'What do you still want to know, then?' asks the gatekeeper. 'You are insatiable'. 'Everyone strives after the law', says the man, 'so how is that in these many years no one except me has requested entry?' The gatekeeper sees that the man is already dying and, in order to reach his diminishing sense of hearing, he shouts at him, 'Here no one else can gain entry, since this entrance was assigned only to you. I'm going now to close it'.

This powerful, fascinating parable of Franz Kafka on waiting,[1] which we cited here in full, was first published in 1915. Ever since it was published it has fascinated many readers. For us and for the purpose of this book, we will zoom in on how the border is portrayed in this parable. The border presents itself as a framing gate that, precisely because it is closed, initiates the question of what lies beyond. As such it offers an unknown possibility by stimulating the man's curiosity as to what is to be found on 'the inside (*das Innere*) ... – not the law itself, perhaps, but interior spaces that appear empty' (Derrida 1992: 203). The threshold figure of the gate constitutes 'a difference between an emptiness and a binding secret' (Vismann 2008: 15), resisting the doctrine of categories by suggesting immense possibilities.

The man is waiting all his life to have permission to enter this imagined world of possibilities. The principal activity of the man from the country therefore is waiting. It is this waiting that is most telling, for to wait is to discipline oneself. Waiting calls for a standstill, a fixation on a place and subjection to the passing of time. It makes you aware that you are not taking part in other activities; you cannot spend your time in other places when you have decided or are forced to wait.

What is perhaps most striking in Kafka's text is that the man from the country is allowed entrance, but *not now*. And this 'not now' is a permanent status. It is precisely the waiting 'before' the Law and this 'not now' that installs and reproduces state power and creates the internalization of control. The man from the country controls and disciplines himself in a Foucauldian sense by waiting on a stool at the gate. To a large extent, perhaps we are all a man from a country at various moments of our lives. For, what the terms waiting 'before' the Law and 'not yet' illustrate are a destiny, a future, a promise, a life beyond the present reality, which can only be reached through training, devotion, honesty, working or even suicide, depending on whatever the promise consists of. It is this promise of good behaviour, of good internalization of

the dominant order, the imagined final appreciation that is constructing the social self, the waiting self. The consequence of this waiting act is that we live our lives in a 'not now' and not yet status, in flux of constant be-coming, of indefinite postponement.

In Kafka's text the Law constitutes an imagined order, a belief. It is a belief in the presence and continuity of a spatial binding power, which becomes meaningful and becomes objectified in our everyday social practices, expressed by the waiting of the man. The spatial separation that a border creates and represents is goal and means at the same time (Houtum 2011). The border makes and is made. A border should hence be seen as a verb, not a noun. As Van Houtum and Van Naerssen (2002) have argued, we should therefore rather speak of bordering. To border is a practice, it is a process of both internalization/subjectification of an in-land, in-side and 'in-laws' and the objectification/*Verdinglichung*/exclusion of the 'out-land', out-side, and potential out-laws.

The practice of bordering is to be understood as a continual space-fixing process that gives the impression of a finite physical process as if it concerned a physically identifiable entity with objective and unchangeable borders. The constitution of a border, a shared truth, creates an immediate satisfaction for a short time, but the consequence is a long-term desire for new appropriations and control of the truth when this truth is threatened (Van Houtum 2010). The desire, the wish for the (comm)unity of tomorrow, the dream of the national utopia, the imagined world of possibilities beyond the not yet, is never-ending.

And what is seen as a utopia or truth in one domain can be a lie in the space and/or eyes of an Other (Van Houtum 2011). Borders are only the construction of a reality and truth in a certain context, in a certain spatial entity. It is the performative act of believing which makes a border real and truthful. The belief in a fantasy of a true life produces the necessary illusion that what is lacking in one's identity is filled, that one's (personal) order can be unified, causally referential and coherent. To border oneself is to discipline oneself to an order, it is to create oneself, to create a social self. It gives meaning to our selves. It fills the 'holes', it makes a whole. Believing in the truthfulness of a self-devised b/orderly scheme of reality is believed to mean that some of the vulnerability and doubts one lives with can be reduced. Believing in the constructed and imagined community helps one to gain some control over the complexities of life. Borders must therefore be seen as a strategic effort of fixation, of gaining distance and control in order to achieve ease (Van Houtum and Van Naerssen 2002).

Although the b/order is an imagined-and-lived reality, that does not stop the desire for the true Self. The true b/order has no end, for realizations of wholeness never align with the fantasy perfectly. The perfect identity is

always there, beyond the threshold, beyond the gates of the Law. The identity is the desire of a self or order that is an unattainable Other. The emptiness of the Law produces a contingent reality and contingent rituals of truth keeping and aesthetic production for those who wish to maintain the constructed b/order.[2] That means that the lack of fulfilment is perpetual and the final truth of the b/ordered self is unattainable. In the words of the guard standing before the Law in Kafka's parable: 'you are insatiable'. The man from the country is waiting before the Law, and by internalizing and believing in the fantasy of the Law he has found a pseudo-home, an in-the-meantime-home at the gate, yet his desire to unmask the void, to have access, to know the truth, to truly come home, is 'insatiable'. This feeling of inexhaustibility is also constructed by the gatekeeper who warns him already in the beginning of his life, when he first sought permission to enter, that there was no end indeed in searching for the truth, for after the first gatekeeper there are only more gatekeepers, even more powerful and harder to get past than him. There is no final truth. Perhaps, extending Kafka's text, like the man from the country, we as human beings are outsiders to our own lives. We cannot enter definitely and forever into one's own Law: there is no final homecoming. And to fill in that lack, we create a fantasy-home by waiting before the Law, a simulacrum-home, illustrated by the stool the man from the country sits on. As such, we necessarily live in a condition of not yet and never will be. We are unavoidably living in the meantime. We are unavoidably waiting before the Law.

It is well known that Nietzsche advocated a powerful remedy for this condition, an escape from this emptiness, this void that is created by the self-disciplinary waiting for a permanent not yet (Nietzsche 1987). In his eyes, nihilism's destructive effects could and should be overcome through the transcendence of man into an overman, the Dionysian *Übermensch*. The *Übermensch* is characterized as someone who possesses the 'will to power', who affirms life, acts out of passion, creates spirit and love. The *Übermensch* acts above and beyond oneself. Becoming an *Übermensch* is a practice of self-overcoming. In a way, therefore, Nietzsche's project is about the self-enlightenment of the Enlightenment, about pointing at the borders of truth, the ratio and the Law (Safranski 2000).

This desire for transcendence, to transcend the borders set out by the Law, to enter the gate, is lucidly present in the parable 'Before the Law' by Kafka. But crucially in Kafka's story, the man is waiting. He does not liberate himself. He does not escape. Seen in this light, Kafka's parable is in fact a testament of the subject. The man from the country denies life by waiting his entire life before the Law.

The Greek poet C.P. Cavafy famously has written about this connection between the death of the subject and the enclosing society around him, in his poem 'Walls': 'Without consideration, without pity, without shame, / they

built around me great and towering walls' (2007: 13). And this figure too is waiting: 'And now I am sitting here and despairing here. / I think of nothing else: this fate is gnawing at my mind; / for I had many things to do out there' (ibid.). Implicitly following Nietzsche's Dionysian desire, Michel Foucault aimed in his later works to find ways to free oneself from the internalization of the silencing and suffocating emptiness. To this end, he tried to theorize about what he labelled the 'aesthetics of existence', that is, on the practices and strategies of rethinking oneself, of liberation and de-subjectification, of the ethical self.

Equally provocative and disobedient as Foucault, but with a different tone and style, Gilles Deleuze and Félix Guattari made it their theoretical goal to theorize on this Nietzschean aspiration for the nomadic, the escape from desiring our own repressive order (Deleuze and Guattari 2004a, 2004b). For Deleuze and Guattari there is an internal struggle between order and flight, what Nietzsche termed the Apollonian versus the Dionysian will to power. Each human moves then between these two poles of monadism and nomadism, or what they label as the paranoid desire and the schizoid desire (Van Houtum 2010). And crucially these desires do not stem from a natural lack, as Freud and Lacan had argued, but are principally socially produced. Society in their eyes is a desire-machine.

The paranoid desire is to be interpreted as being homesick, a desire for order, easiness, nihilism, control, security, comfort, hence the desperate desire for the truth here, the desire for self-repression and disciplining. This desire represents the politically inspired and socially constructed human desire to internalize the b/order, to be subjected, to be-long to this side of the gate, to be a subject made to wait for the promise that is implicit in the bordering of any space: to wait for tomorrow, the near future, the fulfilment of the dream that is the order. In a sense, this waiting is liberating, it gives one a task, a meaning, a social function and a potential identity. But at the same time this desire is a fear: a fear of being overwhelmed by emptiness, by a barbaric madness of total freedom, the fear of being without a b/order, of becoming a stranger (to) oneself, and of being non-existent, of becoming, as Giorgo Agamben puts it, profanely, like the Law itself, pure but empty, a man without content (Agamben 1999). In other words, it is the fear of the Dionysian Overman, the NoMad, the NoMan, the NoWhere, the NoNow, the spatio-temporal emptiness.

On the other hand, there is the schizoid desire of endless becoming and transcendence, of being 'far-sick'. The practice of waiting at the border as a subject is potentially not felt only as a practice of liberation but also of containment, a self-imprisonment of one's multiplicity in a spatially ordered box set out by others. The sentence of imprisonment is therefore precisely this: waiting for the Law to be merciful, waiting for the gates to be opened, the endless waiting at the stool. The fear here is of being suffocated by a repressive

total love, of the lie of the border, of being caged by a communal order, the fear of becoming a monadic Subject, of alienating oneself from the transcendent self, of denying life. The desire then is not to wait in a pseudo-home, to desperately long to be somewhere else. This is the desire to de-border oneself, to turn to the Other, to long for the Other in oneself, to become a stranger oneself, to free oneself from the surrounding, silencing walls, to be outside the Law, to be without the repressive social mask, to be a naked man.

The law of the territorial border then is the constantly moving navigational route that is the result of sailing between the Scylla of the free but Law-breaking anti-social and the Charybdis of the social but self-repressed. In other words, the border is in principle a Janus-faced continuum (Van Houtum 2010). Janus was the Roman God of the end and the beginning, the guard between the world above and the nether-land, and between the centripetal, inward oriented and the centrifugal, the outward oriented face.

We would argue that the totalitarian, monadic order, as well as the totally nomadic schizoid, cannot be reached, as this would lead in both cases to the destruction of the self. Radical paranoia, the home of the omnipresent ever-watching, and inescapable order, would result in the neurotic destruction of the individual self; and radical psychosis, the endless unbounded escape, would lead to a maniacal destruction of the social self. Hence, necessarily, if one does not wish to lose or destroy oneself, there must be a balance between the two poles of desires/fears. So the question Nietzsche puts – how much truth do we need or can we bear – must, as Safranski (2003) later did, be contrasted with the question: how much liberation, how much openness can we bear? The desire for the self-defining subjective order and liberating disorder are generally operating at the same time at once. Desiring therefore has no end, no final fulfilment, as there will always be that other contrasting desire which lurks and pulls us back. Therefore, as there is no end in desiring, equally there is no end in fearing. On this waiting continuum, the delineation of the border is, then, ongoing and dynamic, crucially contingent on our own co-production of our fears and desires.

Coetzee's Waiting

Let us now turn to Coetzee's novel *Waiting for the Barbarians* and see how border fears and desires, and how a state of waiting before and at borders, is used there. Published in 1980, Coetzee's third novel *Waiting for the Barbarians* was the work that brought him international acclaim. Set in an unspecified time and place, the novel has more often than not been read as an allegory with a strong focus on the South African security police, as the language of the novel reflects the language of the apartheid regime. More recently it has

become a useful text for examining the ways in which a state borders through exclusion, justifies torture, the creating of camps as 'states of exception' to let people wait before the Law, and the ways in which ordinary laws became the object of exception post-9/11 (Crocker 2007). Several critics, as well as Coetzee himself in his article 'Into the Dark Chamber' (1992), encouraged such a reading. In fact, Coetzee speaks about the dark scenes of torture in the novel and their erotic appeal for the reader. They are the origin of 'novelist fantasy per se; in creating an obscenity, in enveloping it in mystery, the state creates the preconditions for the novel to set about its work of representation' (1992: 364). Coetzee is aware of the aesthetic dilemma for the novelist: 'The true challenge is: how not to play the game by the rules of the state, how to establish one's own authority, how to imagine torture and death on one's own terms' (Ibid.).

Both Kafka's and Coetzee's texts begin with a prohibition: an act of forbidding action or of forbidding a person to act by command or decree. They also begin with a 'primitivescene' (Cixous 2011b: 86) of the annunciation of a secret, something hidden away due to a prohibition which is announced as an initiation (a period of probation): no one is 'supposed either to know or to ignore the Law' (Cixous 2011a: 76). In both fictional texts, the only hope seems to be for the central character to know how long to wait to pass through the door, which controls the threshold space, the liminal site marking the interspace of being inscribed into the law. All accede to a demand not to try to gain access, at least, 'not yet'. Unable to cross the threshold, they wait: their gatekeepers are both interrupters as well as go-betweens. They are before the law but already in it: paused subjects awaiting orders.

Let us see now how this is developed precisely in Coetzee's novel. To begin with, we will zoom in on the Magistrate. In the novel the Magistrate is a border guard both implicated in and self-consciously critical of the 'the Law'; 'one thought alone preoccupies the submerged mind of Empire: how not to end, how not to die, how to prolong its era' (Coetzee 1980: 133). He is 'no less infected with it than the faithful Colonel Joll' (ibid.), who later arrives with his assistant Mandel and an army to help maintain order. Both men have parts to play in 'the first line of defense' (Coetzee 1980: 52) of the Empire and both are isolated from other people. While the Magistrate considers himself a foreigner in the land through his work for the Empire, he is at home on the frontier since he was born there and is in the process of writing its history. He feels that the acts committed within his jurisdiction, in the name of Empire and necessity, are acts that over time increasingly rob him of his individual authority and from which he seeks to distance himself. But he cannot distance himself from torture, rape, or 'the dark chamber' of interrogation that the army is using and of which he is part.

At the beginning of *Waiting for the Barbarians*, the Magistrate despairs when Colonel Joll's captives are not the barbarians he set out to find: 'Did

no one tell him the difference between fishermen with nets and wild nomad horsemen with bows? Did no one tell him they don't even speak the same language?' (Coetzee 1980: 19). Clearly, in making this point, Coetzee has been inspired by Cavafy's poem, 'Waiting for the Barbarians' which carries the same title as Coetzee's novel. The poem ends with the lines: 'And now, what's going to happen to us without barbarians? / They were, those people, a kind of solution' (Cavafy 2007: 17). In other words, the creation of Others is constitutive for the construction of an b/ordered 'we'. In a similar vein, Ania Loomba argues that the creation of the Other depends on binary oppositions, and 'are crucial not only for creating images of the outsider but equally essential for constructing the insider, the (usually White European male) "self"' (1998: 104). It is the Magistrate who is on the border between the barbarian and the We. He is the literal and metaphorical borderlander, one introspectively seeking a balance between his fears and desires. It is Joll who acts as the hard-ball believer in the above-mentioned Apollonian b/order. The army of the Empire and men like Joll, who act in its service, are in many ways 'foreign' to the land and the community, but 'necessity' has made Joll and his army essential in countering what he believes are existential threats from the enemy at the gate.

The novel is full of city gates and the building of barriers that create an ambivalent topography of Empire oscillating between torture room and incarceration, legal gatekeepers and prison guards, doorkeepers and executioners/torturers. Like in Kafka's parable, there is also in Coetzee's book a hierarchy of gatekeepers of the Law. The Magistrate claims he is the lowest of the legal intermediaries in a pyramid of gatekeepers whose apex is Joll and the Empire, even sovereignty itself. It appears that the first gatekeeper, the Magistrate, is sacrificed to enforcement of the b/order of state control. He will become the collateral damage: what begins in the torture of alien Others (Barbarians) gradually turns, as he begins to doubt the alienness of the barbarians and to dwell in the in-between space between ruler and ruled, into the torture of the Magistrate himself. He thinks he is only an 'interpreter of the law', but he is also its emissary.

Barbarian Girl Awaiting Torture

The other main character in the text, a barbarian girl, is central to any reading of the text and the representation of waiting at the border. Her presence in town is a disturbing factor for the Magistrate. Her father dies during interrogation and her people have abandoned her; like the Magistrate, she is solitary and isolated. The Magistrate, after discovering her, quickly takes up a peculiar relationship with her. Her body bears the marks of Joll's intensive torture

in a quest to search for an imagined hidden truth: her eyesight is damaged, leaving her only with peripheral vision, and her feet have been broken. From living outside on the streets, the Magistrate invites her into his chambers, and 'draw[s] the curtains, light[s] the lamp' (Coetzee 1980: 27), and asks to see her feet. The lamp, with its unforgiving light, makes it easier to scrutinize and see her, yet he can only see what is on the surface of her body. Then the Magistrate commences his cleansing ritual of washing the girl's feet. The Magistrate's search for truth, aligned with Joll's search for truth, is similar as they both take advantage of and attempt to invade the Other's body. In fact, twice in the text the parallelism is emphasized: first, when the Magistrate cares for the tortured girl by taking her into his arms: 'I undress her, I bathe her, I stroke her, I sleep beside her – but I might equally well tie her to a chair and beat her, it would be no less intimate' (43); second, when he considers that 'other cold man with the mask over his eyes who gave the orders and pondered the sounds of her intimate pain?' (148). This brings us to the imagery of seeing, a striking element in both Kafka's parable and especially Coetzee's novel. Not only is the barbarian girl blind, but it is also significant that Joll for most of the time wears dark glasses. These prevent the Magistrate from seeing Joll's eyes. They represent a way of avoiding recognition and scrutiny. Both Joll and the Magistrate assume they can see without being seen. Although he does not cast his eyes down *per se*, Joll is protected from the scrutinizing gaze of others, protected from the kind of gaze he exposes others to. Wolfgang Müller-Funk connects the act of casting one's eyes down to a feeling of shame: 'Shame is quite clearly a phenomenon of borders and limits. As Simmel points out, casting down one's eyes is not a manifestation of us not wanting to look at somebody, but a way of saying we do not want to have that somebody looking at us' (2007: 83).[3]

The Magistrate reads the girl's body as an articulation of imagined speech, a metonymy of torture. He tries to speak the marks on her body, to really see her and make them tell her story: 'she cannot but feel my gaze pressing in upon her with the weight of a body' (Coetzee 1980: 60). Or 'I am like an incompetent school-master, fishing about with my maieutic forceps when I ought to be filling her with the truth' (44). His relationship with her leaves him free to speak for the Other, she has a binding secret only he can reveal. While recognizing that his interrogations of her body might not withstand the light of day, he pulls the curtains creating concealment and allowing himself a body upon which to trace his desire. Yet the barbarian girl's body is a closed room to him since he can find no way of 'penetrating the surface' (43, 49).

Her body contains traces of torture, signifying a disturbance, an alterity. Homi K. Bhabha's reading of such situations is helpful here, the 'silent Other of gesture and failed speech … the Stranger, whose language-less presence evokes an archaic anxiety and aggressivity impedes the search for narcissistic love-objects in which the subject can rediscover himself' (Bhabha 1994: 166).

The Magistrate must force her to speak so that he can become an object of her imaginary desire. Thus the girl becomes the possibility for him to recreate himself yet his act of forcing her to speech is an act of torture. He has sought to bear witness to her suffering but he has no ethical capacity to admit equivalent communication, mirroring Joll's attempts to make the tortured speak 'truth' discussed below.

The Magistrate tells the cook that the torturers 'thrive on stubborn silence: it confirms to them that every soul is a lock they must patiently pick' (Coetzee 1980: 124), inadvertently referring to his relationship with the barbarian girl. The imagery here suggests that the picker of the lock does not have the key that fits the opening, but that he must find something suitable. This is an allusion to the body of the tortured boy at the beginning of the text when his torturer 'makes a curt thrust into the sleeping boy's body and turns the knife delicately, like a key, first left, then right' (10). After attempting to return the Barbarian girl to her native people, the Magistrate is accused of 'treasonably consorting with the enemy'; he soon finds himself subject to the same methods of torture used against the girl. The Magistrate seeks to be the 'one man who in his heart was not a barbarian' (102).[4] Earlier he has called Mandel, the man who has tortured him, 'one of the new barbarians usurping my desk and pawing my papers' (78) and sees himself as a 'go-between, a jackal of Empire in sheep's clothing' (72). Coetzee suggests such sentimental cynical discourse is a dead end. The issue here is that the Magistrate is always guilty of having participated in the acts of the tormentor first by his passive acceptance of the actions of Colonel Joll and later in his objectification of the barbarian girl's body as a site of torture.

The Magistrate has become increasingly connected with the barbarian girl as both her rescuer and her torturer. Several critics have argued that the Magistrate sets out to mend her body during torture, but in our opinion the masturbatory quality of his actions suggests a more selfish goal. The girl's body is always sexual to him but it also 'symbolize[s] the conquered land' (Loomba 1998: 152), which only he can redeem. The girl's body is also a landscape the Magistrate cannot penetrate as he hunts 'back and forth seeking entry' (Coetzee 1980: 43). The Magistrate's attempt to read and identify with the Other leads him to return to the rooms of torture.

Waiting to Torture

Like the stool in Kafka's parable, the torture room in Coetzee's novel becomes a constitutive border: inside, the victim is held in isolation, waiting. And the torture room itself will not bear witness: 'I stare all day at the empty walls, unable to believe that the imprint of all the pain and degradation they have

enclosed will not materialize under an intent enough gaze' (Coetzee 1980: 87). His exclusion is what spurs the Magistrate's search for 'the truth' of what has gone on at the border and in the garrison. His own waiting leads not to seeing but instead he hears rumours of 'the screaming which people afterwards claim to have heard from the granary' (4–5), so he questions his guards and the boy who was interrogated.

In another sense, these two rooms of torture, that of Joll and that of the Magistrate, parallel each other. For both the Magistrate and Joll cannot enter the room of torture other than as a torturer or a victim. Both are locked rooms, windowless, closed from sight but open to expressions of desire for the expression of 'truth' or the promise of forgiveness. His own room and the prisoners' cells cannot be fully scrutinized and will not allow him to bear 'witness'. Like Kafka's text, the novel is allegorical and tautological, revealing a desire for access to what cannot be known about the border itself (Vismann 2008: 20).

Coetzee has stated that the novel is about 'the impact of the torture chamber on the life of a man of conscience': the Magistrate (Coetzee 1992: 363). Furthermore, in his article 'Into the Dark Chamber' Coetzee suggests the torture room is a metaphor for the novelist's imagination: 'the novelist is a person who, camped before a closed door, facing an insufferable ban, creates, in place of the scene he is forbidden to see, a representation of that scene, and a story of the actors in it and how they come to be there' (1992: 364). This sentence is a reimagining of Kafka's *Before the Law*: the fear and the desire for access to a closed-off space on the other side of a border. The border that denies insight into the processes of institutionalization of the law is both self-created and structural. Both alienness and power are imagined and are therefore powerful structures that hold no key to unlock their secrets. While Coetzee seems to be suggesting that the novelist has the ability to cross the boundaries of a closed-off space through the use of their imagination, it is, however, a crossing only 'on one's own terms'. This leaves the author himself 'waiting': to recognize the Other's call, and thus to bear witness. This is a deeply problematic act: 'The witness speaks for someone who cannot speak for him- or herself; the witness's freedom of expression is subjected to the responsibility for Others' (Pinchevski 2001: 72).

Torture will cause a person to tell their story, 'pressuring' them into a narrative act that demands the torturer to interpret the prisoner's fear and desire to speak. When Joll is asked how he can know whether a prisoner is telling the truth or not, he explains:

> I am speaking of a situation in which I am probing for the truth, in which I have to exert pressure to find it. First I get lies, you see – this is what happens – first lies, then pressure, then more lies, then more pressure, then the break, then more pressure, then the truth. That is how you get the truth. Pain is truth; all else is subject to doubt. (Coetzee 1980: 4)

But the truth Joll finds is the story he has already set his mind on hearing. Recognizing this, the Magistrate advises the boy under interrogation at the beginning of the novel: 'Listen, you must tell the officer the truth. *That is all he wants to hear from you – the truth*' (Coetzee 1980: 7; emphasis added). Patrick Lenta's article 'Legal Illegality: *Waiting for the Barbarians* after September 11' argues that '[p]rolonged torture forces victims to try to comprehend the torturer's interests and present themselves in a way that is most likely to satisfy their torturers. After a time, the victim will say what he/she thinks the torturer wants to hear' (Lenta 2006: 75). The Magistrate in this instance functions as a gate-keeper/messenger encouraging the boy to 'confess'. However, when the boy has confessed, and told the 'truth', admitting that there is a 'barbarian' uprising, the Magistrate denies his own hand in it and confronts the boy about it: 'Do you understand what this confession of yours will mean? ... It means that the soldiers are going to ride out against your people. There is going to be killing. Kinsmen of yours are going to die, perhaps even your parents, your brothers and sisters. Do you really want that?' (Coetzee 1980: 11).

The Magistrate attempts to rid himself of guilt and moral responsibility. The boy is as powerless to stop an attack on the 'barbarians' as he is to withstand torture. And the Magistrate, who is equally unable to stop this attack, does nothing but transfer his guilt onto the boy. Later, when the Magistrate is tortured himself, he tells us: 'I discover with surprise that after a little rest, after the application of a little pain, I can be made to move, to jump or to skip or crawl or run a little further' (Coetzee 1980: 128). The Magistrate knows how far he can be pushed: 'I want to live. As every man wants to live. To live and live and live. No matter what' (130).

The Magistrate wants to save himself from the barbarity of the 'civilized': 'what has become important ... is that I should neither be contaminated by the atrocity that is about to be committed nor poison myself with impotent hatred of its perpetrators. I cannot save the prisoners, therefore let me save myself' (Coetzee 1980: 114). Watching his fellow townsmen, women and children all participate in the beating of the 'barbarian' prisoners, the Magistrate is determined to be the 'one man who in his heart was not a barbarian'. He wishes not to be infected by the dis/ease that has overtaken the town. While waiting for the 'barbarians' each new person captured will have the word 'ENEMY' written on their backs, and then will be 'washed clean' by being beaten. The ironic parallelisms with the Magistrate's washing of the 'barbarian girl's' feet and Mandel's washing of his hands are obvious. The Magistrate recognizes that 'A bestial life is turning me into a beast' (87), yet when tortured himself he traces the effects on his own body: 'They were interested only in demonstrating to me what it means to live in a body' (125).

Waiting at the Border: Toward an Ending

In the above we have illustrated how the border concept of waiting could be understood and illustrated in an aesthetical sense. Kafka's story, as Jacques Derrida has argued, is focused on both what is literature and what is the law, on who decides, who judges, and with what entitlement we say this is 'literature' (1992: 188).

What we see in both texts is an internalization of the desire to cross a border hoping that something is on the other side. Both the Magistrate and the man from the country are outside and thereby inside, and waiting before the Law. Each of these two texts is an aesthetic depiction of border performativity: each protagonist is carried to the threshold of his or her own story, before the door that opens them up to the law. At the beginning they are waiting on the edge of language that will constitute them as subjects within the Law. To be inscribed into the Law is to be made to appear 'before' the law, but does one then have access to the law? (Vismann 2008: 15). There is an intersection of form and context presented in each story's performances before the gate and by 'the gate keepers'. In each text the practice of allegorical representation and interpretation is dependent upon sight and what can be framed in outside/inside spatial analogies. Both texts move from these limited analogies, to complex presentations of multiple perspectives within the borderscapes of the nation state and the complexities of gaining access to what lies beyond the border.

The man from the country belongs to the Law while he waits for the doorkeeper's permission to even allow him entry for consideration of his case. The rite of passage and its attendant feelings of anxiety and tension are internalized, as the man becomes his own doorkeeper: he prevents himself, as he is both disciplined and policed by his own b/ordering. The man from the country imagines that behind the door the Law is present, yet the Law has no interior, there is no there There: 'the presence of the law is its concealment' (Foucault 1990: 33–35). In the words of Deleuze and Guattari, 'even if the law remains unrecognizable, this is not because it is hidden by its transcendence, but simply because it is always denuded of any interiority: it is always in the office next door, or behind the door, on to infinity' (1986: 45). In the words of Kafka in the parable: '… and I am only the most lowly gatekeeper. But from room to room stand gatekeepers, each more powerful than the other. I can't endure even one glimpse of the third'.

The point in Kafka's text is that precisely because there is no access to a central and unconcealed Law, the waiting at the border is a form of self-policing, a subjectification[5] of and by the citizen, and a state-ization of and by border

guards and the legal representatives of the State. The waiting act, which is enacted by a border guard and border-crosser, is part of what Deleuze and Guattari have termed the same 'machine' and that machine of justice is a machine with a 'necessary' metaphorical form and function with its files, symbols, personnel and precedents controlling what can be said and what can be desired (Deleuze and Guattari 1986: 81–83).

In Coetzee's novel, citizen and border guard both wait for the barbarian Other within the machine of Empire and the Law. When events cause the imperial authorities to perceive threats to the colonial boundaries of the outpost community and the Empire, the outpost Magistrate, who administers everyday law for the people, has to give way to the imperial officers Joll and Mandel, only to become the object of that same authority. What had been outside, at the limits of the law, using torture to gain information, has moved within the Law itself. It is the Magistrate who figures as a person who both desires to escape the waiting as well as being a border guard himself. For his b/order-crossing behaviour he faces torture himself, he must answer to 'the rule of Law'. At the end of the text he seems to be a man without content (Agamben 1999).

So, in both these texts the border stands between fear and desire, and as a representation of both fear and desire. It is both the conferral and selectivity of belonging and the means to recognize those who need to be seen by the waiting State apparatus. And this b/ordering and production of the Other is endless. Its power cannot be understood by determining its coordinates or lines on maps or on the ground alone. In the words of W.S. Merwin's poem 'Door':

> This is a place where a door might be
> here where I am standing
> In the light outside the walls
>
> there would be a shadow here
> all day long
> and a door into it
> where now there is me (Merwin 1973: 33)

The poem illustrates the above described threshold/border aesthetics: there is an outside and inside simultaneously. At a point, where we seek admittance, 'where now there is me' there is also waiting in the subjunctive: 'long after I have gone'. The poem is searching, like the man from the country in Kafka's parable, for this 'door' that might be the centre of all things, an eternity in the present tense where 'there in front of me a life / would open' (Merwin 1973: 33): the promise of inscription into a text or representation, the promise of a shared truth.

To conclude, what both Kafka's and Coetzee's text on waiting have made powerfully and poetically clear is that a border is neither a beginning nor an

end. A border is the intrinsically temporal and contextual product of a contin-
uous confrontational introspective question: why do we wait and for whom?
A question we perhaps all have to answer before our own door is finally shut.

Professor Dr Henk van Houtum is head of the Nijmegen Centre for Border
Research and Associate Professor Political Geography and Geopolitics at
Radboud University Nijmegen. In addition he is a part-time Professor of
Border Studies at the University of Eastern Finland and a part-time Professor
of Geopolitics of Borders at the University of Bergamo, Italy. His work pre-
dominantly deals with the epistemology and (im)morality of borders, the
external border and migration regime of the EU, processes of b/ordering
and others, cross-border development, redesigning borderlands and aesthetic
remapping of borders. His latest books are: *Borderland: Atlas, Essays and
Design. History and Future of the Border Landscape* (Blauwdruk, 2013) and
Beyond Fortress Europe (Atlas/Contact, 2016, in Dutch).

Stephen F. Wolfe (PhD) is Associate Professor of English Literature and
Culture at the UIT, The Arctic University of Norway. He has co-coordinated
research projects on border aesthetics, and within the EU FP7 project
EUBORERSCAPES. He has co-edited the volume *Border Poetics Delimited*
(2007) and edited 'Border Work/Border Aesthetics', *Nordlit* (2014; Volume
31). Recent publications include: 'A Happy English Colonial Family in 1950s
London? Immigration, Containment and Transgression in The Lonely
Londoners' (*Theory, Culture and Critique*, 2016), and 'The Borders of the Sea:
Spaces of Representation' (in *Navigating Cultural Spaces: Maritime Places*,
Rodopi, 2014).

NOTES

1. Some material in this section of the paper is taken from Van Houtum 2010. We
 wish to thank Professor Ian Johnston of Malaspina University College, Nanaimo, BC,
 Canada for use of his translation of 'Before the Law' which can be found on The Kafka
 Project website: http://www.kafka.org/index.php?id=162,165,0,0,1,0.
2. For example, Hannah Arendt argues that Kafka's *The Trial* implies 'a critique of the
 pre-War Austrian bureaucratic regime whose numerous and conflicting nationalities
 were governed by a homogeneous hierarchy of officials who ran the bureaucratic
 machine, and whose interpretation of the law became an instrument of lawlessness'
 (2007: 97). See also the chapter on Sovereignty.
3. Coetzee in *Diary of a Bad Year* (2007/2008) has the narrator Señor C state: 'Whereas
 the slave fears only pain, what the free man fears most is shame' (39). Shame is a

response to the politics of apartheid and colonialism: 'Dishonour descends upon one's shoulders, and once it has descended no amount of clever pleading will dispel it' (40), or, as the Magistrate states in *Waiting for the Barbarians*, 'When some men suffer unjustly ... it is the fate of those who witness their suffering to suffer the shame of it' (1980: 152).

4. The origin of the word Barbarian and Barbarous is the Greek 'barbaros' of the Latin 'bararus' to signify groups of African peoples without language and culture. To label a group 'Barbara' in European languages suggested 'tribes' who mumbled, or tribes of Africans who resisted Roman rule, Christianity, and who had no language that could be understood. One current historian suggests that from its first use Barbary and Barbarians had not only pejorative connotations but also signified groups of people who refused to communicate or who were reluctant to cooperate with colonial or imperial 'civilizations'.

5. The article 'Reintegrating Sense into Subjectification' (Hildebrand-Nilshon, Motzkau and Papadopoulos 2001) has been useful in our formulation and use of this concept.

BIBLIOGRAPHY

Agamben, G. 1999. *The Man without Content*. Stanford, CA: Stanford University Press.

Arendt, H. 2007. 'Franz Kafka, Appreciated Anew' (1944), in S. Y. Gottlieb (ed.), *Reflections on Literature and Culture*. Stanford, CA: Stanford University Press, pp. 94–109.

Bhabha, H.K. 1994. 'DissemiNation: Time, Narrative and the Margins of the Modern Nation', in *The Location of Culture*. London: Routledge, pp. 139–170.

Cavafy, C.P. 2007. *The Collected Poems*, trans. E. Sachperoglou. London: Oxford University Press.

Cixous, H. 2011a. 'The Pleasure Principle or Paradox', trans. L. Milesi, in *Volleys of Humanity: Essays 1972–2009*. Edinburgh: Edinburgh University Press, pp. 75–84.

———. 2011b. 'Reaching the Point of Wheat, or A Portrait of the Artist as a Maturing Women', trans. A. Liddle and S. Cornell, in *Volleys of Humanity: Essays 1972–2009*. Edinburgh: Edinburgh University Press, pp. 85–105.

Coetzee, J.M. 1980. *Waiting for the Barbarians*. London: Vintage.

———. 1988. *White Writing: On the Culture of Letters in South Africa*. New Haven: Yale University Press.

———. 1992. 'Into the Dark Chamber' (1986), in D. Attwell (ed.), *Doubling the Point: Essays and Interviews*. Cambridge: Harvard University Press, 1992, pp. 361–368.

———. 2007/2008. *Diary of a Bad Year*. London: Penguin Books, Reprint edition.

Crocker, T.P. 2007. 'Still Waiting for the Barbarians: What is New About Post-September 11 Exceptionalism?', *Law and Literature* 19(2): 303–326.

Deleuze, G. and F. Guattari. 1986. *Kafka, Toward a Minor Literature*, trans. D. Polan. Minneapolis: University of Minnesota Press.

_____. 2004a. *Anti-Oedipus*, trans. R. Hurley, M. Seem and H.R. Lane. London: Continuum.

_____. 2004b. *A Thousand Plateaus*, trans. B. Massumi. London: Continuum.

Derrida, J. 1992. 'Before the Law', trans. A. Ronell, in *Acts of Literature*, revised ed. New York: Routledge, pp. 181–222.

Foucault, M. 1990. 'Maurice Blanchot: The Thought from Outside', trans. J. Mehlman and B. Massumi in M. Foucault and M. Blanchot, *Foucault/Blanchot*. New York: Zone Books, pp. 9–58.

_____. 2003. *'Society Must Be Defended': Lectures at the College De France, 1975-76*, trans. D. Macey. New York: Picador.

Hildebrand-Nilshon, M., J. Motzkau and D. Papadopoulos. 2001. 'Reintegrating Sense into Subjectification', in J.R. Morss, N. Stephenson and H. van Rappard (eds), *Theoretical Issues in Psychology*. Boston: Kluwer Academic Publishers, pp. 289–300.

Houtum, H. van. 2010. 'Waiting Before the Law: Kafka on the Border', *Social and Legal Studies* 19(285): 285–297.

_____. 2011. 'The Mask of the Border', in D. Wastl-Walter (ed.), *Companion to Border Studies*. London: Ashgate, pp. 49–62.

_____ and T. van Naerssen. 2002. 'Bordering, Ordering and Othering', *Tijdschrift voor Economische en Sociale Geografie* 93(2): 125–136.

Kafka, F. 2003. 'Before the Law' (1915). Selected shorter writings, transl. by I. Johnston ('Before the Law', 'The Hunter Gracchus', 'Up in the Gallery', 'An Imperial Message', 'Jackals and Arabs'). Kafka Project Web Site: http://www.kafka.org/index.php?id=162,165,0,0,1,0.

Lenta, P. 2006. 'Legal Illegality: *Waiting for the Barbarians* after September 11', *Journal of Postcolonial Writing* 42(1): 71–83.

Loomba, A. 1998. *Colonialism/Postcolonialism*. London: Routledge.

Merwin, W.S. 1973. *Writings to an Unfinished Accompaniment*. New York: Atheneum.

Müller-Funk, W. 2007. 'Space and Border: Simmel, Waldenfels, Musil', in J. Schimanski and S. Wolfe (eds), *Border Poetics De-limited*. Hannover: Wehrhahn, pp. 26–48.

Nietzsche, F. 1987. *De geboorte van de tragedie*, trans. K. Kuyk. Amsterdam: International Theatre Bookshop.

Pinchevski, A. 2001. 'Freedom from Speech (Or the Silent Demand)', *Diacritics* 31(2): 70–84.

Safranski, R. 2000. *Nietzsche: Biographie seines Denkens*. Munich: Carl Hanser.

_____. 2003. *Wieviel Globalisierung verträgt der Mensch?* Munich: Carl Hanser.

Vismann, C. 2008. *Files, Law and Media Technology*, trans. G. Winthrop-Young. Stanford, CA: Stanford University Press.

>• •‹

Intersections: A Conclusion in the Form of a Glossary

Johan Schimanski and Stephen F. Wolfe

In this book we have let six key words – *Ecology, Imaginary, Invisibility, Palimpsest, Sovereignty* and *Waiting* – steer parallel but interconnected paths through the field of border aesthetics. The time has come to pull some of the arguments proposed in the introduction together, sum up our conclusions, and make the links between chapters more visible. Embedded in each chapter are many different terms relevant to chapter themes, and a number of these terms appear in more than one of the chapters. By treating this theoretical lexicon as a network of relations between the chapters, we hope to present a snapshot of our thinking here about border aesthetics, at this point of time in the academic debate. Any such state can only be a momentary and incomplete crystallization of a field, pointing as it does towards future and often unknown potentials for research. So while in the following we provide some hopefully useful definitions of the terms which make up the nodal points, definitions which may seem to claim to be definitive, we are very aware that we do this in order to provide a practical basis for debate and criticism, and that given the historical nature of borders and the other phenomena we are examining here, our definitions must be taken as contingent.

We have chosen to take the idea of nodes in a network and of definitions very literarily by drawing up a network of terms cited or suggested in the chapters, and then providing lexical explanations for these terms in the style of a glossary. To make this conclusion more readable, however, our nodes are not simply arranged alphabetically, but are grouped into several 'rhizomes' which speak to each other through series of glossary terms. First we deal with the themes of the book and our six chapters, and then provide a section for our 'protagonists', the border-crossers who are important actors in any bordering process. After this follow rhizomes of terms addressing the kaleidoscope of various fields in which borderings take place. As it happened, initial group-ings quickly appeared to suggest the five border levels or planes developed in border poetics analysis (Border Poetics Working Group 2008, Schimanski 2006, Schimanski and Wolfe 2007): the *topographical*, the *epistemological*, the

epistemological

border-crossers

naturalization exclusion imaginary monstrous

coliage

subjectivity communities traditions

in/visibility becoming territory palimpsest

temporal symbolic

democracy

b/ordering art forms public unconditional

sensible in/visibility ecology

internal/external hauntings

policing topographical

contact zones truth

bare life medial memory

border subjects fear/desire figurations

borderscape relations palimpsest

others aestheticization

imaginary

waiting spectacularization indeterminancy

migrants in-between

waiting ecology

imperialism

incomplete sovereignty

body law reading

border beings

threshold sovereignty

uncanny

Figure 7.1 A map of our six key themes and the network of terms connected to them.

symbolic, the *temporal* and the *medial*. Thus these categories were chosen as headings for the various sub-glossaries or rhizomes which follow.

In the following, we use cross-referencing by specific lettering styles (thus for example 'RELATIONS' indicates a relation to the entry on relations); this helps to counteract any tendency to limit all of the terms to just one rhizome or perspective. Each entry ends with a reference to the chapters in which the term is used or hinted at, in *italics*. The glossary form brings with it a certain amount of repetition, as the relationality of the different nodes in these networks often opens up different perspectives on the same questions. In this way, the reader can trace intersections with other material in the book. The first section of this glossary and conclusion are anchored by three figures, and then develops in slightly longer groupings throughout the rest of the text.

The Book Rhizome

The first three nodes addressed here, the first three words in our vocabulary, are those which form the main theme of the book itself: *borders*, *aesthetics* and

border aesthetics. As such, they are connected to all of our six key words and addressed in each of our chapters. Our glosses here are slightly more encyclopedic than otherwise, since these three main nodes function as umbrella terms.

- **Borders** have tended to be part of B/ORDERING processes of EXCLUSION and inclusion, becoming fixed as lines of demarcation. Part of that process can be one of NATURALIZATION, and even seeing borders as natural borders. However, cultural and discursive processes allow them to surface as aesthetic FIGURATIONS – narratives or tropes – which can also interrogate their including/excluding function. Borders are also produced through negotiation with BORDER-CROSSERS. Such interrogations point towards a more deterritorialized and process-orientated concept of BORDERING, in which borders emerge as more flexible entities, folded and diffuse, played out across zones or BORDERSCAPES in which many historical layers may be present. Borders can demarcate the edges of TERRITORIES, or they can shelter for example the social imaginary of a COMMUNITY; indeed, they can exist in and connect an almost endless variety of different locations, scales and levels. What happens in the border zone can be both regulated by the sovereign and through the use of various technologies, but it can also provide an UNCANNY and IN-BETWEEN space for BORDER SUBJECTS or BORDER BEINGS. Borders are places of crossing and waiting, and BORDER-CROSSERS constantly contribute to the redefinition of the border. Borders are thus often ambivalent and Janus-faced, caught between the LAW and that which transgresses the law, between fixity and change, between line and zone. This ambivalence can cause INDETERMINACY at the border. *See all chapters*.
- **Aesthetics** as a field can be defined in often (but not always) convergent ways, as focusing on: 1. the senses, perception and cognition; 2. the judgement of beauty and other related values; or 3. artistic production (cf. Welsch 1997). As an EPISTEMOLOGY of the SENSIBLE (or the 'sense-able'), it has a crucial social, political and B/ORDERING function, since it can make constituencies both visible and invisible, audible and inaudible. 'Appearing' in the PUBLIC sphere is an aesthetic process. The aesthetic can thus both give and take away agency and SUBJECTIVITY, function in both hegemonic and counter-hegemonic ways, both include and EXCLUDE. Aesthetic categories of judgement and medial technologies regulate these processes of IN/VISIBILIZATION etc. The transition between the insensible and the sensible, the THRESHOLD to the sensible, is the emergent and instituting space of the imaginary, the 'as if' and the UNCONDITIONAL, a creative, shaping space often instituted in modern democracy as that of ARTISTIC FORMS. *See all chapters*.

- **Border aesthetics** is a way of understanding the aesthetic dimension of borders, BORDERING and BORDERSCAPES. Borders can only exist to the extent that they are tangible; they thus always have an aesthetic dimension. Aesthetical works may give access to imaginaries about borders. At the same time, the B/ORDERING function of borders is a way of differentiating between and making visible social groups and political constituencies. Jacques Rancière's definition of the political as a 'partage du sensible' (2004), a partition and sharing of that which can be SENSED, contains within it the notion of partitions and borders. Yet aesthetics in itself also involves BORDER-CROSSINGS of medial borders, the borders between things and the representations of things. ARTISTIC FORMS are bordered, being paradoxically both INCOMPLETE and whole, folded in on themselves, presented in frames, and approached via THRESHOLDS. *See all chapters.*

The Six Key Words Rhizome

Each of the book's six key words is given a proper discussion in their own chapter; but they also appear in other chapters, creating new links in our network. The length of the entry below for IN/VISIBILITY indicates its centrality to the book's discussion throughout.

- **Ecology** is suggested as a way of breaking with a common circular logic that NATURALIZES borders and notions of home. Ecology is more orientated towards a dynamics of mobility and MIGRATION, and can encompass a more RELATIONAL and entangled approach (e.g. in Bruno Latour's 'political ecology' [2004], in contrast to a more mythic 'natural ecology'), which transcends the divisions between culture and nature, which such circularity is based on. One can envisage a political ecology of borders and of aesthetical BORDER BEINGS. *See chapters on Ecology, Sovereignty and Palimpsests.*
- **Imaginary.** Aesthetic pre-FIGURATIONS and IMAGES can break with accepted and legitimating social imaginaries, such as those defining national COMMUNITIES and sovereignty, and move towards new imaginaries. Such change takes place in a dynamic field involving acts of 'institution', TRADITION and the imaginary. ARTISTIC FORMS are institutions that can produce the imaginary through the imagination; the aesthetic allows for thinking 'as if'. The radical imagination as defined by Cornelius Castoriadis (2007) is orientated towards that which is in the process of BECOMING. The imaginary is often instrumentalized in both alarmist and optimistic 'frontier' scenarios, and if it does not transcend dreams of commonality it will often end up in images of the MONSTROUS. Imaginary geographies form our relationship with the OTHER, and are thus an important

part of BORDERSCAPES and activities of B/ORDERING. We tend to desire
and wait for something on the other side of a border. *See chapters on
Imaginary, Sovereignty, Palimpsests and Waiting.*
- **In/visibility** may refer figuratively to other senses than the visible or to the
SENSIBLE in general, and also to EPISTEMOLOGICAL BORDERINGS such as
the inarticulate, the incomprehensible, the unknown, the unrecognizable,
the irrelevant, the MONSTROUS or the INDETERMINATE. Specifically visual
forms of the sensible constitute a field of inquiry where for example maps,
landscapes and symbolic FIGURATIONS may be central. Invisibility and vis-
ibility are central categories of the BORDERSCAPE, which makes some SUB-
JECTIVITIES and their articulations visible, allowing them to participate in
a performative way in public political processes, while OTHERS are silenced
and marginalized. Being visible may however be the opposite of privilege,
as when people are made visible through surveillance and other forms of
POLICING, perhaps forcing them to hide themselves from sight. In/visibility
is regulated by many different technologies, MEDIAL BORDERS and aesthetic
processes. Such regimes can give visibility and take away SUBJECTIVITY at
the same time; they can, for example, make borders so ahistorical, stereo-
typical, TRADITIONAL, ubiquitous, monumental or NATURALIZED that they
are rendered invisible and absent; or they can AESTHETICIZE in a superficial
fashion (as in the aestheticization of sovereign power). Territorial borders
can be part of hegemonic B/ORDERINGS which render other subjectivities
than the nation invisible; creating a border establishes the INTERNAL AND
THE EXTERNAL, thus framing the visible and the invisible. Historical layer-
ing in the form of cultural palimpsests can be rendered invisible through
selection, folds and erasure. A political ecology, HAUNTING or an episte-
mology of seeing has the potential to interrupt regimes of in/visibility and
epistemologies of blindness; without countering the regimes themselves
through silence or mimicry, subjectivities run the risk of being made visible
on the terms of the regime. *See all chapters.*
- **Palimpsest** is a paleographical term for a manuscript written on parch-
ment which has been used before and is often imperfectly erased of pre-
vious writing, rendering that previous writing sometimes partly visible as
historical layers behind the present text. It is now often used metaphorically
for an intertextually layered text, or also a culturally layered landscape and
multi-layered borderland, i.e. a borderland made up of different registers,
scales (global-local) and cultural histories. Layers cannot remain auton-
omous however; rather, meaning and values cross the borders between
them, and they find themselves RELATIONALLY entangled; the present
cannot be seen as wholly separate from the past, and must be thought of in
a genealogical or archaeological fashion. The palimpsest is an aesthetic ren-
dering of in/visibility. Territorial and other borders may also function as

cumulative palimpsests, hiding behind them many earlier versions accessible through archives and MEMORY. The palimpsest is a figure connected with TEMPORAL BORDERS, shifts between for example historical periods, the old and the new, the traditional and the modern – though these shifts can often be crossed by hidden continuities. The palimpsest encourages reuse, bricolage and COLLAGE, and the renegotiation of previous uses and meanings. *See chapters on Palimpsests and Imaginary.*

- **Sovereignty,** in modern DEMOCRACIES, is associated in public discourse with the people's right to self-government, with claims over national TERRITORY, and transgressions of other nations' rights; but underlying these somewhat abstract principals is the historical figure of the sovereign, the royal or imperial head of state. Sovereignty is a regime which has traditionally been most SENSIBLE through the SPECTACLE of power (originally through the body of the head of state), and (in modern nation-states) most arbitrarily powerful or despotic at the territorial border: in the IN-BETWEEN, on the THRESHOLD, in spaces of waiting and interrogation where the LAW is no longer a protection. Sovereignty is thus concerned with determining where we are in relationship to the border, and where the border is. The Sovereign stands at the far end of the BORDERSCAPE (just as the border stands in the far end of the 'sovereignscape'). Giorgio Agamben (1998) has posited that sovereign power is now generalized in variously permanent states of exception, which render subjects into BARE LIFE, and the on-going tendency towards the INTERNAL AND EXTERNAL dissemination of state border POLICING across extended BORDERSCAPES provides an example of this logic. Sovereignty thus relates to the citizens with SUBJECTIVITIES which can be transformed into a lack of subjectivity, but is at the same time haunted by 'insovereign' BORDER BEINGS who may escape this economy by taking up INTERDETERMINATE positions which worry the boundaries of in/visibility. Such border beings become figures of the potential UNCONDITIONALITY of aesthetic ART FORMS. *See chapters on Ecology, Sovereignty, Palimpsests and Waiting.*
- **Waiting** is an activity which often takes place at borders, on THRESHOLDS, places in which attempting BORDER-CROSSERS wait to cross and border guards wait for the OTHER. Indeed, the border can be defined as an act of waiting. Through waiting, the border becomes a zone, a liminal space, or an IN-BETWEEN, regulated by a process of B/ORDERING. Waiting produces both SUBJECTIVITIES and TERRITORIES through aesthetic encounters and acts of witnessing characterized by in/visibility of the crosser, the guard, the border and the LAW, within the BORDERSCAPE. Through waiting, border POLICING becomes internalized. Acts of waiting also characterize our experiences with ARTISTIC FORMS: waiting for stories to begin or end, waiting for meaning, etc. *See chapter on Waiting.*

The Border-Crosser Rhizome

- **Bare life** is a concept developed by Agamben (1998), designating a marginal form of existence produced by and necessary to the workings of sovereignty. Typically, bare life results in a lack of SUBJECTIVITY stripped of rights by LAW within a B/ORDERING process of in/visibilization and EXCLUSION. Thus BORDER SUBJECTS, BORDER BEINGS and BORDER-CROSSERS (such as migrants) can be reduced to states of bare life in the border zone or IN-BETWEEN. Aesthetic processes can make visible subjects out of bare life. Yet some border beings may escape the bare life/sovereignty economy by attaining an alternative state of INDETERMINACY. *See chapters on In/visibility and Sovereignty.*
- **Border beings** are a more general category than BORDER SUBJECTS, since border subjects relate to the border and make it tangible, thus partaking in an act of B/ORDERING. Border beings can however retain a more INDETERMINATE position, and may include nonhuman actors, ghosts and the MONSTROUS. *See chapters on Sovereignty and Waiting.*
- **Border subjects** are BORDER BEINGS who have attained SUBJECTIVITY, negotiating regimes of in/visibility so as to become SENSIBLE. Border subjects include border guards, BORDER-CROSSERS, and borderland dwellers, and can have the potential to enact new strategies of in/visibility. *See chapters on In/visibility and Sovereignty.*
- **Border-crossers** are BORDER SUBJECTS who alter the BORDERSCAPE by entering border zones and crossing borders. Their crossings are regulated by border POLICING, which can act selectively, and some attempted border-crossings are unsuccessful. Border-crossers may be MIGRANTS, displaced persons, tourists, business travellers, family visitors, artists, researchers, smugglers, etc., but also animals, goods, ARTISTIC FORMS and ideas. *See chapters on Ecology and In/visibility.*
- **Migrants** are BORDER-CROSSERS with displaced citizenships who often are seen as passive BORDER BEINGS, but may disturb the workings of B/ORDERING, and through the negotiation of in/visibilities may be able to participate as SUBJECTIVITIES. A political form of ecology can provide migrants with new imaginaries, which are not NATURALIZED, creating CONTACT ZONES and RELATIONS. Migrants are often forced into positions of waiting, while border police also wait for migrants. Migrants can be given agency through access to plurivocal agencies inherent in specific aesthetic and ARTISTIC FORMS. *See chapters on Ecology, In/visibility, Sovereignty and Waiting.*
- **Others** are products of a specific form of B/ORDERING process, 'othering', which excludes SUBJECTIVITIES and places them in EXTERNAL spaces. Historically it is a category common to many IMPERIALIST cultures, which

tend to think of the self as civilized and the Other as barbarian. The Other is FEARED, but creates strength for the self. Others are subject to the workings of in/visibility; they are sometimes AESTHETICIZED (and thus made invisible) through stereotypical exoticism, sometimes able to show resistance through silence. A discourse may allow (an often inauthentic) respect for those on the other side of the border, but at the same time partake in an othering of BORDER BEINGS living in the IN-BETWEEN. The Other can sometimes appear as part of the self, creating an UNCANNY effect. *See chapters on Ecology, In/visibility, Palimpsests, Sovereignty and Waiting.*

• **Subjectivity** is here defined as the agency to interpret for oneself and more generally to have some agency or autonomy as a discursive or psychoanalytical subject, rather than being the object of representation. Subjectivities are made SENSIBLE through different processes of in/visibility. Attaining subjecthood, according to Louis Althusser's logic of interpellation (1971), can paradoxically mean to internalize regimes of B/ORDERING. Subjects are structured as selves, often in contrast to OTHERS, but paradoxically the borders between self and the other can often house IN-BETWEENS, in which the MONSTROUS and the UNCANNY can be manifested. The development of SUBJECTIVITY, as it takes place for example in childhood, involves the production of transitional objects and third spaces. A processual form of politics would involve alternative and participatory forms of subjectivity and DEMOCRACY, contributing to counter-hegemonic BORDERSCAPES. *See chapters on Ecology, Imaginary, In/visibility and Waiting.*

Each of the following five 'border plane' rhizomes is introduced with the entry for the border plane (topographical, epistemological, symbolic, temporal and medial) concerned. Other entries in each of these sub-glossaries follow in alphabetical order.

The Topographical Rhizome

• **Topographical borders** can exist on many scales and configured (and subject to FIGURATION) in many different ways in both concrete and conceptual landscapes or spaces. They can be mapped onto or articulate spatially other border planes, be they SYMBOLIC, EPISTEMOLOGICAL, TEMPORAL or MEDIAL, all of which can be spatialized and thus made topographical. They are part of the BORDERSCAPE, and are both physically visible, and, existing in palimpsests, partly hidden. *See all chapters.*

• The **body** has topographical borders, albeit on a micro scale when compared for example to nation-state TERRITORIES. The body provides metaphorical FIGURATIONS of other territories, such as nation states. The body is the basis

of *SUBJECTIVITY*; its borders can encourage a *NATURALIZING* organicism, but also manifest the *INCOMPLETE* and the *MONSTROUS*. Bodily or corporeal borders are subjected to regimes of in/visibility; they can articulate narratives and can be subject, like texts, to *READINGS*. *BORDER BEINGS* have incomplete bodies which can be situated in *BORDER-CROSSING* locations. Captivity, torture and the meeting of bodies attempt to double the border of the body, confining the already bordered body with another border; one may desire, through *FEAR*, to be captive and *INTERNALLY* self-disciplined, or desire to be free from captivity. *See chapters on Sovereignty and Waiting.*

- **Borderscape** is a recently coined term combining the words *border*, *landscape* and Arjun Appadurai's notion of *scapes* (1990). The term *borderscapes*, like scapes, is mostly used in a more metaphorical way than landscape; the borderscape combines the physical landscape with many other levels. However, the word *landscape* also suggests a way of thinking the physical object (a topographical landscape) at the same time as the representation (a landscape painting); thus borderscapes bring together representations and practices. The notion of *landscape* also suggests a regime of in/visibility (since a landscape can be seen from a power perspective). In line with Appadurai's notions of various imaginary scapes connecting up our globalized world, borderscapes are more extended, flexible, disjunctive, amorphous and flowing than border landscapes, peripheries, border zones or borderlands, at least when those are thought of as contiguous areas bordering onto a border. Borderscapes are multileveled, *RELATIONAL* networks entangling different objects, imaginaries, *BORDER SUBJECTS* and *INTERNALIZED OR EXTERNALIZED* borders. They involve everything involved in the processes of *BORDERING* and *B/ORDERING*. Borderscapes are politically ambivalent: on the one hand they are regimes of hegemonic in/visibility, but on the other they avoid the *TERRITORIAL* trap of thinking borders as lines and thus open up deterritorialized zones and *IN-BETWEENS*. Potentially, they can be the basis for counter-hegemonic borderscaping, a word pointing back to the etymological roots of the element *scape*, having to do with shaping and creating, suggesting the relevance of *ARTISTIC FORMS*. Borderscaping can potentially be a form of performative resistance. Since they are *SENSIBLE* and open to the imaginary, borderscapes are home to many forms of border aesthetics. It is possible to conceptualize different levels of borderscapes: audio-visual borderscapes, sonic borderscapes, borderscapes of sovereign power, etc. *See chapters on Ecology, In/visibility, Sovereignty, Palimpsests and Waiting.*
- **Contact zones**, Mary Louise Pratt's (1992) term for a shared space or zone in which imperial travellers can meet indigenous peoples and engage in cultural translation, are places of what Mireille Rosello has called 'performative encounters' (2005) in the sense that *IDENTITIES* are negotiated on

both sides. They are where the OTHER can be seen, heard, etc., and while they are regulated by regimes of in/visibility, they are also susceptible to unexpected effects which disturb such regimes, such as when an interrogator meets the other and questions his/her own SUBJECTIVITY. Some border zones are however interdicted, and encounters can be bordered in such a way that no true encounter happens, or be hindered by the INDETERMINACY of BORDER BEINGS in an IN-BETWEEN. Border zones can be places of mixing, but also of the B/ORDERING of selves and others etc. *See chapters on Ecology, Imaginary, In/visibility, Sovereignty and Waiting.*

- The **in-between** is a third space between two territories; a borderless zone created in the contested spaces, folds and overlappings of the border, an effect of the discrepancies between borders on different, sometime incompatible levels and scales in the palimpsest or as seen from two different perspectives, those of the periphery and the centre. It is a place of doubling and the UNCANNY where in/visibility is uncertain and ambiguous, a liminal space or THRESHOLD that makes INDETERMINACY and insovereignty possible. It is a transitional place for in-between BORDER BEINGS. Homi K. Bhabha has argued that the in-between or third space is a site of creativity, the 'location of culture' (Bhabha 1994b). *See chapters on Ecology, Palimpsests and Sovereignty.*

- **Incomplete.** ARTISTIC FORMS, COMMUNITIES, BODIES, SUBJECTS, TERRITORIES, NATURES, sovereignties and NATIONS have traditionally been perceived as bordered wholes, yet the BORDERSCAPES, IN-BETWEENS and border zones which are associated with their borders challenge this presumed completeness. Incompleteness creates fragments, MONSTROUS and UNCANNY effects. B/ORDERING desires wholes, yet perfect wholeness is an unattainable fantasy; the UNCONDITIONALITY of the aesthetic may however function as a transitional, unfinished and fragmented wholeness. *See chapters on Ecology, Sovereignty and Waiting.*

- **Internal and External.** Borders are increasingly being seen (not least where nation-state borders are concerned) as not only located at outer edges, but also projected outwards into other spaces and introjected inwards into one's own space. They thus become disseminated over an extended BORDERSCAPE, crossing the divides between the internal and the external, the inside and the outside, the self and the other, us and them, civilized and barbarian, community and the alien. The folding of border inwards and outwards challenges NATURALIZED notions of borders as instruments of EXCLUSION and inclusion, while at the same time extending the sovereign power to B/ORDER in both directions. The internal and external dissemination of borders is often seen as an effect of globalization, which is now revealed as globalizing borders rather than moving to a world without borders, and at the same time has led (like imperialism

before it) to a proliferation of BORDER-CROSSERS and BORDER BEINGS. Sovereignty, B/ORDERING and the LAW ask that things be located either inside or outside borders, and yet are themselves both inside and outside borders, as are border beings. Being IN-BETWEEN or on the THRESHOLD can mean being both internal and external. Borders and BORDERLANDS also face inwards and outwards, creating an UNCANNY doubleness at the border; and borders which have been folded inwards can be the basis for forms of treason and shame in relationship to TRADITION, or to POLICING itself. SUBJECTIVITY can give an external agency in the public sphere, but also mean that external regimes are internalized. *See chapters on Ecology, Imaginary, In/visibility, Sovereignty and Waiting.*

- **Territory** implies a hierarchical regime of B/ORDERING and sovereignty, edged by borders and demarcations dividing between the INTERNAL AND EXTERNAL and constituting a unit. Within the BORDERSCAPE paradigm, the discrepancies and disjunctions between territories are taken seriously, and territories become less stable, more fluid. They are, to use Gilles Deleuze and Félix Guattari's terms (1986), de-territorialized – and often then re-territorialized through renewed b/ordering processes. Such processes are accompanied by BORDERING and re-bordering. Deleuze and Guattari's argument that territorialization may apply not only to terrestrial territories, but also for example to bodily or semantic territories (i.e. meaning), is a reminder that the logics of the territory can apply on many different levels. *See chapters on Ecology, Imaginary, In/visibility and Sovereignty.*

The Epistemological Rhizome

- **Epistemological borders** are the borders marking the difference between the known and the unknown, between the comprehensible and the incomprehensible, between TRUTH and lies, between the articulate and the inarticulate, between reality and the imaginary. They can be mapped onto borders on other border planes – TOPOGRAPHICAL, SYMBOLIC, TEMPORAL and MEDIAL. For example, the border to another country is often a barrier to understanding, and the OTHER is often seen as an unknown; or the past can be lost to MEMORY, forgotten in the folds of the palimpsest and thus become part of the unknown. Epistemological borders, since they mark the borders of the known, are part of the aesthetics of the SENSIBLE and of in/visibility. *See chapters on Imaginary, In/visibility and Palimpsests.*

- **Aestheticization** is a process where objects and subjectivities are given an aesthetic surface which conceals B/ORDERINGS and the workings of power. As such it is part of a regime of in/visibility. It can take the form of gentrifying design (of urban landscapes, but also of the control stations of border

POLICING), stereotypical exoticization, political rhetoric, the dazzling dress or ritual of the sovereign, or SPECTACULARIZATION. Aestheticization in this sense should not be confused with what Wolfgang Welsch calls 'epistemological aestheticization' (Welsch 1997), i.e. a turn in the human sciences away from a 'reality', which is seen as inaccessible, and towards interpretations. This is a turn which places aesthetics as central in fields such as border studies. *See chapters on In/visibility, Palimpsests and Sovereignty.*

- **Indeterminacy**, ambiguity, ambivalence, UNCONDITIONALITY and contradiction between different parts of the BORDERSCAPE are the products of entanglements between layers of the palimpsest and of the mixings of the IN-BETWEEN. Indeterminacy seems to contradict B/ORDERING and the territorialization of meaning, avoiding a recourse to TRUTH and authenticity. With reference to in/visibility, it makes it difficult to see whether something is EXTERNAL OR INTERNAL to the border. The unconditionality and ecological mobility of the aesthetic can render ARTISTIC FORMS indeterminate. *See chapters on Ecology, Palimpsests and Sovereignty.*

- **Reading** is an act not only of crossing epistemological borders of interpretation, but also of crossing the MEDIAL BORDERS constituted by the borders of a text; landscapes can also be read as texts and as palimpsests. Texts come into being through acts of reading, and since a reading or interpretation is an attempt to find an ever deferred meaning in a text, reading is also an act of waiting. *See chapters on Palimpsests and Waiting.*

- **Relations** are central to an ecology of borders in which beings, objects, ideas and ARTISTIC FORMS in the BORDERSCAPE find themselves entangled with each other. Latour (2004) theorizes relations as 'matters of concern', which have no clear boundaries, being 'tangled beings' which form metaphorical rhizomes and networks. If borders can no longer be seen as clear-cut lines, they can potentially be understood as relations (Schimanski and Wolfe 2013, based on work by the Border Aesthetics project group). Objects, SUBJECTIVITIES and practices exist on the borderlines between different fields, discourses, layers in the palimpsest, inextricably connecting them into BORDERSCAPES. Thinking in terms of relationality and networks can counter more hierarchical B/ORDERINGS and mechanical ways of dividing representations into border planes. Unlike COMMUNITY belonging, relations do not tend to include/EXCLUDE; they might also be UNCONDITIONAL ways of connecting to BORDER BEINGS. Aesthetic objects such as ARTISTIC FORMS can be described as being both entangled and partly autonomous in their relationships to the world. *See chapters on Ecology, In/visibility, Palimpsests and Sovereignty.*

- The **Sensible** is here understood as that which can be sensed and perceived and which is subject to cognition, rather than just possessing 'common sense'. It is thus part of an aesthetic field and often addressed through

a particular form of the sensible: in/visibility. Attaining SUBJECTIVITY is often associated with been seen, or articulating oneself and social imaginaries so that they can be heard in the PUBLIC sphere. For Rancière, politics is defined as the 'distribution of the sensible' (2004), connecting DEMOCRACY to different aesthetic regimes of in/visibility. Borders must always have a sensible or tangible component. CONTACT ZONES are built around the possibility of perceiving the OTHER. ARTISTIC FORMS can redistribute the sensible, as long as they do not AESTHETICIZE in a superficial way. Instead, as Shklovsky argues (1965 [1916]), aesthetic representations of the border may estrange and thus heighten cognition, allowing us to see things anew from a distance. *See chapters on Ecology, In/visibility and Waiting.*

- The **truth** is a promise of territorialized meaning and authenticity, ultimately inaccessible and thus producing situations of waiting. Border-crossers are often perceived as liars, and borders are places of fantasies, fiction, figuration, the UNCANNY and the imaginary. The job of border POLICE is surveillance. The sovereign and other agencies of B/ORDERING seek the truth and the authentic. The NATURALIZED and the originary in an ecology or a palimpsest can appear authentic. *See all chapters.*

- The **uncanny** is according to Sigmund Freud (1955) the product of an unexpected perception that part of the self is OTHER: the familiar suddenly seems unfamiliar. It creates a doubling of the SUBJECT. Bhabha (1994a) connects the uncanny with national borders. BORDER BEINGS can put the sovereign, in its search for TRUTH, in an uncanny position. *See chapter on Sovereignty.*

The Symbolic Rhizome

- **Symbolic borders** are differences or conceptual oppositions between concepts, values and SUBJECTIVITIES. They are borders in a mental or social landscape that can be articulated as TOPOGRAPHICAL BORDERS (cf. Simmel 1997 [1903]), or other kinds of borders, including those created rhetorically, or through FIGURATION. The symbolic is an essential component of both social and aesthetic worlds, and can often be represented in the form of images set in cultural landscapes. Power and B/ORDERING are not only expressed, but also work symbolically. *See chapters on Ecology, Imaginary and Palimpsests.*

- **Communities,** for example nations, have been shown to be dependent on common understandings or social imaginaries – also in the guise of ARTISTIC FORMS such as the novel – by thinkers such as Benedict Anderson (1991) and Charles Taylor (2004). They are homogenized forms of belonging and participation constituted within NATURALIZED borders, providing both homes for their members or citizens and the basis for DEMOCRACIES

and PUBLIC spheres; as such they express a desire to internalize B/ORDER-ING, to include and EXCLUDE. Communities posit a bounded homogeneous TERRITORY which reinforces their naturalness, but their perceived homogeneity may be disturbed by the UNCANNINESS of borders, for example in the form of multiculturalism. Borders, while bounding the community, belong also to other communities and create IN-BETWEENS, which are HAUNTED by BORDER BEINGS. In borderlands, the naturalized markers of belonging in the palimpsestal landscape may be more susceptible to being revealed as inauthentic, lacking in TRUTH value. New communities in the borderlands may create new borders which overlap with and diffuse earlier ones. The borderscape paradigm may help communities to accept a DEMOCRACY of BECOMING rather than a naturalized politics of being. *See chapters on Ecology, Imaginary, In/visibility, Palimpsests and Waiting.*

- **Democracy** has traditionally been based around COMMUNITIES of citizens who have been allowed to participate in a PUBLIC sphere. It is thus a space for the representation of SUBJECTIVITIES, bringing together politics with in/visibility. Democracies also guarantee through the rule of LAW the B/ORDERING of communities; but this form of sovereignty is haunted by earlier forms of despotism. ARTISTIC FORMS have had an important role to play in the development of democracies, since the aesthetic, with its UNCONDITIONALITY, can be a space in which to make visible alternative imaginaries without being excluded. The participatory dimension of democracy can be activated as a strategy in art, for example in participatory migrant videos; but MIGRANTS and OTHERS are often EXCLUDED from citizenship, and forced to wait outside democracies. A new form of democracy must be imagined if BORDER BEINGS are to become BORDER SUBJECTS; borders must be democratized. Politics as process (rather than politics as POLICE) would promise a democracy in the form of an ecology which would avoid NATURALIZATION, allow plurivocal negotiation and participation in the PUBLIC sphere, and encourage the creation of new imaginaries. *See chapters on Ecology, Imaginary, In/visibility, Palimpsests and Sovereignty.*

- **Exclusion** and inclusion are the products of a regime of B/ORDERING which divides between the INTERNAL AND EXTERNAL. Exclusion makes people into OTHERS, and denies them SUBJECTIVITY and participation in COMMUNITIES. Borders function selectively, including some and excluding others. Hegemonic BORDERSCAPES strengthen exclusion, while counter-hegemonic borderscapes can include new subjectivities through a constant INDETERMINACY. ARTISTIC FORMS may also exclude and include through regimes of in/visibility, but the UNCONDITIONALITY of the aesthetic can foster an indeterminacy which avoids such regimes. *See chapters on Imaginary, In/visibility and Sovereignty.*

- **Imperialism** is a form of COMMUNITY which has historically produced many IN-BETWEEN border zones in the form of colonies and also caused massive migration movements across global frontiers. Imperial ideologies treat external TERRITORIES as gendered BODIES with crossable borders. Many NATURALIZED ways of thinking about borders (for example, as peripheries or frontiers, as B/ORDERING dividers between selves and OTHERS, or as subject to a specific form of despotism on the side of the sovereign) stem partly from imperial and colonial thinking, be it Roman, European or Soviet, and haunt our contemporary PALIMPSESTUAL landscapes as dreams and imaginaries in waiting. *See chapters on Ecology, Palimpsests, Sovereignty and Waiting.*
- The **law** (and all kinds of cultural and TRADITIONAL norms) is intimately connected with B/ORDERING, social imaginaries and traditional forms of DEMOCRACY and sovereignty. It also however implies the possibility of transgression, a form of BORDER-CROSSING. The law paradoxically produces IN-BETWEEN spaces of exception, and the BORDER BEINGS in these in-between spaces live UNCONDITIONALLY both inside and outside the law, both waiting and transgressing, as does the law itself. ARTISTIC FORMS are often held against the standards of aesthetic norms, and can often transgress those norms at their MEDIAL BORDERS. *See chapters on Ecology, Sovereignty and Waiting.*
- **Fear and desire** are two sides of waiting at the border: on the one hand a paranoid fear of the OTHER and need for B/ORDERING; and on the other hand a schizoid desire for the other and need for debordering, which is also a desire for BECOMING and transcendence. Fear and desire also correspond to various aesthetic effects – the UNCANNY, the MONSTROUS and the sublime. *See chapters on Imaginary, Sovereignty and Waiting.*
- **Policing** is a major B/ORDERING industry, involving border guards and various other forms of securitization, control and internalization of FEAR. Central to policing is surveillance, involved in regimes of in/visibility. According to Rancière (2010), policing is an oppressive form of politics which stands in opposition to politics as process, a form of DEMOCRACY in which new SUBJECTIVITIES may appear and be negotiated. People living in borderlands may be disciplined into internalizing regimes of B/ORDERING. *See chapters on In/visibility and Waiting.*
- The **public** sphere is itself a BORDERED space, and should ideally guarantee participation and regulate in/visibility so as to make sensible new SUBJECTIVITIES, but at the same time resist strategies of POLICING which invade the private sphere, securing, as Hannah Arendt (1958) suggests, the invisibility of the natural. *See chapters on Ecology, Imaginary, In/visibility, Palimpsests, Sovereignty and Waiting.*
- The **unconditional** is a form of RELATION which does not act in a B/ORDERING fashion, avoiding the power and desire of the sovereign and

thus suggesting new models of citizenship in DEMOCRACIES. It is not NAT-URALIZED and does not find its origins in TRADITION. BORDER BEINGS live in a state of unconditionality and INDETERMINACY. ARTISTIC FORMS may attain unconditionality and help SUBJECTIVITIES do the same. *See chapters on Ecology, Imaginary and Sovereignty.*

The Temporal Rhizome

- **Temporal borders** mark the shifts between different periods of time in history or in the life of a person, thing or artwork; they can also divide the present and the past (crossed by MEMORY and HAUNTINGS, but also the intertextual PALIMPSESTS we surround ourselves with), or the present and the future, that which is BECOMING. All forms of BORDER-CROSSING are also crossings of a temporal border between a before and an after. Temporal borders are configured as processes and transitions which, just like other borders, are not necessarily clear-cut. Indeed, they are often RELATIONALLY entangled and involve IN-BETWEEN spaces of waiting and the liminality of the THRESHOLD. In such spaces we may find BORDER BEINGS and the transitional objects that Donald Winnicott (1971) mentions in connection with processes of children becoming SUBJECTIVITIES. Borders themselves change with time, opening and closing, undergoing debordering and rebordering, and border studies itself has undergone a 'processual turn' towards thinking borders as borderings or B/ORDERINGS. The attempt to NATURALIZE borders, to pretend that they are based on primary or 'natural' borders, denies the possibility of rupture, transcendence and becoming. Certain changes, such as sudden changes in MIGRATION patterns, appear as SPECTACULAR ruptures that take away attention from more long-term transitions. *See all chapters.*
- **Becoming.** The future, utopias, emergent borders and SUBJECTIVITIES are in a state of becoming; they wait on a THRESHOLD. Creating, instituting or performing the new is a function of the social imaginary, and counteract NATURALIZED and TRADITIONAL conceptions of borders and COMMUNITY. ARTISTIC FORMS can be capable of creating UNCONDITIONAL spaces in which the new comes into being, and of contributing to processes of creative BORDERSCAPING. That which is in a state of becoming can promise transcendence, or can appear as MONSTROUS and cause FEAR, and being caught in a waiting position can be a way of avoiding the new. Utopian scenario building and the appeal to the 'frontier' can however be a way of in/visibilizing through AESTHETICIZATION and SPECTACULARIZATION, and thus a form of B/ORDERING. *See chapters on Imaginary, In/visibility, Palimpsests and Waiting.*

- **Bordering** and **b/ordering** are relatively new concepts in border studies (cf. Houtum and Naerssen 2002), intended to give a more verb-like, processual and performative dimension than that conveyed by the noun *border*. B/ordering often takes the form of a regime of in/visibility, for example mapping, which can provide the basis of using borders to EXCLUDE and to include. Bordering as such is always a transitional activity involving processes of debordering and rebordering; it thus creates an INDETERMINACY which paradoxically subverts b/ordering regimes and diffuses the border across extended BORDERSCAPES. B/ordering and the LAW can become INTERNALIZED as a position of waiting. *See chapters on In/visibility and Waiting.*

- **Hauntings** and encounters with ghosts often take place on TOPOGRAPHICAL BORDERS, but are also figurations of the temporal border between the living and the dead. Ghosts are a form of BORDER BEING that create an UNCANNY effect in the IN-BETWEEN; like the MONSTROUS, they are typical of imaginative and gothic ARTISTIC FORMS; as apparitions, they regulate an indeterminate in/visibility, and, importantly, are often associated with traumatic MEMORIES in either a historical or a familial context, making visible a spectral palimpsest. *See chapters on Imaginary, Palimpsests and Sovereignty.*

- **Memory** is a BORDER-CROSSING between a present and a past, the actual temporal border being that of forgetting. Borderscapes and border ecologies do not however focus on NATURALIZED origins or a past TRADITION as such, but on archaeological or archival elements which are palimpsestually present in the cultural landscape, or as HAUNTINGS from previous historical (e.g. IMPERIALIST) and sometime traumatic B/ORDERINGS. *See chapters on Ecology and Palimpsests.*

- **Naturalization** designates an ideological tendency, made SENSIBLE in many border FIGURATIONS, to use nature as an essentializing and circular principal in the B/ORDERING of SUBJECTIVITIES and TERRITORIES. TRADITIONS, along with notions of home and COMMUNITY, are often naturalized, along with their borders and norms or LAWS. Territorial borders are sometimes called natural or artificial, though it is clear that it is symbolic processes of b/ordering which determine whether for example a mountain range becomes a national border. While ecology is often presented as a science or principal of nature, naturalization paradoxically goes against and renders in/visible the notion of a political ecology of borders; the latter would allow for greater mobility and transgressions, for example made visible in MIGRANT border-crossings and ARTISTIC FORMS. BORDER-CROSSERS are often OTHERED as unnatural; but at the same time PUBLIC invisibility often reduces subjectivities to sets of naturalized traits, a 'natural visibility'. *See chapters on Ecology and In/visibility.*

- The **threshold,** combining both temporal and topographical borders, is a central chronotope in Mikhail Bakhtin (1981) and in theories of liminality (from Latin *limen,* 'threshold') proposed by Arnold van Gennep (1960) and Victor Turner (1970, 1992). The threshold is an IN-BETWEEN and transitional space of waiting, whether it is by the door to a building, at a border-crossing control point, or at the beginning of an ARTISTIC FORM like a literary text. *See chapters on Sovereignty and Waiting.*
- **Traditions**, like MEMORIES, cross a temporal border between the past and the present, even continuing on into the future. Crossing that border, however, they involve, as the etymological origins of the word *tradition* suggest, a form of 'treason'. As traditions move into the field of BECOMING, they are betrayed by new ideas, and thus within their self-same logic of identity hides an obscure darkness: the INTERNAL borders in the social imaginary of a community. Traditions can both NATURALIZE fixed ideas of what borders are by appealing to their origins, and be used in an ideological, AESTHETICIZING way to cover over B/ORDERING processes. Understanding the cultural landscape as PALIMPSESTS produced in the conflict between globalization and tradition aids in seeing traditions as part of a present-day COLLAGE. *See chapters on Imaginary and Palimpsests.*

The Medial Rhizome

- **Medial borders** are the borders of the (re-)presentation rather than any borders which might be represented; 'medial' is here meant in the general sense, as connected to the different media (e.g. text, paintings, installations, film, architecture, sound, digital networks, etc.) which provide material, TECHNOLOGICAL supports and cultural constraints to ARTISTIC FORMS and other forms of communication. For example, literature works mostly with textual and written media, and works of literature are framed with beginnings and endings; they feature textual THRESHOLDS and shifts between sections, styles and narrative modes, and they present a SENSIBLE and interpretative border to the person who is READING them (a medial border which is also an EPISTEMOLOGICAL BORDER). As with other borders, medial borders can be crossed or transgressed, they open up into diffuse and folded IN-BETWEENS, and they can be used in an aesthetic B/ORDERING and BORDERSCAPING process. *See all chapters.*
- **Artistic forms**, genres, and styles in many different media together constitute one of the fields addressed by aesthetics as a discipline. They also present themselves as the outer medial borders of artworks, and both experiment and negotiate with different border concepts. Since every artistic form presents a specific (and sometimes highly sophisticated) way of

distributing the SENSIBLE, they will have to be evaluated separately for their aesthetic impact on the political. Artistic forms have a key role to play in making visible new imaginaries of SUBJECTIVITIES and borders, in a process of BECOMING; where borders are concerned, artistic forms such as MIGRANT and transcultural forms of art may have special importance as elements of BORDERSCAPES. In the tradition of Kantian aesthetics (1977 [1790]), artworks have been understood as independent of political interests; we suggest however that artistic autonomy – the border around the artwork – is RELATIONALLY entangled rather than clear-cut, and moreover stands in a relationship of UNCONDITIONALITY to the political. The artistic form can thus potentially act as a BORDER BEING, escaping the sovereign. One artistic form in particular, architecture, has a major impact on geographical landscapes, in particular urban spaces, and can be read for the social shifts they represent and constitute in a cultural palimpsest. *See all chapters.*

• The **collage**, in which elements of different cultural providences are reused in a new context, is an important aesthetic effect of palimpsest, and thus a typical effect of (historical) TEMPORAL BORDER-crossings in urban landscapes, though it is also an active aesthetic strategy in other cultural forms. The collage mixes the old and the new, the local and the global, emphasizing medial borders in a fragmented, torn and cut continuum or network of images, buildings or words. It comes about through the actions of *bricoleurs* reusing disparate, hybrid and transcultural elements to create a pastiche in which new imaginaries are formed (or mimicked), at the same time that others are erased. These *bricoleurs* could be border subjects such as MIGRANTS, but they could also be opportunistic substitutes for the sovereign in, for example, post-Soviet spaces. *See chapters on Imaginary, In/ visibility and Sovereignty.*

• **Figurations**, in which one image, word or phrase is used to form or convey another, are in themselves BORDER-CROSSINGS, creating deviations which cross between different semantic, linguistic and visual fields; or perhaps EPISTEMOLOGICAL BORDERS in themselves, making some meanings visible and hiding other meanings (like a palimpsest), including and EXCLUDING. Figurations make SENSIBLE in an indirect way, which is to say that they do not, like representations can pretend to do, operate in a direct way. In a broad sense, figurations include for example metaphors and tropes, the use of fiction and other deviations from the TRUTH, narrative configurations of real or fictional worlds, visual images, monuments, maps, etc. Figurations condition and make sensible borders, determine how we think about them, and participate in social imaginaries and in the BORDERSCAPE. Border-crossers, caught in an in-between, often have to narrate their stories and articulate themselves figuratively. *See all chapters.*

- The **Monstrous** is often a by-product of BECOMING as it is enacted through new imaginaries; as such it creates FEAR similar to that expressed in reaction to the UNCANNY. Within regimes of B/ORDERING, all transgressions of norms and the LAW are monstrous; in normative aesthetics, transgressions of period and style are seen as creating ugliness in art. As an aesthetic category, it is often used in imaginative, gothic modes, and is particularly apt at making SENSIBLE disjunctions between SUBJECTIVITIES and BODIES; formally, the monstrous is the transgression of bodily borders. The challenge to the new is to find ways of making itself sensible which do not evoke the monstrous. *See chapters on Ecology and Imaginary.*
- **Spectacularization** is a medial process (often mass medial) by which complex issues (such as borderscapes) are reduced to simple narratives and FIGURATIONS, thus making invisible the complexity behind them. In this way, an aesthetic makes SENSIBLE SUBJECTIVITIES, MEMORIES, etc., but at the same time EXCLUDES them from the public sphere. Spectacularization is common in B/ORDERING processes (one example being the gestural politics of erecting border fences and walls), and is used as a way of concealing the power processes of the sovereign. The combination of rewriting and erasure makes the spectacle a simple form of palimpsest, and in some cases, careful READING of the spectacle can bring out its COLLAGE of disparate elements. In the urban palimpsest, architectural and sculptural monuments often function in a spectacular manner; mass tourism, in its representations of such landscapes, often spectacularizes and makes the landscape or borderscape for the most part invisible. *See chapters on In/visibility, Palimpsests and Sovereignty.*

Configuring Borders

We know that to come to a conclusion is to come to a border – a place or space to verify our findings and our arguments for the reader – which we have sought to do in the elaboration of a network of terms in the glossaries above. But in doing this we have not sought to demonstrate our sovereignty over a field, a place, an Other. We have not sought to create or conclude the book in this fashion. Rather, we have provided the reader and ourselves with a way into a new field in border studies so that we can make full use of the arguments and conceptualizations opened up as at the thresholds of our disciplinary perspectives and within the interconnective patterns of thought developed in this book. For by operationalizing the interactions of aesthetics and borders we have sought to set in motion important questions. How can we make and tolerate the 'risky attachments' and 'tangled objects' that political thinking – and we would add aesthetic thinking – should recognize

and engage with in our contemporary societies? And how can we make clear the tenuous process by which imaginative and imagined representations of emerging worlds and worldviews in cultural productions mark stages in the process whereby tropes and genres have been placed, through spatialization, into an aesthetic space?

Finally, these questions have also been echoed in our cover photo of a site-specific installation by Morten Traavik at the 'Barents spektakel' border arts festival in Kirkenes, Norway, 2011. Look carefully and you can see two countries' border posts in the town street. This installation interrogated the relationship between borders, visuality and processes of inclusion and exclusion and its negotiation within a specific space – the town of Kirkenes – and within an outdoor space. By moving the border posts into an installation within an urban space, Traavik not only sought to aestheticize the border, but also clearly reminds us that the border is already an aesthetic construct.

Johan Schimanski (Dr. art.) is Professor of Comparative Literature at the University of Oslo and Adjunct Professor of Cultural Encounters at the University of Eastern Finland; he was, while working on contributions to this book, Adjunct Professor at UiT The Arctic University of Norway. He has co-cordinated research projects on Arctic discourses, border aesthetics, Arctic modernities and within the EU FP7 project EUBORDERSCAPES. He has co-edited the volumes *Border Poetics De-Limited* (2007), *Arctic Discourses* (2010) and *Reiser og ekspedisjoner i litteraturens Arktis* (2011). Recent publications include 'Border Aesthetics and Cultural Distancing in the Norwegian-Russian Borderscape' (*Geopolitics*, 2015) and (with Ulrike Spring) the monograph *Passagiere des Eises: Polarhelden und arktische Diskurse 1874* (2015).

Stephen F. Wolfe (PhD) is Associate Professor of English Literature and Culture at the UIT, The Arctic University of Norway. He has co-coordinated research projects on border aesthetics, and within the EU FP7 project EUBORERSCAPES. He has co-edited the volume *Border Poetics Delimited* (2007) and edited 'Border Work/Border Aesthetics', *Nordlit* (2014, Volume 31). Recent publications include: 'A Happy English Colonial Family in 1950s London?: Immigration, Containment and Transgression in The Lonely Londoners' (*Theory, Culture and Critique*, 2016), and 'The Borders of the Sea: Spaces of Representation' (in *Navigating Cultural Spaces: Maritime Places*, Rodopi, 2014).

BIBLIOGRAPHY

Agamben, G. 1998. *Homo Sacer: Sovereign Power and Bare Life*, trans. D. Heller-Roazen. Stanford, CA: Stanford University Press.

Althusser, L. 1971. 'Ideology and Ideological State Apparatuses (Notes towards an Investigation)', trans. B. Brewster, in *Lenin and Philosophy and Other Essays*. London: NLB, pp. 121–173.

Anderson, B. 1991. *Imagined Communities: Reflections on the Origin and Spread of Nationalism*. Revised and extended edn. London: Verso.

Appadurai, A. 1990. 'Disjuncture and Difference in the Global Cultural Economy', *Theory, Culture & Society* 7(2–3): 295–310.

Arendt, H. 1958. *The Human Condition*. Chicago: The University of Chicago Press.

Bakhtin, M.M. 1981. 'Forms of Time and of the Chronotope in the Novel: Notes toward a Historical Poetics', trans. C. Emerson and M. Holquist, in *The Dialogic Imagination: Four Essays*. Austin: University of Texas Press, pp. 84–258.

Bhabha, H.K. 1994a. 'DissemiNation: Time, Narrative and the Margins of the Modern Nation', in *The Location of Culture*. London: Routledge, pp. 139–170, 266–269.

———. 1994b. *The Location of Culture*. London: Routledge.

Border Poetics Working Group. 2008. 'Border Planes', in *Border Poetics Key Terms*. Tromsø: University of Tromsø. Retrieved on 31 May 2016 from http://borderpoetics. wikidot.com/border-planes.

Castoriadis, C. 2007. *Figures of the Thinkable*, trans. H. Arnold. Stanford, CA: Stanford University Press.

Deleuze, G. and F. Guattari. 1986. *Kafka: Toward a Minor Literature*, trans. D. Polan. Minneapolis: University of Minnesota Press.

Freud, S. 1955. 'The "Uncanny"', trans. J. Strachey, in *The Standard Edition of the Complete Psychological Works of Sigmund Freud*. London: Hogarth, pp. 217–256.

Gennep, A. van. 1960. *The Rites of Passage*, trans. M.B. Vizedom and G.I. Caffee. London: Routledge & Kegan Paul.

Houtum, H. van and T. van Naerssen. 2002. 'Bordering, Ordering and Othering', *Tijdschrift voor Economische en Sociale Geografie* 93(2): 125–136.

Kant, I. 1977. *Werkausgabe: Band 10: Kritik der Urteilskraft*. Frankfurt a. M.: Suhrkamp.

Latour, B. 2004. *Politics of Nature: How to Bring the Sciences into Democracy*, trans. C. Porter. Cambridge, MA: Harvard University Press.

Pratt, M.L. 1992. *Imperial Eyes: Travel Writing and Transculturation*. London: Routledge.

Rancière, J. 2004. *The Politics of Aesthetics: The Distribution of the Sensible*, trans. G. Rockhill. London: Continuum.

———. 2010. *Dissensus: On Politics and Aesthetics*, trans. S. Corcoran. London: Continuum.

Rosello, M. 2005. *France and the Maghreb: Performative Encounters*. Gainesville, FL: University Press of Florida.

Schimanski, J. 2006. 'Crossing and Reading: Notes towards a Theory and a Method', *Nordlit* 19: 41–63.

_____ and S. Wolfe. 2007. 'Imperial Tides: A Border Poetic Reading of *Heart of Darkness*', in J. Schimanski and S. Wolfe (eds), *Border Poetics De-limited*. Hannover: Wehrhahn, pp. 217–234.

_____ and S.F. Wolfe. 2013. 'The Aesthetics of Borders', in K. Aukrust (ed.), *Assigning Cultural Values*. Frankfurt am Main: Peter Lang, pp. 235–250.

Shklovsky, V. 1965. 'Art as Technique', trans. L.T. Lemon and M.J. Reis, in L.T. Lemon and M.J. Reis (eds), *Russian Formalist Criticism: Four Essays*. Lincoln, NE: University of Nebraska Press, pp. 3–24.

Simmel, G. 1997. 'The Sociology of Space', trans. M. Ritter and D. Frisby, in D. Frisby and M. Featherstone (eds), *Simmel on Culture: Selected Writings*. London: Sage, pp. 137–170.

Taylor, C. 2004. *Modern Social Imaginaries*. Durham: Duke University Press.

Turner, V. 1970. 'Betwixt and Between: The Liminal Period in *Rites de Passage*', in E.A. Hammel and W.S. Simmons (eds), *Man Makes Sense: A Reader in Modern Cultural Anthropology*. Boston: Little, Brown and Company, pp. 335–369.

_____. 1992. 'Variations on a Theme of Liminality', in *Blazing the Trail: Way Marks in the Exploration of Symbols*. Tucson, AZ: The University of Arizona Press, pp. 48–65.

Welsch, W. 1997. *Undoing Aesthetics*, trans. A. Inkpin. London: SAGE.

Winnicott, D.W. 1971. *Playing and Reality*. London: Tavistock.

Index

www.ingramcontent.com/pod-product-compliance
Lightning Source LLC
Chambersburg PA
CBHW070931030426
42336CB00014BA/2627